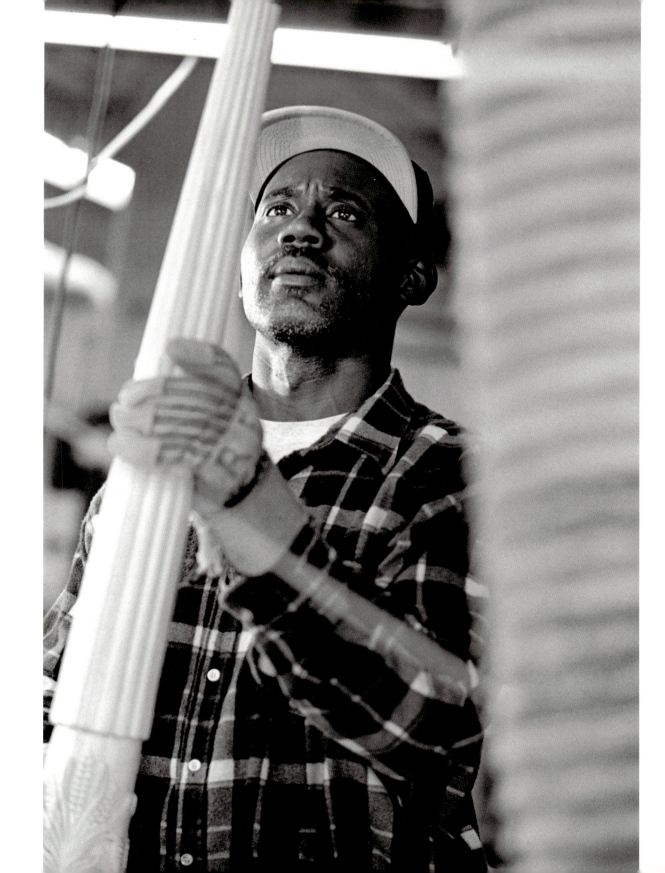

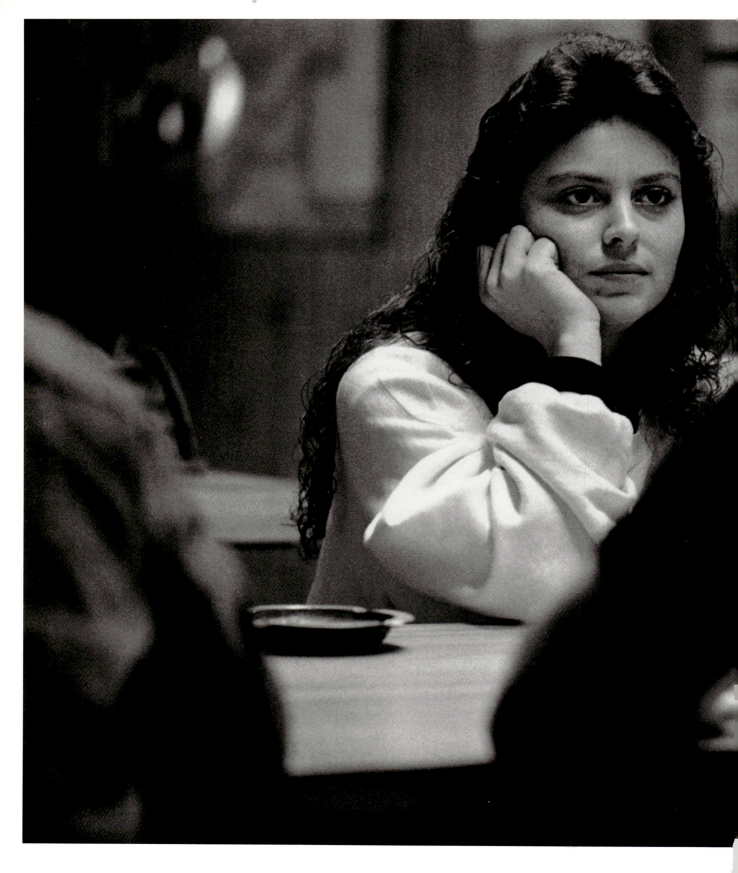

Tammy, lunch break

Preceding page: Andrew inspecting bedpost, sanding room

Overleaf: Donald and Rodney, veneer department

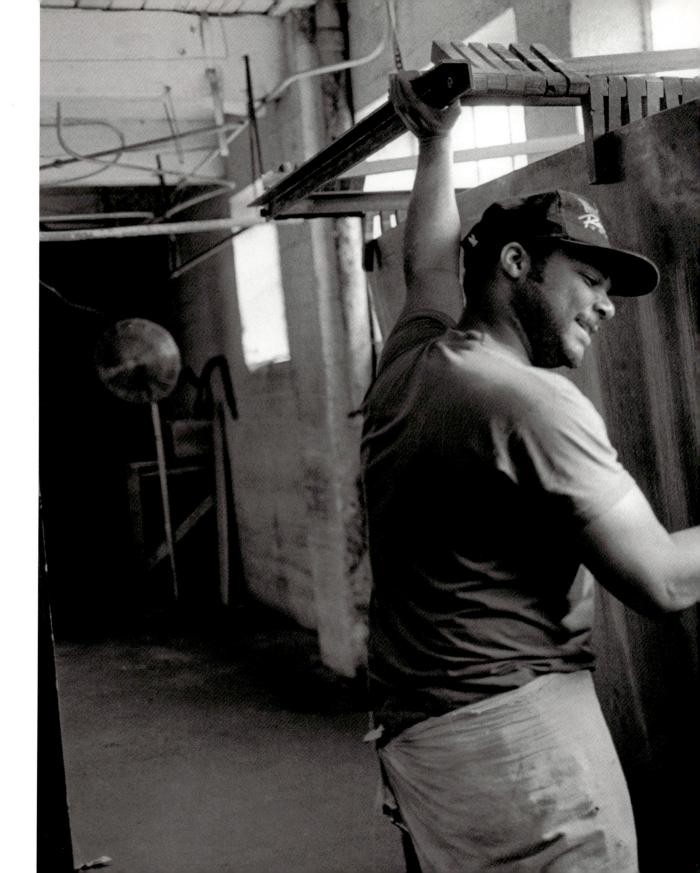

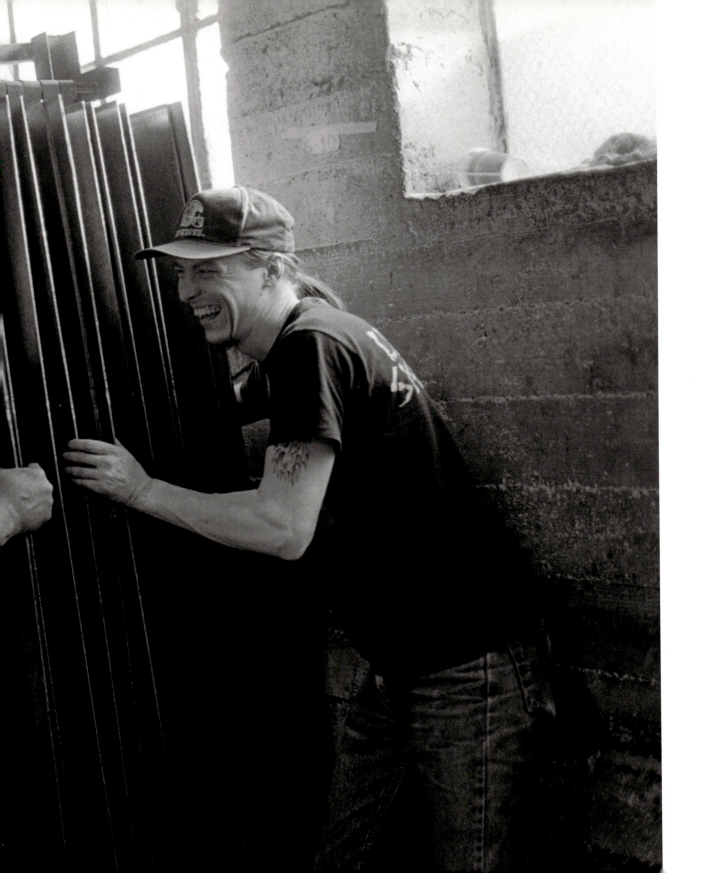

James sanding mirror
frames

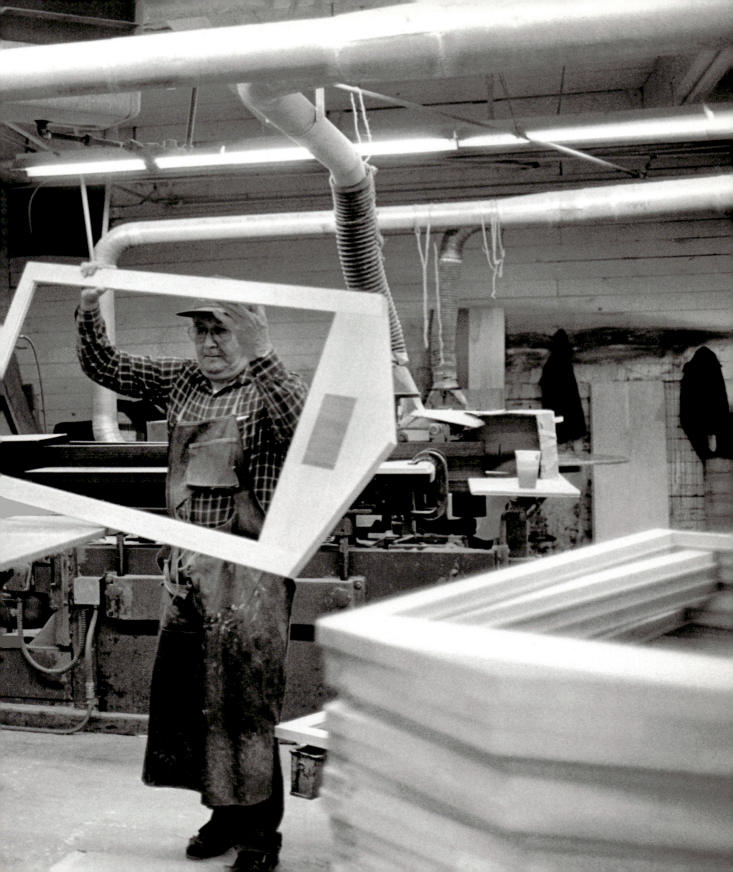

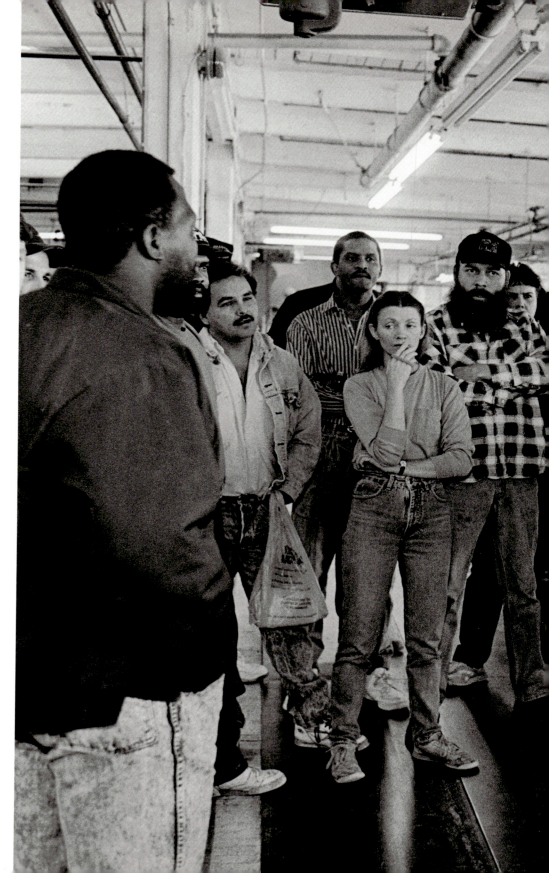

Layoff meeting, cabinet room

Overleaf: Avery leaving the cabinet
room on his final day of work

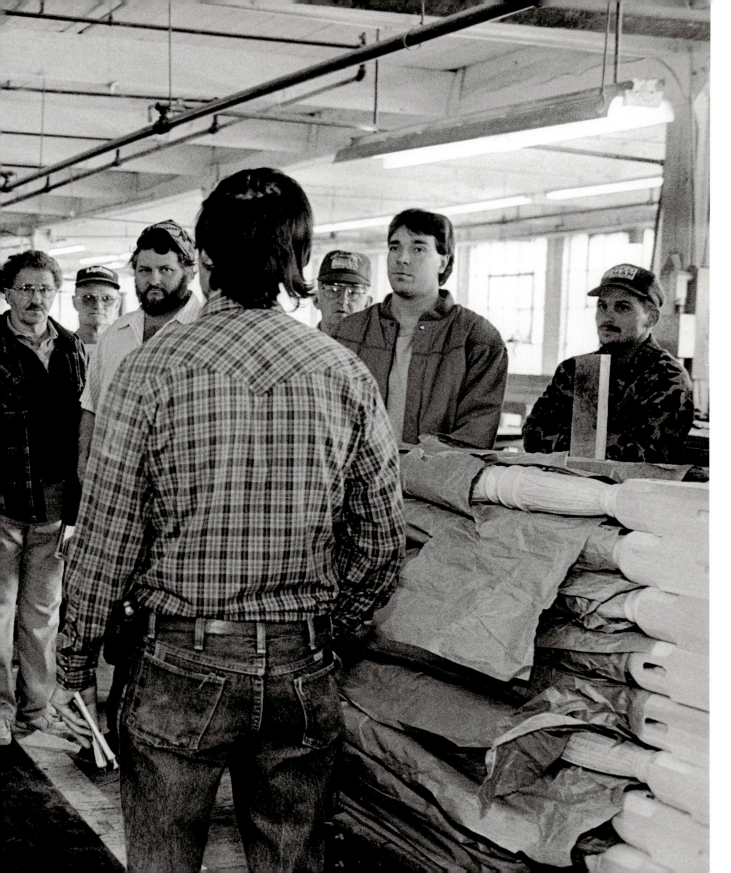

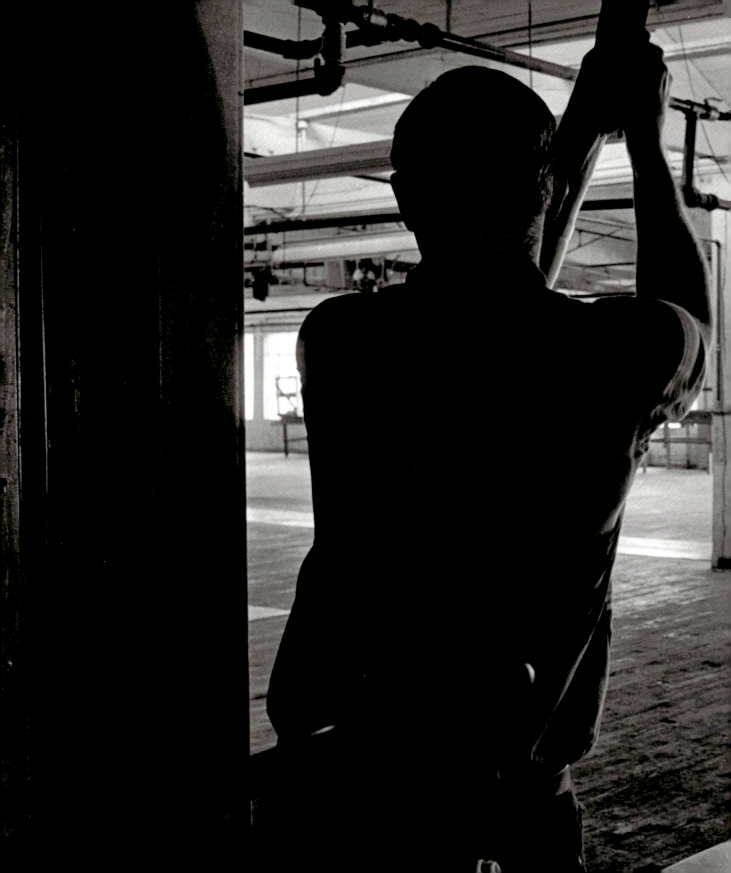

Bill Bamberger
Cathy N. Davidson

Closing

The Life and Death
of an
American Factory

The Lyndhurst Series on the South
A DoubleTake Book
published by
the Center for Documentary Studies
in association with
W. W. Norton & Company
New York • London

Closing: The Life and Death of an American Factory

Text © 1998 by Cathy N. Davidson

Photographs © 1998 by Bill Bamberger

Library of Congress Cataloging-in-Publication Data

Bamberger, Bill.

Closing : the life and death of an American factory / Bill Bamberger, Cathy N. Davidson.

 p. cm. — (The Lyndhurst series on the South)

"A DoubleTake book."

Includes bibliographical references.

1. White Furniture Company. 2. Furniture industry and trade — United States.

3. Downsizing of organizations — United States — Case studies. 4. Plant shutdowns —

North Carolina — Mebane. I. Davidson, Cathy N. II. Duke University.

Center for Documentary Studies. III. Title. IV. Series.

HD9773.U7W473 1998

97-36923

338.7'6841'00975658 — dc21

ISBN 0-393-04568-4

W. W. Norton & Company, Inc.

500 Fifth Avenue, New York, New York 10110

http://www.wwnorton.com

W. W. Norton & Company, Ltd.

10 Coptic Street, London WC1A 1PU

1 2 3 4 5 6 7 8 9 0

DoubleTake Books & Magazine publish the works of writers and photographers who seek to render the world as it is and as it might be, artists who recognize the power of narrative to communicate, reveal, and transform. These publications have been made possible by the generous support of the Lyndhurst Foundation.

DoubleTake

Center for Documentary Studies at Duke University

1317 West Pettigrew Street

Durham, North Carolina 27705

http://www.duke.edu/doubletake/

To order books, call W. W. Norton at 1-800-233-4830.

To subscribe to *DoubleTake* magazine, call
1-800-234-0981, extension 5600.

Contents

Closing

Preface

When the last worker passed through the doors of White Furniture Company in May of 1993, hardly anyone beyond the city limits of Mebane, North Carolina, noticed. In national terms, it made little difference that 203 men and women were out of work or that a venerable, family-owned firm (the "South's oldest maker of fine furniture") had been sold to a conglomerate and now was being shut down. After all, what happened to White's is hardly unique. In the 1990s, in every walk of life and on all social levels, Americans have had to learn a new vocabulary of economic anxiety—layoff, outsourcing, buyout, off-shoring, downsizing, closing. The statistics are mind-numbing: 70,000 people laid off from General Motors in 1991; 50,000 workers from Sears and 63,000 from IBM in 1993; 40,000 from AT&T in 1996. In these times, why should we care about the closing of one furniture factory in a small southern town?

There are many reasons to care, not least that the story of White Furniture Company is a study in miniature of work—what it means when you have it, what it means when you don't. Behind the grim headlines are real men and women who, like the White workers, are devastated not just by the lack of income but by the end of a way of life based on doing a job and doing it well. The wages at White Furniture may have been low; the equipment was antiquated and the working conditions harsh—incessant noise, fumes pervading the air, the factory building cold in winter and sweltering in summer. Yet, looking back, White's workers mourn the closing of the plant and, mostly, they mourn the loss of their craft and their companions. Factory work—industrialization—had a high price tag. Now we are seeing, everywhere around us and on every social level, the dire cost of post-industrialism.

The former workers and supervisors at White Furniture Company represent a cross-section of the American workforce. There is Annette Patterson, who fed her

family's hogs and chickens when she was a kid and went on to become one of the only women in the White rough mill, feeding lengths of raw lumber into the snarling ripsaw. James Gilland's work life began in the bean fields of Tennessee following the death of his father, when he was scarcely more than five years old. He worked at White's for forty-two years, as an upholsterer and cabinetmaker, and later, as supervisor of the upholstery department. Robert Riley began doing menial work out in the lumberyard when the plant was still segregated and went on to become the first African American supervisor at the company. Since the White closing, he has had to start all over again, working two jobs in order to make ends meet. Margaret Holmes White was an efficient, even powerful, executive assistant to the president by day; by night, she nursed her ailing parents and, later, her husband. Don McCall was called to Mebane to help reorganize and supervise the sanding department after the factory was bought out by Hickory Manufacturing Corporation. Three years later, he found himself helping to shut down the plant. Now living quietly back in the North Carolina mountains where he was born, he has still not fully recovered from the shock and stress of the closing.

The corporate players who vied for the future of White Furniture are also recognizable as individual types, Shakespearean in their outsize motives and intentions. At one extreme was Stephen A. White V, the company's elderly president—Harvard-educated, patrician, civic-minded. Desperate to hold on to the family business begun by his father and his uncles, he believed in doing things pretty much the way White's had done them in the past, with a paternalistic loyalty to its employees and little interest in modernizing the operation or cutting costs in order to guarantee higher profits. At the other extreme was Clyde Engle, the forty-something CEO of the Acton Corporation (now Sunstates), the parent company of Hickory. A Chicago-based venture capitalist, Engle built up a $500-million corporation by acquiring small, floundering companies like White's. Somewhere in between the models of American business embodied by these two different men is Martin Eakes, a civil rights lawyer turned astute businessman. Eakes tried, in the eleventh hour, to prevent the takeover by proposing an employee buyout of White's. Dismissed by some as an idealistic do-gooder, Eakes, through his Center for Community Self-Help, now has one of the best return records of any lending agency in the state.

As we shall see, different people have different ideas about who was responsible for the closing of the White Furniture Company. Whether labor or management, new or longtime employee, the White workers are articulate not only about what

happened to them but about the ways their story is a national story—a tale of where we have been, where we are now, and where we are going as a nation.

What becomes evident from their stories is that there are no clear villains, even though there is clear, human pain. Many insist that White's was an anachronism, a relic from America's golden age of mechanized, industrialized labor, and that the closing was inevitable given technological innovations in the industry as well as today's aggressive, market-driven, globalized economy. Others counter that White's demise portends the end of an era for highly crafted furniture and symbolizes the loss of community and values that plagues late-twentieth-century America. From a corporate perspective, closing the Mebane operation made good, practical business sense. In Mebane, most old-timers call the closing a tragedy.

More and more of us feel the disparity between the realities of a postindustrial economy and old virtues such as loyalty or the work ethic. Many of us find our lives increasingly governed by enormous economic processes that seem not only out of our individual control (as has long been the case) but out of anyone's control. One out of four Americans today has been directly or indirectly affected by a layoff—and yet the economy is booming, Wall Street flourishes, productivity is at an all-time high. What does this all mean? How does it add up?

The White story can teach us some of the economics that propel our era, especially how and why smaller businesses, many of them begun in the late nineteenth century, are being taken over by corporate conglomerates with headquarters elsewhere and then, as often as not, sold off, consolidated, or simply closed down. It is almost impossible for the layperson to understand what all the implications might be when a giant like Disney Corporation plunks down nineteen billion dollars to buy ABC. Nor can we conceive how many it will affect. At White's, the numbers are smaller, the human consequences vivid and easier to track. The Hickory proposal won in a close vote of the shareholders, 54 to 46 percent in what amounted to a "hostile takeover." That complex and frightening term is humanized and more readily understood when we realize that the shareholders were president Steve White's own children, grandchildren, cousins, nephews, and nieces. They accepted a buyout proposal that mandated Steve's resignation because White's was losing money and they feared for the company's future. Afraid that their inheritance, the White stock, would dwindle to nothing, they voted to sell.

At its heart, then, the White Furniture story is not just about economics. It is about personal loss and family tensions. It is about the joy of work and the tragedy of being deprived of work. It is about the sense of self that comes from taking

pride in one's craft. And it is about the sense of community that develops when people who might otherwise have little in common—men and women, blacks, Hispanics, and whites—work side by side, depending on one another to get a job done right.

The human story of the White Furniture Company is what photographer Bill Bamberger hoped to capture on film. Bill had lived in Mebane since 1988 and thought of the 111-year-old firm as the heart of the town. When he heard that White's was closing, he wrote to the CEO of Hickory Manufacturing Corporation (renamed Hickory-White Corporation) asking for permission to go into the historic factory and photograph the workers during their final months at their jobs. In December of 1992, Randolph J. Austin, the man who took responsibility for the decision to close the Mebane plant, granted Bill's request to photograph it.

Bill was there until May of 1993. He stayed until the last piece of furniture had been made and the last worker had left. He photographed women and men doing their jobs. He recorded intelligence in their faces and dexterity in their hands, the sense and sinew of the White workers. He recorded the vastness of the factory building and the bustle and vitality within. Bill's photographs reveal the postures and gestures of people at work—the intense concentration of trying to get a joint or a finish exactly right or the tender, almost balletic grace of operating an enormous machine that an outsider might find terrifying.

A job is so basic to our sense of self in the United States that a chasm separates the employed from the unemployed. Even in situations where a layoff happens through no fault of one's own, the sense of shame often renders the unemployed person silent and invisible. The unemployed often quietly disappear. Bill's photographs are a guarantee against that invisibility. He photographed every stage of the plant's closing, from the gradual layoff of workers and shutting down of departments to the final auction where grim-visaged buyers purchased White's last effects. Most remarkably, he was even there in the room taking pictures when the severance papers were handed around and when the workers read, for the first time, the details of their future. His candid black-and-white photographs of the pension meeting, taken with a hand-held 35 mm camera, document the devastation of postindustrial America. Once-proud workers look scared and small as they contemplate their fate. Seeing Bill's photographs, we think: this is the diminution of the human spirit that comes from being laid off, downsized. This is what unemployment looks like.

"It tee-totally pissed me off," says Ivey Jones, a cabinetmaker who came to White's in 1976, thinking back on the first time he saw Bill taking photos inside the plant. "I said, 'It's humiliating enough to lose our jobs. We are already frustrated. We don't know where our next paycheck is coming from and we don't know where we will find a job and here this guy is looking at everybody's face and taking pictures, taking pictures, taking pictures.'"

Ivey and Bill can laugh about this now, but there's bitterness in Ivey's voice, even two years later, as he recalls that painful time. Bill was coming in to photograph only weeks after the announcement that the plant would be closed. "When I first saw him with his camera, I considered him the enemy," Ivey says candidly. "I looked at him just like I did management, just one more vulture in here trying to pick the bones of the employees."

Bill knew what he was getting into when he began photographing. He knew some people would resent him. He decided there was nothing he could do but be patient, keep working and talking to people, explaining why he was photographing them. He hoped they would come to trust him. For the five final months of the company's existence, he worked all day and then would come back many nights to work, too. Often he ran into people inside the factory who were working overtime. "He was around a long time," Ivey says with a smile. "He was even there at the very closing of the plant." Finally, Ivey became one of Bill's biggest supporters. When he talks about the photographs now, he expresses Bill's fondest hope for the project. "What he's doing will give people a sense that, even though I did lose my job, it's not totally forgotten," Ivey insists. "Somebody will have pictures of this. Somebody will remember."

A small company, White Furniture never had the name recognition, outside of the industry or outside of North Carolina, of its larger competitors in the high-quality furniture market (for example, Baker or Thomasville). To cognoscenti, White's was known as some of the finest furniture crafted in America. The pieces were made on a factory assembly line, but many of the steps were done by hand. Many of the workers were highly skilled artisans who specialized in one process, such as sanding or finishing. Working with mahogany and other fine woods and primarily in traditional furniture styles, White's made reproduction antiques. It was not furniture for the masses. A dining-room set, in 1993, sold for between fifteen and twenty thousand dollars, more than some White workers earned in a year.

By the time I came onto the project to write this story, the White factory in Mebane was closed. I visited other furniture factories in the area to gain some sense of what it must have felt like to work at the Mebane plant, but I went inside the old factory building in Mebane only once. Bill took me through in May of 1994, almost a year after the closing. A security guard let us in. We chatted with him for a while, and then Bill and I started our tour. Light inched through smudgy windows revealing floating trails of dust and wood shavings and, on the floor, pools of inky water. "This used to be the sanding department," Bill said. "This was the rough mill." We were shocked by the decrepit condition of the building. Whatever was once here had been discarded. The space, once so full, was now lifeless, abandoned, dead. No machinery. No stacks of wood. No furniture. Of course, no people. Two hundred and forty thousand square feet of nothing. "I've never seen it feel so empty," Bill said quietly, and then we left.

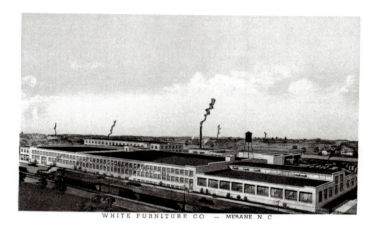

WHITE FURNITURE CO — MERANE N C

Chapter One

White Furniture Company of Mebane

You enter Mebane the way you enter many small North Carolina towns — from the expressway, turning off, slowing down. Just beyond the I-85 exit is the main residential thoroughfare, tree-lined with elegant turn-of-the-century homes, neatly painted, freshly restored. There is a small business section and, clustered nearby, the tidy homes of working people. Mebane would seem like a quietly prosperous place were it not for the hulk of the old White Furniture Company, looming at the center of town.

Like many towns in this part of North Carolina, Mebane is a furniture town. Nearly one in twenty of Mebane's residents worked at White's and virtually everyone knew someone who did. White's generated much of the town's economy and regulated many of the rhythms of the town — opening and closing time, lunchtime, weekends, holidays. "Life ran around the whistle blowing," says Wallace Bradshaw, who began at White's in 1947.

The history of Mebane is a microcosm of the American furniture industry. The glory of that history is White's. If you ask longtime residents of Mebane about White Furniture, you will hear certain phrases repeated over and over. You will hear that White's was a family-owned business and that it was known as "the South's oldest maker of fine furniture." The words "oldest" and "fine" carry particular weight in this description. Longevity, tradition, and a past that counts are

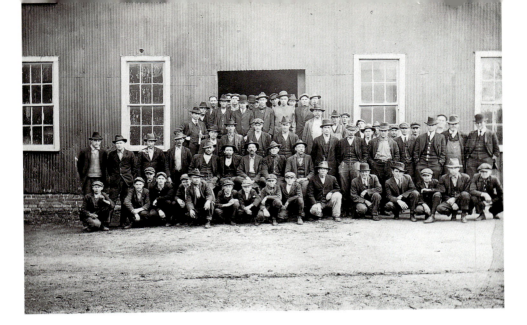

important in Mebane. There is pride of place and pride of craft when residents talk
of White's.

The White Furniture Company put Mebane on the map. Literally. The town
was incorporated in 1881, the same year the company was founded by the two
White brothers, Dave and Will. Fueled by the success of White's, the town grew
from a one-company village of 231 inhabitants to, by the First World War, a thriv-
ing town of over a thousand people with jobs in eleven different businesses, many
of them ancillary to White's — textiles (for upholstery), lumberyards, factories that
made other kinds or grades of furniture, machine shops that could make parts to
keep the equipment at White's running.[1] White Furniture Company grew and
prospered, and so did Mebane.

And White's grew because the whole region was changing rapidly. In fact, the
Piedmont crescent would become the heart of the so-called "New South," the first
area in the South to be industrialized in the late nineteenth century as northern
investors, in particular, started up large-scale manufacturing operations (primarily
steel, textiles, and furniture) designed to undersell competitors in the Northeast
and Midwest.[2]

Like other American industries, woodworking started in New England. Origi-
nally concentrated in the "Massachusetts chairmaking district" on the outskirts of
Boston,[3] the industry dispersed to different regions of the country as the popula-
tion expanded westward after the Civil War. By the heyday of mechanization and
steam power in the late nineteenth century, furniture making was becoming de-

centralized, with some factories remaining in New England but others opening in Ohio, Illinois, Indiana, and, most famously, in Michigan, clustered around Grand Rapids. The industry moved south, too, settling within a 150-mile area stretching from Bassett, Virginia, to Lenoir, North Carolina.[4]

Why North Carolina? The reasons are partly historical and partly geographical, but they boil down to three overlapping factors: a good railroad system with access to the markets in the Northeast; an abundance of hardwood forests as well as fast-growing native poplar, gum, and pine trees; and, of continuing importance, a skilled but cheap labor force.[5] North Carolina was always one of the poorest southeastern states, looked down upon by its more prosperous neighbors, Virginia and South Carolina. (An old southern adage refers to the state as a vale of humility between two mountains of conceit.) Unlike southern states that had been dominated by massive cotton or rice plantations, in North Carolina the single-family subsistence farm provided the principal source of income. The hard red-clay soil and the vagaries of North Carolina weather made this a meager and unpredictable existence for most.

These conditions were made even more difficult by new land-use taxes designed to discourage small-scale agriculture and encourage industry in the last decades of the nineteenth century. Similarly, new fencing laws (equivalent to the enclosure laws passed in England decades earlier) made the former practice of grazing one's livestock on unfenced private or public lands illegal. Since few could afford enough land to raise both crops and farm animals, the effects were immediate and catastrophic. Both black and white subsistence farmers were forced to sell their family farms for a pittance and then rent tracts of land on large farms that specialized in profitable cash crops such as cotton and tobacco. Tenant farmers were paid in crops as well as in scrip that could only be cashed in at the company store.[6] Not surprisingly, for many the factory provided an alternative to this debilitating system by promising actual cash money for actual labor.[7]

Many of the first furniture workers came from this class of white tenant farmers.[8] They not only worked in the factories; they also bought the products they made. As the *Southern Lumberman* noted in 1901: "There have been thousands of families in the Southern States that have not had a new bedstead, bureau, or set of chairs since the close of the War between the States."[9] In cyclical fashion, the North Carolina furniture industry expanded partly to cater to new consumers created by the South's recent industrialization.

By 1900, North Carolina boasted forty-four furniture factories producing

$1,547,305 worth of goods.[10] By 1902, an exhibition building for furniture shows opened in High Point (some thirty-five miles from Mebane) and a monthly trade journal, *Southern Furniture Journal,* began publication. The furniture industry was becoming professionalized, with its headquarters firmly established in North Carolina. Today, twenty-five of the nation's top thirty furniture manufacturers are located within the region, with High Point being the unlikely epicenter of the nation's twenty-billion-dollar furniture industry—its Paris, as it were. Here, far from a major urban center such as New York or Atlanta, each season's new furniture lines and designs are unveiled for the public. Twice each year, fifty thousand retailers from all over the United States and abroad flock to High Point to visit the International Home Furnishings Exposition.

Dave and Will White were local residents of Mebane, from one of the more prosperous and prominent families in the area. Their father, Stephen A. White III, had won a seat in the state senate as a Republican in a Democratic county, was an elder in the local Presbyterian church, and served as postmaster from 1855 until the time of his death. However, a series of loans extended to friends badly hurt by the depressions in the 1870s forced him into bankruptcy. Determined to preserve the family honor, sons Will and Dave pledged to pay off the money owed to their father's creditors, and set out to do that by opening White Furniture Company.[11] They started with a small loan from a family friend and a stash of $275 that they amassed from their jobs as telegraph operators. Eventually, four brothers would enter the company. Will White served as the company's president, Dave as general manager. In 1896, the most ambitious of the three brothers, J. Sam White, finished his college degree but then came into the family's company as a day laborer, working sixty hours a week, at a starting salary of five cents an hour. Later, he was elected secretary-treasurer while a fourth brother, Stephen Arthur, worked as a company salesman.[12]

The White brothers were aggressive businessmen who took seriously their place in the town and who, like many in the New South, equated industrial growth with civic duty and regional pride. These values of industrial gentility are evident in the obituaries for their father, who died in 1908. Characteristically, the newspapers pass over in silence his bankruptcy, yet all of them devote almost as much time to the successful sons as they do to the father and his Scotch-Irish genealogy. The Whites, one obituary notes, have been "foremost men in the development of Mebane and the surrounding country, industrially, educationally, and morally."[13]

They learned on the job, initially manufacturing only wagon wheels and round oak dining tables. Operating out of a simple, barnlike building with only two pieces of equipment (a boiler and a planer), they so impressed a local businessman with their early success that, in 1886, he loaned them the money to expand their building and add more sophisticated machinery. Soon White's employed thirty-two people who made tables, chairs, and other small household items. One specialty was a solid oak bedroom suite (bed, dresser, and washstand) that sold for nine dollars.[14]

At the turn of the century, the White's briefly entered into a partnership with a northern businessman, A. J. Rickel, who had twenty years' experience in the Ohio furniture industry. He came to White's (for a time renamed White-Rickel Company) as plant manager and helped to modernize the operation, essentially turning it from a cabinet shop to a factory using the most current methods of production in the furniture industry, including belt-driven and later motor-driven assembly lines powered by steam boilers burning scrap lumber.[15]

Recognizing that a whole furniture industry was burgeoning around them, the Whites decided to stake out a different territory for themselves. While most southern furniture makers specialized in low-cost furniture catering to the needs of southerners, White Furniture sought to produce quality furniture well advertised in both the North and the South.[16] White's is credited with being the first furniture company in America to advertise a "line" as a way of consolidating its reputation.[17] It also pulled off an impressive publicity gimmick by featuring, at the annual furniture exhibition of 1897, a "center table of unique design, built of the famous Mai-Padoo wood, all the way from Siam, probably the only piece of wood of its kind in the United States."[18] Articles about this table appeared in newspapers all over the United States and the White Furniture Company became synonymous with quality.

In 1906, when the U.S. government needed furniture for American officers and enlisted men in Panama, the bulk of the contracts went to White's. A total of fifty-eight boxcars full of White furniture was shipped from Mebane, North Carolina. A local newspaper reported the singular event: "The first solid train load of furniture of one order ever shipped by a southern factory left here containing the first installment of furniture for the Panama Canal, contracted for by the government with The White Furniture Company. This train of cars was handsomely placarded, each car bearing a twenty-foot banner worded, 'FROM THE WHITE FURNITURE CO., MEBANE, N.C., FOR U.S. GOVERNMENT, PANAMA CANAL,' and then the company trademark, 'The White Line Guarantees Satisfaction.'"[19] Regional newspapers reported the story widely, always emphasizing that this was

the first time such a contract had been awarded "by the government to a *southern* factory."[20]

One year after the Panama Canal shipment, White's consolidated its reputation by winning the award as the best manufacturer of American furniture at the Jamestown Exposition, a world trade exposition. A few years later, in 1912, J. Sam White approached millionaire Edwin Grove and his son-in-law Fred Seely about supplying some of the furniture for the luxurious mountain resort hotel, the Grove Park Inn, that they were building in Asheville, North Carolina. It was an audacious move since the original plan was to furnish the hotel entirely with chairs, tables, and accessories hand-built by the most famous furniture guild in America, the Roycrofters of New York, pioneers of the American Arts and Crafts movement, with its solid oak, Mission-style furniture. The Roycrofters supplied several hundred pieces, but White's did the rest. "Mr. Seely was a very exacting man and a hard worker and wanted everything perfect and did not believe that a furniture manufacturer in the South could make furniture satisfactory to them," J. Sam White recalled later. "After examining the sample, Mr. Seely was convinced that we could make the furniture. . . . [He] was so pleased with our work that he asked us to make many of the doors and other pieces used throughout the hotel."[21] Today, the Grove Park Inn boasts one of the largest collections of Arts and Crafts furniture in the nation, and many of the pieces still have, in the upper right-hand drawer, a small metal label: "The White Line, the Right Line."

With great civic fanfare, White Furniture Company celebrated all of its successes by moving into an enormous new building near the center of Mebane. The five-acre plant was heralded as a model for the industry as a whole, utilizing the best new technologies in the furniture business. In 1916, when Dave White was killed in an automobile accident, people all over the county mourned. No one worried, though, about the continuation of White Furniture Company. Brother Will continued as the company's president. He retained that position until his death at seventy-six in 1935.

Because of Will White's long reign as the head of White Furniture Company, he has become an almost mythic figure in local history. In the stories residents tell about the company, Will, more than anyone else, symbolizes White's attitude of benevolent paternalism toward its workers. Chief among these is the story of the disaster that hit the company on December 21, 1923, when sawdust exploded in the huge, new White building at the corner of Fifth and Center Streets and the entire factory burned to the ground. Although no one was killed in the fire, nothing of

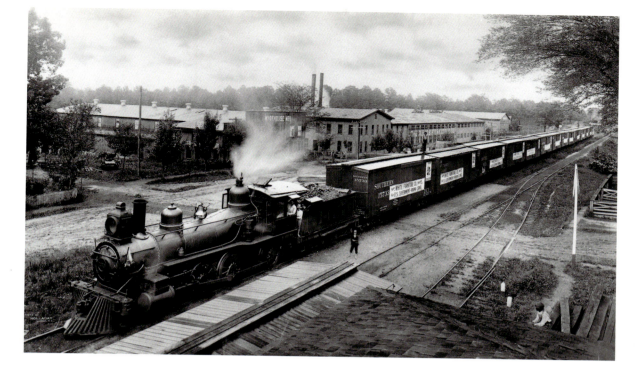

the building or the equipment could be salvaged from the blaze. Will White was sixty-seven years old and, a bachelor, he had no direct descendants to inherit the company. As the largest stockholder, it was his decision whether or not to reinvest in White Furniture Company. Most workers feared he would not reopen the plant, but, according to local lore, he not only decided to rebuild, he actually gave all of the White employees the Christmas bonus he had promised them. He also pledged that everyone who was willing to wait until the new plant opened would be hired back. Since White's was the first furniture company in North Carolina to use lacquer in its operation, DuPont, which manufactured the lacquer, provided emergency funds for rebuilding the factory, and many of the workers—both wage employees and management—were hired to construct the new building. White Furniture Company was operating again within seven and a half months of the fire.

According to one favorite White family story, when the plant reopened Will White made sure that each and every one of his original employees was back at work at the new plant. He asked his men if anyone was missing, and was told that one employee had had to go to Virginia to find work during the layoff period. "I'll wire him money so he can come back and go to work here," is what Will White is reputed to have said.[22]

Trainload of White furniture headed to the Panama Canal, 1906. Photograph by Waller Holladay.

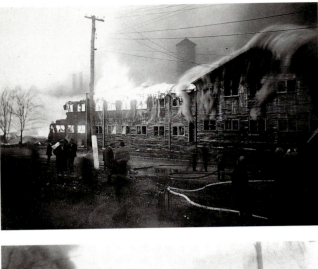

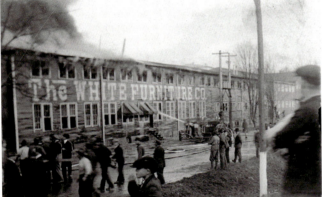

The fire of 1923

The White Furniture Company survived the Depression reasonably well, again helped along by workers who were willing to work at reduced wages in order to keep the company afloat. Additionally, the company was able to function throughout the Depression with a subsidy from DuPont. Will White apparently went to the DuPonts and emphasized that White Furniture had been a good customer in the good times and that now they needed some help to stay solvent in bad times. The deal was closed with a handshake.

After Will's death, J. Sam White (called "Mr. Sam"), moved from being secretary-treasurer to become president of White's. The new leadership made barely a ripple in the company's policies or vision. During the nationwide building boom of the forties, Mr. Sam expanded the company, purchasing a second plant in Hillsborough. By the end of the war, the White operation was at its largest, with over five hundred employees at the two sites, and business flourished. In 1966, Mr. Sam received a seventy-year service pin from the company, the "longest tenure pin that the Balfour Security Pin Company had ever given to any employee in the United States."[23]

It wasn't until 1969 that the first generation of White brothers would finally step down from leadership of the company they had founded in 1881. That year, Mr. Sam assumed the largely honorary title of chairman of the board, and made his son, Stephen A. White V, president. His nephew, Steve Millender, became vice president and director of sales. It would be these two Steves, first cousins, who would run the company for the next fifteen years, who would disagree over the course and vision of the company, and who would, ultimately, face off over the decision of whether or not to sell the family business to Hickory Manufacturing Corporation in 1985.

Mebane had reason to be proud of White's. Its successes were impressive by any standard, and certainly for a small, family-owned company. The early history of the company has almost a fairy-tale quality—valiant sons repaying their father's debt, the shipment to the Panama Canal, first prize at the Jamestown Exposition, billing with the Roycrofters as furnishers of the Grove Park Inn, the 1923 fire and subsequent rebuilding, phoenix-like from the ashes. As is often the case, the company's origins are bathed in the happy glow of nostalgia. Whether there were fights between the company's founders, moments of crisis or indecision, all are lost to posterity.

These are not White's only claims to fame, though. For when Mebane residents talk of White's, they typically pay as much attention to the *kind* of factory the White family ran as they do to the company's successes. Many of the old stories, so grounded in the values of mutual loyalty and respect, are confirmed by similar stories workers now tell about White's. Former workers reminisce about how they could work five or ten years with the same partner. Although there was no guarantee of lifetime employment, most of the White employees believed that, as long as they did their job well, they would have a job. As we shall see, they felt there was reciprocity at White's. White's demanded excellence, and, in turn, respected workers and gave them an unusual degree of autonomy to produce at their own speed and to police themselves and one another for quality workmanship. The U.S. Bureau of Labor Statistics labels most assembly-line furniture workers as unskilled or semiskilled laborers, but the White workers invariably describe themselves as skilled artisans and feel that they were treated that way at White's.[24]

The intense identification workers felt with the company and with the furniture they made partly explains the labor relations that persisted at White's until the buyout. As with much of the southern furniture industry, White's was only sporadically and partially unionized. A brief strike in 1919 is indicative. The White workers voted to strike as part of the post–World War I labor actions all over America and, specifically, in response to textile strikes in High Point where over five hundred union members marched downtown, led by a brass band and carrying banners that read, "We Will Work Under Union Conditions. Or We Will Leave High Point."[25] Some of High Point's furniture workers expressed solidarity by refusing to work, picketing their companies, throwing eggs at strike breakers, and disrupting High Point's furniture production. Manufacturers refused to accept the

union and locked out the striking workers for six weeks, drawing from the state's vast pool of underpaid workers to fill the strikers' jobs. North Carolina governor Thomas W. Bickett was called in as a mediator on September 12. He consulted with both sides and finally won an agreement from management to recognize the union; from the union, he won an agreement that the factories would be run as open shops, with nonunion workers allowed to work side by side with union members.[26] By contrast to the situation in High Point, when Governor Bickett came to Mebane to arbitrate after the White workers voted to strike, the sides came to an agreement almost immediately. The strike attempt at White's ended without loss of a day's work or a single act of violence.

Even in the 1940s, when membership in the United Furniture Workers of America and similar trade unions was highest, less than 10 percent of the southern furniture industry was unionized.[27] Today, the percentages remain small. Many would say, in fact, that the South continues to dominate the furniture industry largely for this reason. North Carolina's furniture workers continue to be paid as much as one quarter less than equivalent workers in the Northeast and Midwest.[28]

The Whites considered unions a violation of the "familial" bonds within the factory and actively discouraged their employees from joining. Old-time workers recall that in the fifties, when organized labor was gaining a small foothold at White's, the managers had two "snitches" placed in the union (one white, one black) who would spy on workers and report on their activities.[29] Management would then bring pressure to bear on potential organizers. Significantly, workers and management alike agree that the pressure came mostly in the form of innuendo, rather than by actual threats or punishments. They insist the Whites never fired anyone for joining a union. Ivey Jones, who came to White's in 1976, tells of a failed attempt to organize a few years before he started at White's. Older workers would talk about "one time having a meeting. There was such a big mess about it, they just swept it under the rug, and it never was brought up again."[30]

It is easy to be cynical about the ways an ideology of family and respect kept downtrodden workers docile. Yet this demeans the White workers, making them seem passive and stupid.[31] They were not. They often speak about other job opportunities in the area — at larger plants, many of them unionized — that offered higher wages and better benefits. For many, working at White's was a conscious choice for a certain kind of work as well as a decision that job security was more important than better wages. Equally important, they did not feel that they were being exploited. Like other furniture businesses, the profit margin at White's was

modest, and White's could remain a viable business precisely because it produced top-quality furniture for 10 to 20 percent less than its chief competitors. If the Whites underpaid workers, they also underpaid themselves, running the company with modest executive salaries and admirably low administrative overhead. As many White workers relate, management kept the same long hours as the workers. There was little sense that the workers toiled while the owners played.

Unquestionably, there was a gap in wealth and social position between the owners and the workers. The original White home, which was directly opposite the factory, was quite grand. The Whites would be on anyone's list of the most important citizens in Mebane. At the same time, most of the workers were able to live comfortably if modestly on their wages. Steve knew the workers by name, and socialized with a number of them. Dr. Thomas Langford, a retired Duke University professor who supported himself through divinity school by working as a minister in Mebane, recalls how a labor action in the mid-1950s backfired when union organizers tried to rally the workers by characterizing the owners as money-grubbing, exploitative capitalists. "Steve White went duck hunting with the workers," Dr. Langford says. "You just don't say those things about a birding buddy."[32]

Race relations, too, were shaped by White's paternalistic philosophy. Relative to other conditions in the rural, segregated South, working conditions at White's were good for African Americans.[33] Traditionally, furniture factories in the South employed mostly white workers while lumberyards (which paid lower wages) employed mostly black workers.[34] Interestingly, White's hired African American workers at least back to the 1930s and, by the end of the Second World War, was known as a place where black workers would be treated decently. Joe Thompson, an African American who worked at White's for thirty-eight years, talks about how he started in 1946, soon after returning from active duty in Europe. "That was a good place for black folk," he insists. "It was the best at that particular time. When a black man got into White's, he was doing pretty good."[35]

Thompson acknowledges that the situation wasn't perfect. For most of his career, all of his supervisors were white. By the time he retired in 1983, he estimates that a third of the workers were black, although, he points out, there were still only two or three black "boss men." He is quick to observe, however, that, among the nonmanagerial workers, wages and responsibilities felt equally divided among blacks and whites doing the same job. Like a number of other black workers, Thompson says that he experienced relatively little overt racism on the job. Like many other black workers, he feels loyal to the White family.

In order to gain a clearer picture of the circumstances leading to the buyout, it is useful to see White's within the context of the furniture industry as well as within the larger corporate climate of the mid-1980s. The fifth most decentralized American industry, furniture manufacturing continues to be dominated by companies like White's that are family owned, privately held, independent, and small, even with the buyouts and mergers of the seventies and eighties.[36] There are no giants in the furniture industry equivalent to Henry Ford or, more recently, Lee Iacocca, or Bill Gates. Even the most familiar names in the American Furniture Hall of Fame in High Point are only vaguely recognizable to the general public: J. D. Bassett, James Edgar Broyhill, Peter Kroehler, Edward Hudson Lane.[37] Individual companies operate autonomously, with their own idiosyncratic rules and procedures that are remarkably private, if not downright secretive.[38]

Like many small businesses begun in the nineteenth century, White's was out of step with what came to be standard corporate financial procedures in the eighties—and, consequently, was vulnerable to mergers, takeovers, and buyouts from large firms outside the furniture industry. While the major corporate players of the eighties were borrowing as much as possible at low interest rates and then speculating in more lucrative and diversified enterprises, White's was operating very much as a cash-and-carry business—no debt, no investment, no capital expenditures (not for depreciation purposes or even to make the operation more competitive).

White's was also typical of small, family-owned businesses founded in the late nineteenth century, at the height of America's industrialization, which faced problems in subsequent generations. While the tradition of loyalty and respect carried over to the second generation, many people report that the entrepreneurial energies of the first generation—the excitement of excelling, expanding, and modernizing—was gone. By the 1970s, White's began to feel like a company in decline. Little was done to modernize the physical plant at White's during the two decades before the sale. Much of the machinery was dilapidated and out of date. Yet when interviewed in 1981, on the occasion of the company's centennial, about the possibility of further automating the plant, Steve White answered adamantly: "I think we're about as automated as it is possible for us to be."[39]

Automating the plant is different from updating the equipment. Many of the White employees found some of the machines they worked on frustratingly anti-

quated, slow, or potentially dangerous. Although Steve was much admired as a human being, some felt that he just didn't have the cutting-edge business instincts and drive for expansion, growth, and improvement that his father did. "Our furniture is just like the horses," Steve White told a reporter from the Alamance County News Bureau in the 1981 interview on the occasion of the centennial of White Furniture. "I raise purebred Arabian horses that are just beautiful, but if anyone wants to buy a plug mule, that's all right with me. Our furniture is not for everybody. It wouldn't fit everybody's bedroom. Ours is very high styled. It's expensive. It has to be."[40] Some would say that this superior attitude was required to maintain the exemplary quality of White's furniture; others might criticize Steve for his inflexibility and lack of responsiveness to changing customer needs.

As early as 1981, the sixty-nine-year-old Steve White acknowledged that there were merger designs on White's, but that the owners had no interest in selling or merging at that point. "We're big enough now to do what we want to do and small enough to do what we want to do," he joked, then added more seriously, "You might say we're big enough to be flexible and small enough to be flexible." When asked about the company's future, Steve was guardedly optimistic. "The industry is now in a state of flux," he admitted. "I do not think this year will be as good as 1969, but I don't think things are going to pot."[41] He even predicted that the trend toward mergers in the furniture industry would continue but not at the frantic pace of the late seventies. "I feel there is less general enthusiasm about mergers than there has been," he said. "People are looking more carefully at merger proposals now."[42]

Yet 1982 and 1983 saw the company thrown into debt for the first time since the Depression. Steve had to borrow money in order to meet his payroll and pay off his expenses. Proposals for mergers began to look more attractive to many of the stockholders, all of whom were White relatives. Dismayed at the shrinking rate of return on their stocks, alarmed at the magnitude of the company's losses, the stockholders worried about White's future. Steve White's health was failing, and his disagreements with cousin Steve Millender were unresolved. The two Steves not only had different corporate visions and different aptitudes; they also both had sons whom they hoped would become president of White Furniture Company one day. Steve White brought his son, Sam, on in 1966 to serve as a vice president and company secretary while Steve Millender brought in his son, Charlie, as manager of sales in 1971. It was unclear which, if either, of the descendants was the right person to lead the business into the next century.

At Hickory corporate headquarters, a story is often repeated that supposedly exemplifies the degree of enmity between the two Steves at the time of the buyout (and, not incidentally, justifies the buyout by Hickory). It is said that, by the end, the two Steves were not speaking to each other and that they actually entered the corporate offices of the Mebane plant through separate entrances. Like ships passing in the night, CEO Steve White came in one door while head of marketing Steve Millender used the other. When some people tell the story, they add a third door, this one for the director of manufacturing.

However many entrances there were to the plant and whatever they did or did not symbolize, it is clear that, by 1985, there were divisions within the White management. Many would insist that it is a combination of these third-generation problems that resulted in the 1985 sale of the company to Hickory Manufacturing Corporation. With strains evident both in and outside of the plant, White Furniture Company was ripe for corporate picking.

Yet it is far too easy to think that White's was first sold and then shut down because something went wrong, someone failed. Although it would be reassuring to think that only bad businesses fail, the corporate economics of the eighties and nineties have been more complicated than that. What made White's attractive for a takeover was not only the indirection of its leadership and the dissatisfaction of its relatively small body of shareholders; it was also that the company was basically sound. After two years of debt, 1984 and 1985 saw White's turn a modest profit again. The ten-year profile (1975–1985) of the company was solid, far more so than many businesses during the volatile eighties. And White's had many attractive assets—virtually no debt, $300,000 in savings, over a million dollars in accounts receivable from credit-worthy clients, a stack of unfilled orders, a huge inventory, a yard filled with top-grade lumber, and a pension account for the White workers purportedly overfunded by well over a million dollars. A different management team, attuned to a crisis and eager to maximize growth, could have taken advantage of these assets. Instead, these features made White's extremely attractive to others, including investor Clyde Engle, the Chicagoan who already owned a 93 percent share of Hickory Manufacturing Corporation. Engle had built up Acton Corporation by buying out vulnerable companies like White's.

At its board meeting in May 1985, the shareholders of White Furniture Company were presented with two alternatives: to maintain business as usual or to sell to Hickory for an estimated $5.1 million. The lawyers for Hickory took charge of the meeting, emphasizing the dire prospects for White Furniture Company and

pointing out, by contrast, the health of Hickory. After a day of procedural battles that took on the air of a hostile proxy fight, the shareholders were asked to vote yes or no to a proposed sale of White Furniture Company to Hickory Manufacturing Corporation. The family was, once again, divided. Some wanted the company retained as a family-owned venture. Others supported the Hickory buyout, believing the vague promises made by Hickory that, even after the buyout, Steve White's son, Sam, would be kept on as the company's president. Until the end, CEO Steve White vociferously objected, arguing that, once White's was sold, no one could guarantee what would happen. The vote was close, but, ultimately, Steve White's arguments were unpersuasive. The majority voted to sell. Steve White reluctantly signed the bill of sale and walked out of the room.

It is almost superfluous to say that, once the papers were signed, sealed, and delivered, everything changed. Steve White's resignation had been a condition of the Hickory purchase. Steve Millender also resigned, aware that his retirement would be mandatory after the sale. Under the new ownership, virtually all the rest of the White management team was fired—including Sam White and Charlie Millender, who were asked to resign within a year of the sale. As we shall see, the direction of the company also changed radically as did the product it made, until, as longtime employee James Gilland notes, "White Furniture just wasn't White Furniture any more."

Could White Furniture Company have been saved? It's hard to say. But it is important to note that, at the time of the sale, there was a third possibility, one that was entertained too late and was ultimately unsuccessful. Alarmed that Clyde Engle might not have the best motives for buying out White's, two of the White offspring—Steve's son Zan White and Zan's cousin Carter Garber—at the eleventh hour approached a local businessman and lawyer, Martin Eakes, to see if he might be able to work out a way of both wresting White's from the control of the divided family factions and preventing its being bought out and folded into a furniture conglomerate that might not have the firm's best interests at heart.

Martin Eakes was head of the Center for Community Self-Help, a North Carolina–based operation committed to some basic social principles: "Our stated vision was to try to take the civil rights movement and the women's movement and translate them out of the legal arena and into the economic arena."[43] His organiza-

tion sought to make loans to local businesses, often businesses turned down for conventional loans.

Eakes proposed an employee stock ownership plan (ESOP)—a tax-favored method that would allow the White employees to buy out the company from its former owners. This would have been Self-Help's biggest project to date, and they needed time to secure financing. He also knew that he and the workers would not be able to support the entire cost of the buyout and so sought participation by the White shareholders to the tune of 10 to 20 percent of the purchase cost. Since the shareholders were deeply divided and since many of them wanted out immediately, there was no way that such a cooperative venture was possible, especially since the Eakes proposal stated, up front, that a new management team and a new CEO were necessary to revitalize the organization.

The Eakes employee buyout proposal could have worked only if the White family's long-standing concern for workers and community was, first, more important than its sense of ownership and control over the company and, second, only if a majority of the voting family members were united in wanting to save the company from ownership by a conglomerate. By the time of the buyout, however, the family was dispersed; many of the shareholders had never set foot in the plant. As with stockholders everywhere, for some of the White shareholders the issue was dwindling rates of return on an investment. While Eakes was scrambling to find funds and trying to argue his case with the shareholders, Hickory put its buyout proposal on the table.

Martin Eakes showed up for the shareholders' meeting and requested that the vote be postponed. Hoping to alert the shareholders, he distributed copies of a 1984 article from *Fortune* magazine entitled, "Clyde Engle Wants to Be Friendly," a scathing exposé. The lead to the *Fortune* article is indicative of the entire piece: "A secretive Chicago investor is stalking takeover targets. He says he'd rather go where he's welcome, but his trail is marked by proxy fights and litigation."[44] He is described, by *Fortune,* as a "corporate raider" whose modus operandi is to buy up a small company, take control of the board, and then work "a little financial magic" and turn it into "an investment war wagon," using a new acquisition to secure bank loans that he then invests in other corporate enterprises or takeover schemes.[45] The article also reported rumors that Engle had raided pension and employee profit-sharing funds and sent profitable companies into bankruptcy. The Hickory lawyers dismissed the article as libelous and untrue. Eakes's request for a postponement was denied. His proposal was never entertained by the shareholders as a serious option.

Eakes continues to believe White Furniture would be alive and well today if his employee buyout plan had worked. Like many of the White supervisors, he believes the company was worth closer to eight million dollars and that the enormous inventories plus the overfunded pension plan could have been turned into capital. Instead, White Furniture Company went the way of the companies described in the *Fortune* article. It was bought out and then closed down. "We believed that what would happen is exactly what did happen," Eakes insists, "that the company's assets—whatever was of value—would gradually be transferred out of that community and the business would be left to languish." He says Hickory's actions after the sale support this theory. They sold off the Hillsborough plant first, since it was more modern—and more valuable—than the one in Mebane.

Of course, Martin Eakes's point of view is that of the loser who turned out to be right, the prophet who can say, "I told you so." But there is nothing gleeful or self-satisfied in his tone when he discusses the buyout and the closing of the White Furniture Company. Nor is there any ambiguity in Eakes's stark verdict on what happened to the venerable old company: "It was a rape."[46]

I f this explanation were entirely true, this story would be much simpler. But it overlooks a crucial fact: Hickory owned the Mebane plant for almost eight years. If Engle was buying the company simply as an investment tool and a tax write-off, he could have milked it, closed it down, and been free of it in two or three years. You don't build a $500 million megacorporation by holding on to failing companies after you need them. For the seven years after the buyout, Hickory made improvements to the machinery in the Mebane plant. The workers who stayed on invariably report that, under Hickory, their wages and benefits both increased. Pensions have been paid on schedule and with no reductions in the amount owed the workers. New equipment was installed. Finally, once the decision was made to close the plant, the terms offered White workers were more generous than that required by law or even by accepted business standards. This just is not the usual scenario for corporate raiding.

On the other hand, Hickory made big mistakes at White's, something that virtually every White worker felt immediately. In the succinct words of Ed Clayton, who had worked at White's since 1963, from the moment Hickory came in, White's "went downhill in a hurry."[47] A new management team attempted to transform one of America's most elite furniture manufacturers into a production-oriented company where quantity was the main goal. The results were disastrous,

with the distinguished White name now attached to an inferior product. Customers who counted on White's for quality were furious.

If the furniture business had been booming in the years after the buyout, it is quite possible that Hickory would have kept White's going. The reverse was true. The late eighties and early nineties witnessed a severe decline in production and sales across the entire furniture industry.[48] As Jefferson Cowie has noted, "Dun and Bradstreet reported more than three hundred failures among furniture and home furnishings retailers in the first quarter of 1991 alone, an increase of thirty-one percent from the same period in 1990."[49] A dramatic increase in furniture imports (from 4 to 20 percent of the market share in the mid-eighties) added to the troubles besetting the furniture industry. White's was not alone: "From 1987 to 1991, 33,000 furniture workers lost their jobs."[50]

Although the White workers, including a number of the blue-collar managers, remain convinced that the company was running in the black at the time of the shutdown, representatives for the company insisted that the Mebane branch was operating in the red to the tune of over $100,000 a month and that it was bleeding the main Hickory-White operation.[51] Equally significant, many workers report that the main plant, in Hickory, North Carolina, was working on short time in the early 1990s, sometimes running only three days a week. CEO Randy Austin has maintained all along that, had he not made the decision to close the old Mebane plant, the entire Hickory-White Corporation might have gone under, leaving not just the 203 Mebane workers without jobs but also the 500 people who worked at the Hickory plant and at the Hickory-White corporate headquarters in High Point. Both the Hickory and the Mebane plants were "operating at less than capacity," Austin noted.[52] "This has been a very difficult decision," Austin said in a press release issued at the time of the closing. "White of Mebane has long been regarded as one of the finest plants in the industry. This recession has, for the first time in many years, had a tremendous impact on white-collar workers, many in upper income brackets. Those are our customers, and they are spending their home furnishing dollars on lower price merchandise."[53]

We will probably never know for sure if White was bought to make a profit or to exist for more complicated financial dealings for as long as it served its purpose and then was shut down when it was no longer useful to larger corporate goals. Nor is there any way of knowing if it could have survived the economic problems that beset furniture companies in the late eighties and early nineties as a family-

owned or employee-owned business. What we do know, definitively, is that preserving the old White Furniture Company in Mebane was not the top priority of Hickory-White Corporation. As part of a conglomerate, White Furniture was expendable.

A closing doesn't happen in the melodramatic way one might expect: a door slamming shut and two hundred people out in the cold. It happens in bits and pieces, one worker at a time. At White's, there was a grim logic to the layoffs. They followed production. The last piece of furniture came down the line, was worked on, and then the line closed down behind it, and the workers in that section would be let go. A few workers made one last walk-through of the plant, saying good-bye to their friends, but most just left.

The layoffs started in the kiln area where the lumber was brought in to the yard. After the lumber ran through the saws in the rough mill, those people would be let go. After the wood was glued together, the workers on the glue machine left. The piece was machined, and the next day the machine room was empty. The last piece of furniture was sanded, assembled, and then finished, with workers from each department leaving in turn. Finally, the piece went to rub and pack, where it was prepared for shipping and then boxed. The last piece on the line was ready to be sent away. And so were the last workers. You finished your job. You were called away from your department an hour or so before closing time. You sat in the personnel room and signed some papers. The personnel officer shook your hand. And then it was over.

There's a reason for laying off people in this way: it is the best way to ensure that a plant shutdown will be orderly, economical, and efficient. Yet, as many industrial psychologists have noted, people who leave their jobs like this typically feel despair, isolation, and shame. They feel oppressed by the enormity of what lies ahead for them, at the mercy of forces beyond their control. There is little sense of solidarity with other workers, either those who have gone before or those who will be laid off in the future. There is no opportunity for collective anger or organized protest. No one knows who is being laid off, when, how many, or who will be next.

And yet people are not so easily extinguished. When the announcement came that the Mebane plant would be closing and that the 111-year history of White Furniture Company was over, most of the workers were too shocked to philosophize.

But some months after the event, they were eager to talk. They could not prevent the closing of White Furniture but at least they could tell their version of what happened.

The story of White Furniture—in its glory and in its final days—is offered here through portraits of five of these men and women. Three of them—Margaret Holmes White, James Gilland, and Robert Riley—each worked at White's for over thirty years. While they worked in different parts of the plant and have different backgrounds and points of view, in many ways they represent the "typical" White worker in their loyalty to and longevity with the company. Because of the tacit guarantee of lifetime employment, the White workers were considerably older than the national average, many in their fifties and sixties. None of these workers was well off during his or her working years but, at the same time, they never had to contend with the anxiety of losing a job until the buyout and the closing. They enjoyed an economic security granted to few people in our society. The other two people, Don McCall and Annette Patterson, were hired by Hickory-White and represent more typical patterns of industrial employment. Don, who was brought in by Hickory-White to supervise the sanding department, is a middle manager who has experienced a number of factory layoffs during his work life. Annette, a blue-collar worker (classified as "unskilled" by the U.S. Department of Labor Statistics), has supported herself her entire life by arduous physical labor. She earned more money at Hickory-White than she ever had before or since. Her entire adult work life has been marked by slowdowns and layoffs, partly occasioned by the dramatically changing economy of the part of North Carolina where she lives.

Since they all now live in different circumstances, it is inevitable that they view the past with nostalgia as well as with a justifiable pride. Even when they are realistic about some of White's shortcomings, their tone toward the company is reverential. They speak with all the deference and respect of eulogy, a recognition that not only White's but a whole form of work is now gone. Whether manager or laborer, all five tell compelling stories of surviving everyday economic life in the postindustrial age.

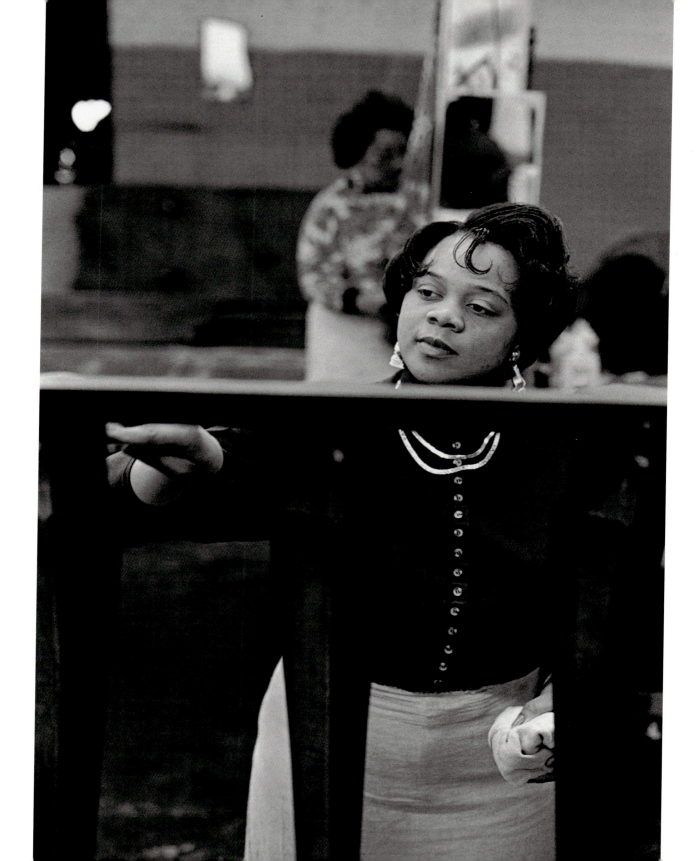

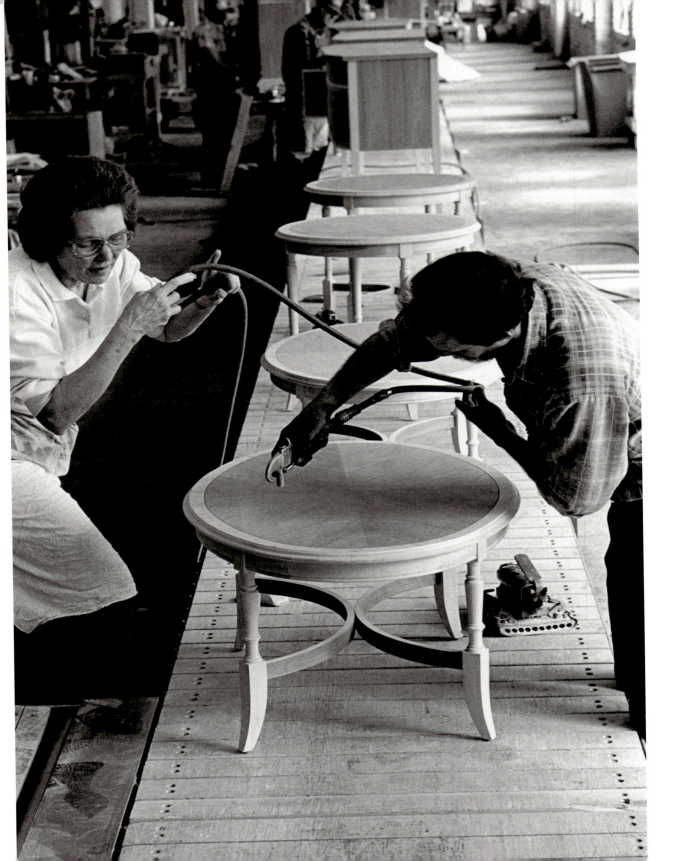

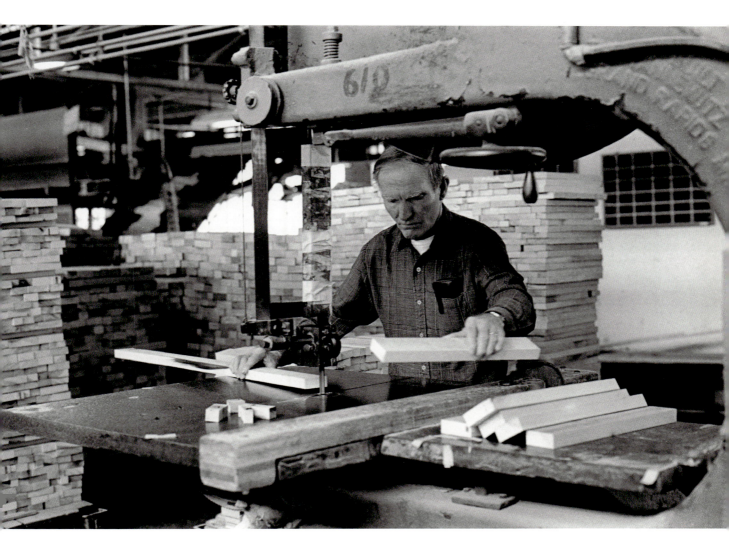

Above: Robert at the band saw, rough mill

Left: Charlotte and Kirk sanding samples, cabinet room

Preceding page: Melissa retouching table leg, finishing department

Overleaf: Joan in the spray booth, finishing department

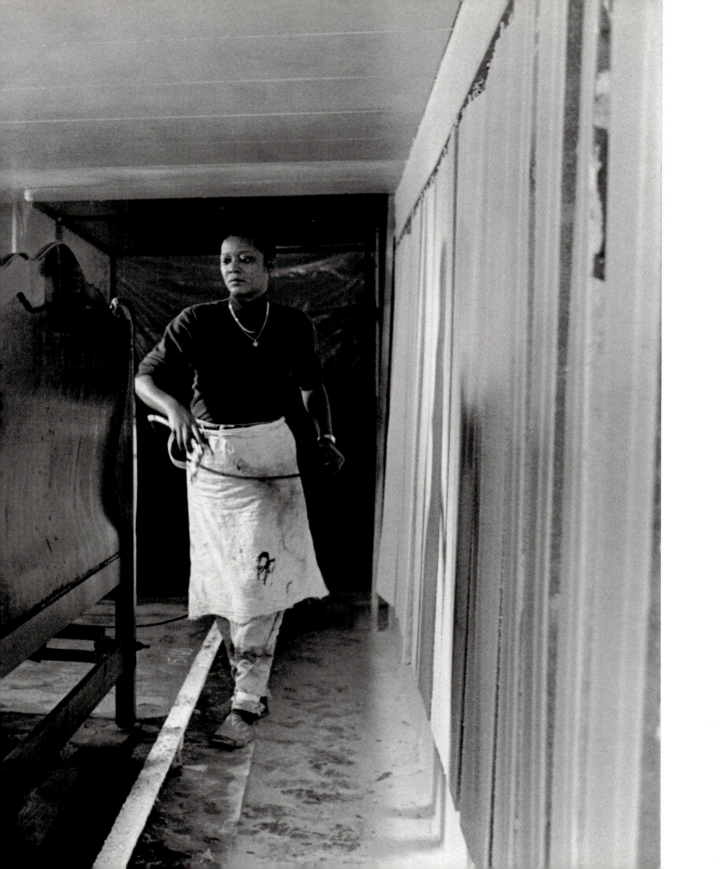

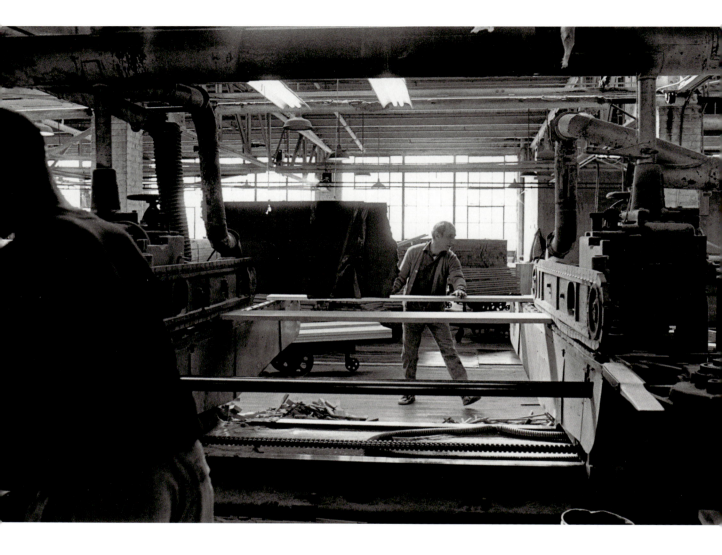

Above: Manuel at the end-cutter, rough mill

Opposite: Lunch break

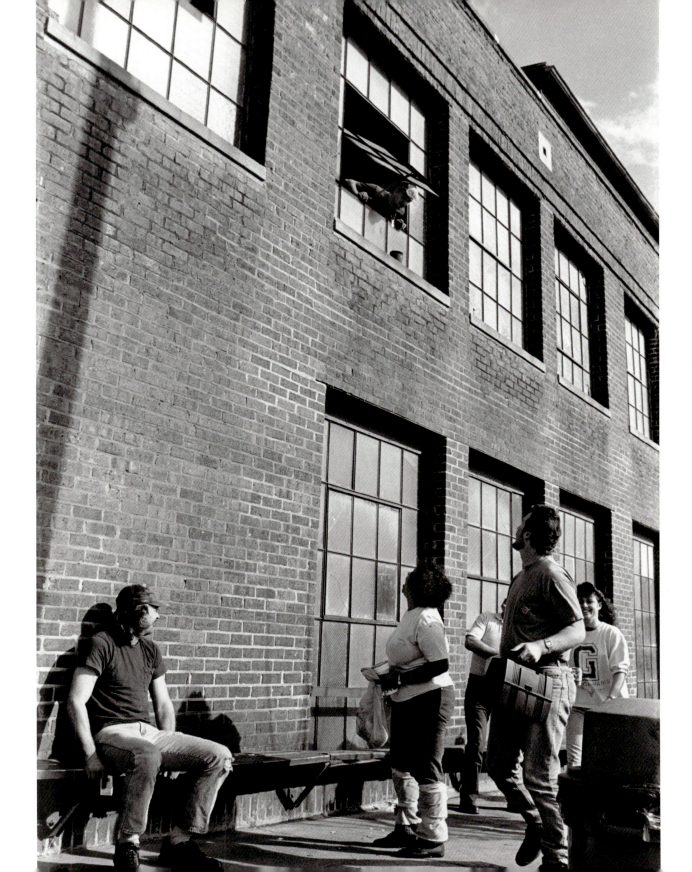

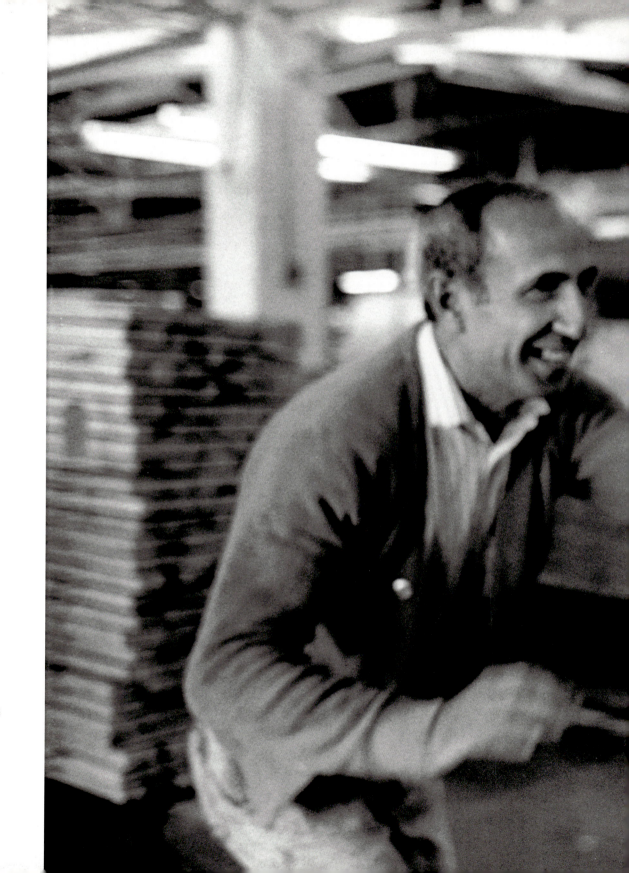

Manuel and José

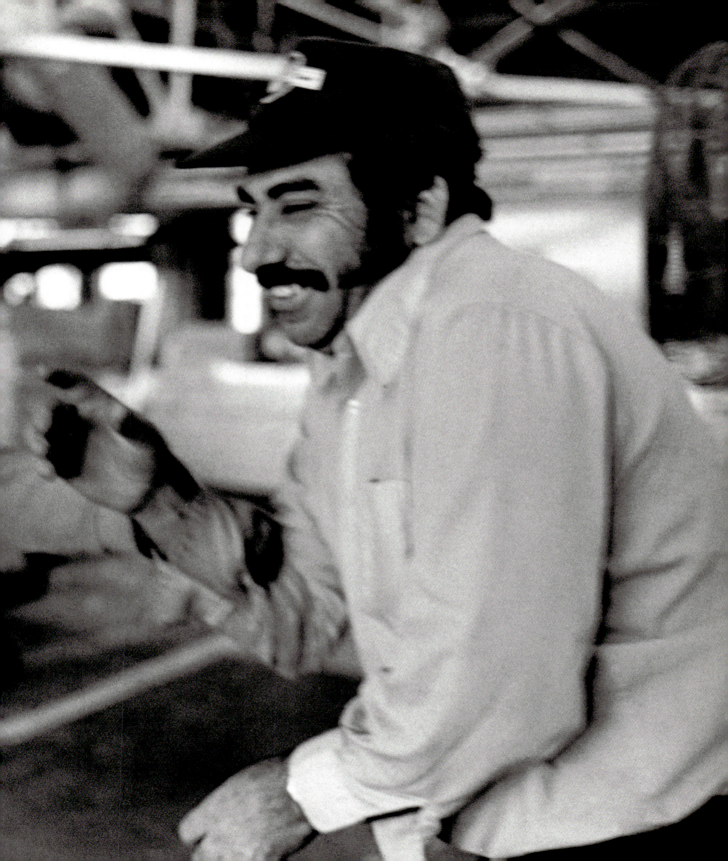

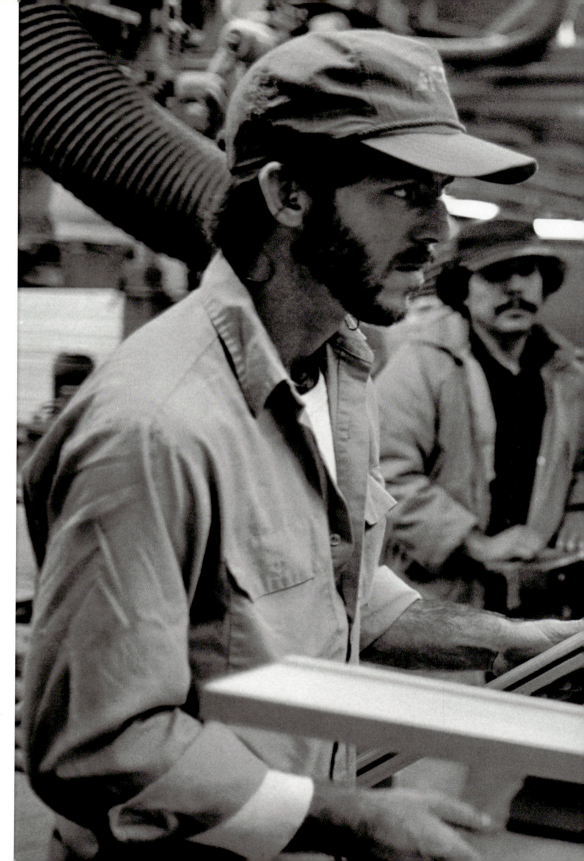

Tim with John, his
supervisor, machine room

Following pages:
Carl changing band-saw
blade, machine room
(left). Tammy, rub-and-
pack department (right).

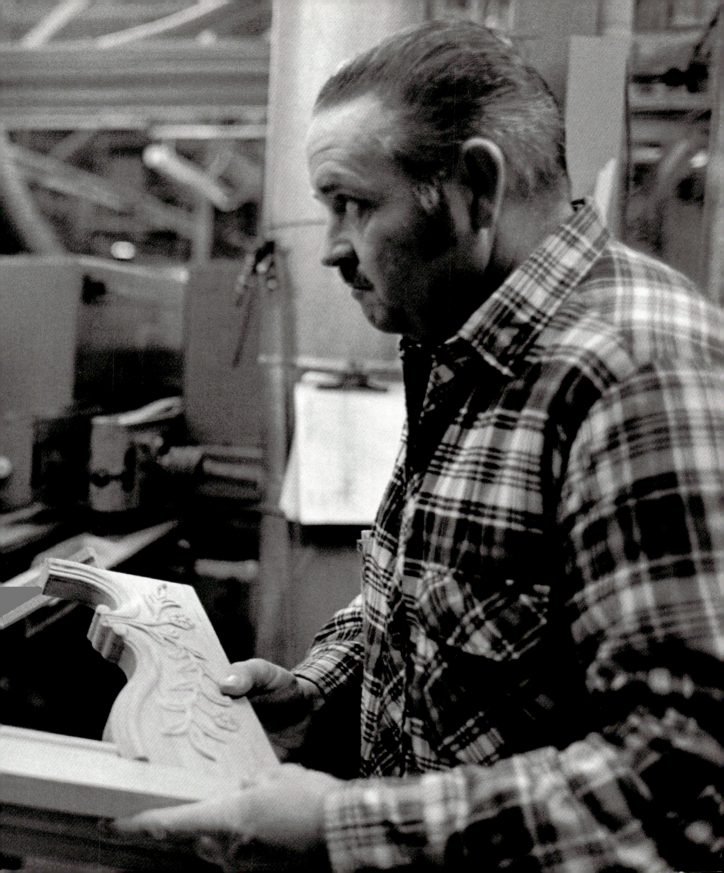

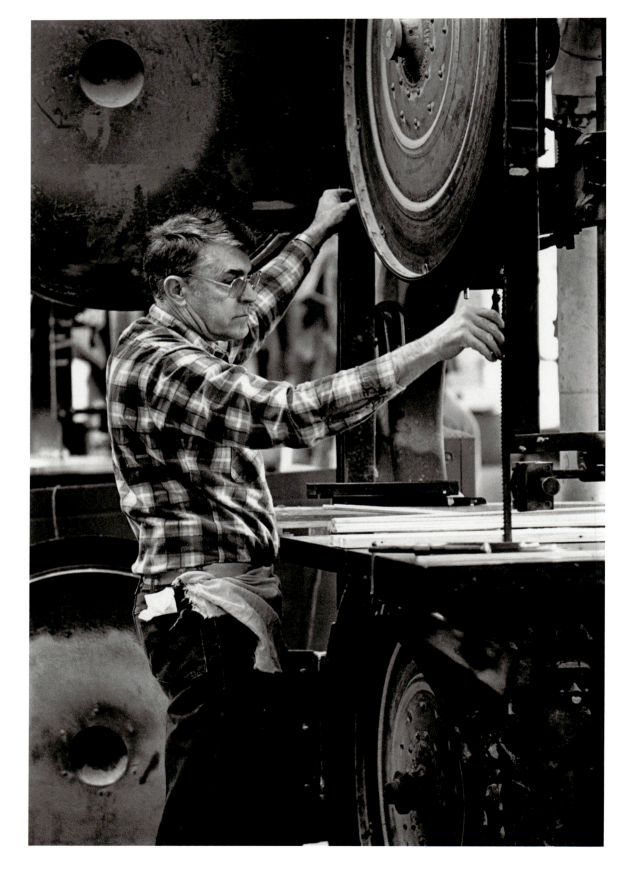

Maylo, Nate, and Donald, veneer department

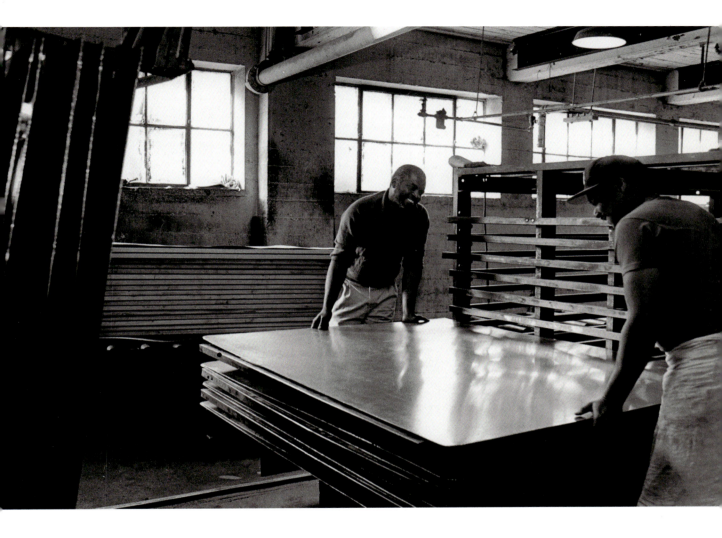

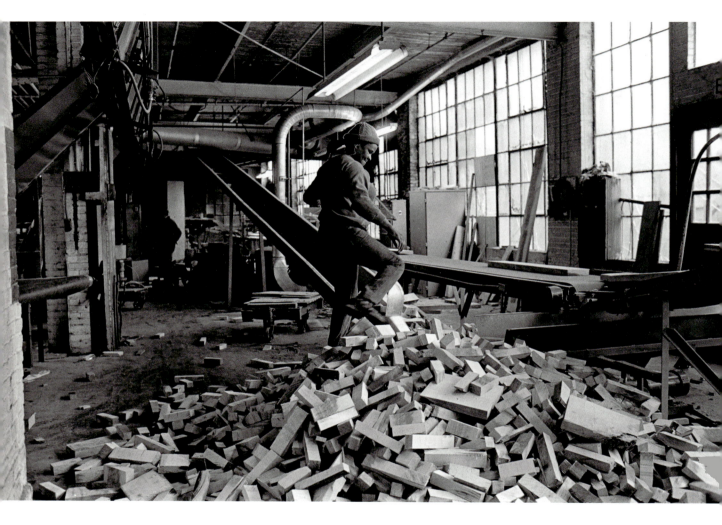

Above: Annette "feeding the hog," rough mill

Opposite: Quitting time

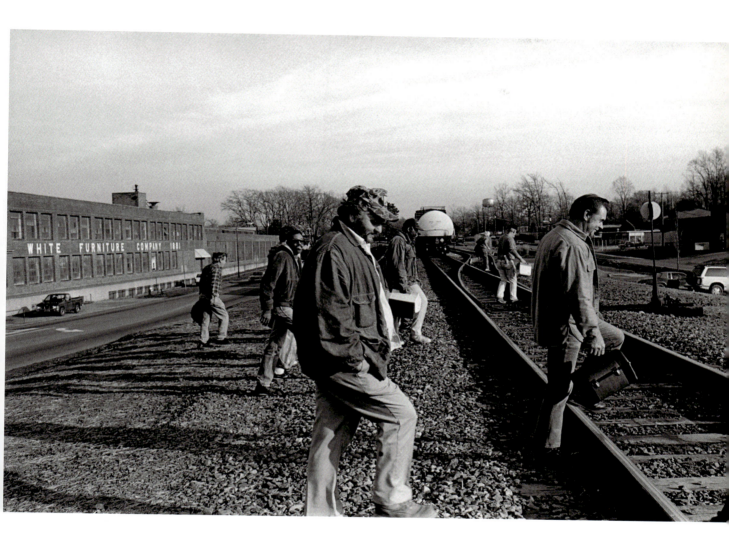

Chapter Two

Margaret, with Steve

"I was scared to death," Margaret Holmes White confides about applying at White Furniture Company in 1956.[1] She had just graduated from high school and knew she wanted a job at White's. After all, her father had worked there since 1948, when he closed his country store. "He came home very dirty and oily," Margaret says of his job in the finishing department, "but he loved his work." Her brother Fletcher went to work at White's, too, eventually becoming head of purchasing. "We grew up with a loyalty to the company. We all worked there at one time or another. The White Furniture Factory was it for all of us."

She got the job—and ended up staying at White's for thirty-seven years. She worked her way up from billing clerk to executive assistant for four company presidents—Mr. Sam White, Stephen A. White, and, after the buyout, Richard Hinkle and Robin Hart. Margaret and her brother Fletcher were among the only people from the White main office who were asked to stay on by the new management. Even after her 1989 marriage to the widowed and ailing Steve White, Margaret continued at Hickory-White. A number of the new Hickory managers were convinced that, along with four or five other women who worked in the main office, Margaret had kept the operation running on track during the eighties when decision-making was bogged down by disagreements among White's top managers.

Born in Mebane in 1938, Margaret was single for most of her life. She lived with her parents in the house where she was born. When lingering illnesses left both

her mother and father invalids for several years before their deaths, Margaret hired a professional nurse to care for them during the day while she worked at White's and then she looked after them at night. Working for decades in the White head office, Margaret became friends with Steve's wife, Mary, and she helped her friend through her final battle with cancer. After Mrs. White's death, Margaret began looking in on Steve, caring for him as she had for others. Broken from the sale of his company and then the deaths of both his wife and his sister just a year after the buyout, Steve was also physically disabled by heart problems when he asked Margaret to marry him. A stroke soon after their wedding left him partially paralyzed and with impaired speech. Some years later, he could barely talk at all, and he allowed Margaret to speak on his behalf.

In our numerous conversations, Margaret shifts easily among her unique perspectives on White's. She is confident in the role of spokesperson for Steve, the company, and the White family. She is protective of Steve, alert to even the slightest criticism of him and fierce in his defense. As a longtime White employee, Margaret expresses appreciation for the way the company's owners and managers treated workers as individuals and did everything they could to ensure their job security. As the president's executive assistant, Margaret measures her words, being careful to speak in the company's official language and communicate its official history. She is adept at voicing her husband's thoughts and opinions, glancing at him for signs of agreement or disagreement. When her guard is down, one glimpses the warmth and wit much praised by her coworkers. Off the record, in private conversation, Margaret is capable of turning a phrase, mixing witty and sometimes salty colloquialisms with her always sharp observations. On tape, Margaret assumes, quite literally, the formal role of mouthpiece for White Furniture and, especially, for Steve White, the ailing husband who sits silently by her side.

Top to bottom: Margaret with Steve. Margaret in her office with Cindy and Patricia. Steve and Margaret at the factory on the final day of production.

The caring between them is touching. Occasionally, when she turns to him, their eyes sparkle and glances linger. It is clear Steve trusts her implicitly. They seem comfortable together in the elegant two-story White home on Fifth Street, the stately main street leading into downtown Mebane. Their living room is formal, immaculate, but also sun-filled and cozy. The White furniture in the dining room is a special point of pride. Steve smiles as Margaret points out the magnificent chest handmade by White artisans in 1981 to commemorate the hundredth anniversary of the company.

Margaret has clear eyes, lovely smooth skin, and thick, curly champagne-blond hair. She comes alive when asked to reminisce. She laughs heartily over stories of various pranks workers played on her or that she played on others. When the topic turns to the final days of White's, her tone changes entirely. Her voice trembles and, on one occasion, she has to hold back tears. Asked how long it has taken for the shock of the closing to pass, she answers immediately and decisively, "It still hasn't passed."

Steve White is equally solemn. Although he is known for dressing casually around town, he takes this interview seriously and is in his more formal attire, a navy blue blazer, white shirt, and tie. Surprisingly, the kind eyes and slightly distracted look are not much different from the expression one sees in old photographs from the forties and fifties. He sits tall and dignified in a winged-back chair by the window, but there is little about him that betokens the imperious captain of industry. One remembers that he had wanted to be a doctor as an undergraduate, but ended up with a degree in English literature from Davidson College, and then, later, when it was clear he would enter the family firm, he did graduate work at Harvard Business School. He devoted countless hours to running White's, but it is easy to imagine him making time for a second love, his Arabian show horses.

Whether in more informal conversations or in the taped interview conducted on April 3, 1995, Steve is determined to participate as much as possible, sometimes nodding or making a low noise of approval. Occasionally he gestures to indicate Margaret is doing a good job, speaking for both of them. Silent, he can still be completely engaged, his face filled with quiet delight when there is talk of the good old days. The expression in his eyes is inconsolably sad when talk turns to the sale of the company and the closing of White Furniture Company. At times he is distant, and it's not clear whether he's not paying attention or is so pained by the discussion that he has simply tuned out. His is a haunting presence, a shadow of the past, like the forlorn building standing at the corner of Fifth and Center.

"I was the baby when I first went," Margaret reminisces about starting out at White's while still a teenager. She grew up at White's, and was happiest during the years when she worked for Steve. He was an excellent boss. "If any of us had a question, he would always take us out and show us on the spot what it was." As his executive assistant, she learned to do everything: keep records, construct budgets, compile tax figures, and even make decisions about ordering lumber. She remembers how one day Steve even took her directly to the boxcars and taught her "how to tell good lumber from bad."

He was a responsive boss, but he had some traditional attitudes. Notably, when Margaret and the other women in the front office asked him if they could start wearing pantsuits instead of dresses to work, he refused, saying it just wasn't proper for ladies to wear pants. The women were unhappy about this, especially since, they joked, he paid so little attention to their appearance that they were positive they could walk around in front of him stark naked and he wouldn't notice.

Margaret enjoys retelling the story of the ruse the women in the office used to convince Steve to change his mind on this issue. "I remember one day we stationed somebody at the front door and somebody at the back door. We had our guards stationed, and Carol Neville put on a pair of pajamas and walked in to get his dictation:

"'Good morning, Mr. White. How are you?'

"'Fine, thank you, ma'am. How are you doing?'

"'Oh, I'm doing very well. How are your horses today?'

"'Oh, they are doing fine.'

"She was getting her dictation the whole time standing three feet from him. He never did see her. She walked out and then into the hall, and we all started laughing. Then we let her come back so he could see what he had done. He had not noticed it, and she had on pajamas, lingerie." Steve got the point of the joke and soon the women were wearing pants to work.

He was an easy boss to tease, invariably good natured about being the butt of office pranks. "His birthday, we'd always have a party for him. He had so many birthdays that we couldn't get all the candles on his cake. We put on an extension, styrofoam or whatever it was we had, and then had somebody standing there with a fire extinguisher." As usual, he took their ribbing in good spirits.

Among Margaret's favorite events during her decades at White's were the employee dinners where the service awards were given. They were usually sit-

down dinners, catered at Eastern High School, with some kind of entertainment such as a hired comedian or a barbershop quartet. Spouses were invited and there were corsages for the women and a drawing for door prizes, usually cash. "It was jovial. It was good cheer all the way through. It was just a really good time, and the men seemed to be in a really good mood. They were getting off for the week, and they were going to get their bonus checks. Everybody seemed to be in a good mood."

Like other workers who knew Steve directly, Margaret emphasizes his generosity. She tells of how proceeds from the vending machines at White's all went into a Hard Luck Fund that workers could take advantage of in a crisis. More personally, she is grateful that Steve gave her carte blanche to come in late or to take off early when her parents were ill. Her mother had brain surgery in 1966 and never walked another step until her death over a decade later. Her father had Parkinson's disease and was bedridden for many of the years until his death in 1984. Because of Steve, she was able to care for them at home. "For several years there I had two beds to change at night, two people to wait on going from one room to the other." She never actually took a full day off but she "was late a lot of mornings. Steve told me when Mama had her brain surgery, 'Just do the best you can do.'" Whenever she was late, she would bring the work home and make it up there. The only full days of work she missed were for her parents' funerals, yet Steve's latitude eased much of the stress of her difficult situation.

Autonomy and individual responsibility were two hallmarks of the White operation. Like other workers in the front office, Margaret filled out her own time cards; she never punched a clock. Nor was there anyone standing over her to supervise her work. Even in major decisions, such as when to go on maternity leave, Steve White trusted his workers' judgment. Typically, women only stayed out six weeks, and they would stay on the job until just about the time of delivery. "One of the older employees said one time that it would just tickle her if Steve White had to deliver one of those babies because he would let them work as long as they felt up to it. He said he would leave it entirely up to them."

Steve also did everything in his power to keep jobs open for workers who had to take leaves, including maternity leaves. "Girls would work up until time for the baby to be delivered. I know one year we had fifteen girls and seven babies. I made out a chart of the times that everybody was expecting. We shifted people around. We substituted in every job down there, just about. We shifted people and shifted

people and shifted people that year. But we got by and were able to take everybody back so we could save their jobs."

The relationships, she emphasizes, between management and workers were excellent in the old White Furniture Company. "Men were free to come and go as they wished, if they wanted to speak with management. There was an open-door policy." Management would also help employees in various other ways—obtaining schooling or scholarships for their kids, setting budgets for (and advancing paychecks to) employees who found themselves in financial trouble, even going to court with employees when it proved necessary. She also remembers that if there was a death in the family, Steve White would go to the funeral, and any worker who wanted off could go, too. Even after his stroke, Steve insisted on going to the funerals of old-time White employees whenever his health permitted.

Given her emphasis on the compatibility between workers and management at White's, it is not surprising that she considers unions anathema and is uncomfortable discussing unionization at White's. She emphasizes that there was never a union at White's, and the one union story she tells is intended to confirm the lack of interest by the White workers. By her account, the union was voted in by a small majority of employees but, after the vote, the union people never came back again, and no one at the plant stepped forward to serve as the local union leader. Yet, when asked again about the union activity of the early seventies (as reported by various workers), she answers grimly, "It was a terrible time. We had a thick file about all of it. I was happy when it was all over."

Others confirm that the representatives of the United Furniture Workers of America (UFWA) came to Mebane in the sixties and in the early seventies to try to organize the plant but were met with only half-hearted approval and withdrew. "Operation Dixie" (an earlier attempt to unionize the furniture industry, mostly in High Point in the forties and on into the early fifties) never succeeded in Mebane.[2] None of the other furniture companies in Mebane had unions either. As quick as she is to dismiss the unions, however, Margaret also insists that there was never pressure on workers not to unionize or retaliation against any employee who organized for unions. That just wasn't the way things worked at White's, she says.

Corporate borrowing was also not part of the White tradition. Despite the trend of the eighties for owners and CEOs to borrow against assets and reinvest in more lucrative projects, Steve had an old-fashioned conviction against putting his company into debt. Even with the large losses of 1982 and 1983, he borrowed only

the minimum that he needed to meet his payroll. "Never in the 110 years that it was owned by the White family," Margaret notes, "was there a mortgage against any of the property, against any of the equipment. Any loans were secured on signature of the president of the company, and it was for operating costs only. There was never a mortgage on any of the assets in all those years."

Although the company was coming back and doing better by 1984, the shareholders saw the two years of losses as an opportunity to force the sale. "In a family-owned company there's not a whole lot of dividends. And I think [the other family members] saw the dollar signs and thought that was a way of getting their inheritance out in a way they could use it." In the years before the sale, old Phonse Bean, the former vice president and director of manufacturing, predicted that the family members who wanted to sell would soon be in the majority. "I've heard Mr. Bean say many a time he never saw a family-owned company last through the third generation. And in our case that was so. It didn't last."

Margaret has to work to keep her voice steady when she talks about the sale. It was "just unbelievable to be in on the disagreements. It just hurt so bad. You'd known both sides for so many years." The decision would affect nearly 500 workers (almost 300 at the Hillsborough plant and 203 in Mebane) and the economy of two towns. But the bottom line was that this was a family dispute—intimate, personal, hurtful, and extremely divisive, setting at odds fathers and sons, brothers and sisters, grandchildren, cousins. To make matters worse, it was public. The *Mebane Enterprise* ran stories about what was happening, how the shareholders were leaning, what alleged disputes had arisen in the various branches of the White family, who was trying to buy the company, and what everyone thought about it. "The newspapers were on it tooth and toenail," Margaret says, her voice rimmed in disgust.

Steve was devastated when the majority voted to sell. "He fought the sale as hard as he knew how to fight. He did all he could do. He wrote letters, made phone calls to the stockholders. Nothing was enough." For Steve, the matter was deeply personal and emotional. At one of the crucial meetings, he even had an episode with his heart and had to leave the room. Margaret had to get him his nitroglycerin tablets and call his doctor. He remained opposed to the sale to Hickory Manufacturing until the last and signed the paper as a dissenting stockholder on the day of sale. He left immediately after the vote, but, since Margaret was the only notary present, the new owners asked her to stay and make the sale official. "It was very hard to do," she says, her voice little more than a whisper.

The new management team from Hickory told Margaret she could keep her job if she wanted it. "That was the first time I realized there was any question because we thought the office staff would be secure." She didn't hesitate a second to tell them she would stay on. She says that she felt it her duty to do whatever she could to make sure the plant would stay in business and stay in Mebane.

There was no transition period whatsoever. "After the vote was taken, it was immediately clear that Hickory was in charge. It was a shock." The official sale took place on a Wednesday. The next day, Richard Hinkle, the new CEO, told Steve he wanted his office by Monday. That weekend, Margaret organized friends and family to come by with pickups and load everything up from Steve's office. A number of women washed down the floors and the walls of the office to make things clean for Steve's replacement. Because of his heart condition, Steve didn't come himself—and everyone was glad for that. "It was rough enough" without having him there watching, Margaret says. "I was crying the whole time I was doing it, and some of the women who were cleaning up the walls had tears running down their faces, too."

After coming in every morning for fifty years, Steve couldn't break the habit. "On Monday morning Steve came flying through the door. Richard was sitting at Steve's old desk. I was sitting in front of the desk, and Richard was giving me a list of things to do, and Steve came flying into the room and he had the most shocked look on his face and said, 'Pardon me, pardon me,' and backed out. He had gotten up and forgot and came to work and could have just died." Richard tried to ease the situation by telling him to feel free to come down any time he wanted.

Steve asked permission to make one last trip into the factory to tell the men good-bye. And the next week he did. "He went through the factory and shook hands with as many people as he could shake hands with. He went all the way through the factory. And told the men 'bye." After that last trip, he never went into the factory again. He never made any trouble or said a word against the new owners, and they treated him with the same respect. "He would come and get his mail, and get a drink of water, and would leave—and he would always be treated courteously."

It was a terrible time for Steve. In 1985, he lost his company, and then in 1986 both his sister and his wife died. "It was a blessing that he had his horses. I think they kept him from sinking. He stayed at the barn and played with his horse-friends and he grew his herd to thirty-five horses." Yet his heart condition worsened, and he suffered a severe heart attack in 1989.

Margaret's brother Fletcher was one of the only managers to be retained after the buyout, despite assurances that had been made, informally, to some of the White family members who voted for the sale. Margaret continued on in her role as chief administrative assistant to the new president. "It was a real time of uncertainty," she recalls. She hoped her own presence would lend some stability in the midst of so much change.

Margaret confirms that Hickory-White tried to manage the downsizing in a relatively humane way. People who could draw social security — people over sixty-two and handicapped people — were the first to go. But these layoffs were followed by others, at both the Mebane and the Hillsborough plants, including people in their fifties who had little prospect of ever finding another job. "Seemed like every day someone was laid off," Margaret says sadly.

The operating procedures also changed almost immediately. Whereas workers had been fairly autonomous and self-regulating before, the new management instituted a system of hourly production reports. Every section of the factory was monitored and reports were filed indicating how much production had been accomplished there. Margaret was put in charge of entering all the data. "I would take it home and work until midnight to get it all done. They would report how many pieces the cabinet room had done. How many pieces the finishing had done, the packing, and I would have to evaluate and then report how much production had been done." It was Margaret's job to crunch numbers to determine just how many pieces of furniture had been produced in the plant on a given day and to evaluate places where production might be lagging behind.

Hickory also brought in supervisors, called consultants, to reorganize and run different parts of the plant. "These people supposedly knew more about how to run the plant than our people did." Since upper management kept changing, everyone felt insecure. The closing of the Hillsborough plant in 1991 and the consolidation of the two plants reassured some people in Mebane who thought this meant that Hickory was investing all its resources in Mebane, but other people wondered if the closing of the Mebane plant wasn't the inevitable next step. Rumors abounded. Everyone had theories about what would happen. Morale was dismal. On the job, the workers pretty much did whatever they were told by the new supervisors. "Everybody was running scared in those days so they tried to do the best they could with whatever came."

Margaret also confirms what all of the workers on the floor at White's experienced daily, the new emphasis on production and quantity. "To start with, they

pushed production very hard. They reengineered everything, took what Steve called 'the guts' out." Whereas Steve believed that the essence of White Furniture Company was its reputation for quality and its reliance on the individual, highly trained artisan who exercised the highest standards of craftsmanship, workers who continued on at Hickory-White felt that now the emphasis was on how much they could make, not on how well they could make it. The new method of reporting and supervision rewarded speed. What was important was how quickly a piece could move from the rough mill (where the raw lumber comes into the plant), through to the machine room (where the parts are created and shaped), to the sanding department, the cabinet room, the finishing department, and then to rub and pack (where the finished piece is polished and then crated for shipping). "For a long time it was get it in the box, get it in the box," Margaret says with exasperation.

It wasn't the fault of the workers, Margaret insists. "They were putting stuff in the box that wasn't all together." One customer, exasperated with the poor craftsmanship in her new White dining-room set, sent the company a videotape enumerating the defects. The workers were made to watch the tape. They were humiliated. Finally, after being besieged by complaints and returns, the new Hickory-White managers were forced to switch back to a more artisanal approach. They made "a conscious change in directions, to be more careful about the quality."

Although Margaret still did the day-to-day accounting for the Mebane plant, she had no idea whether the changes led to greater or lesser profits since a comptroller was brought in to do the overall financial statements. Margaret was never shown any of those. Certainly, the basic financial policies of the company changed drastically. "They mortgaged everything that wasn't nailed down and what was nailed down, too. Of course, I'm sure it was used to finance other projects." Margaret acknowledges that Hickory updated much of the machinery in the White plants, but remains uncertain about what percentage of loans went for improvements at the old White plants and what went into other parts of the corporation. The bottom line was that now the old White Furniture Company was simply one small part of the larger Hickory organization.

The financial scheme became far too complex to sort out. All of the borrowing also added to the sense of insecurity. "We were forever having bankers coming in to evaluate everything and see if we could borrow more money. And when you have bankers coming in, you wonder how long you're gonna be here." Margaret is cautious on the question of whether White's was operating in the red or the black

when it closed. She says the financial dealings were so complicated, and so entwined with what was happening at the corporate office in High Point that it was impossible to know how well or how badly the Mebane factory was doing. The whole economic base of the company had changed completely from the frugal and old-fashioned cash-and-carry ways of Steve White.

By far the happiest event for Margaret during these days was her marriage to Steve White on September 16, 1989. She even took off work for her honeymoon — a landmark event in her life ("It was the only two days I ever missed in my life, except for my parents' funerals."). But even in their happiness, she and Steve were apprehensive about what would happen to the company. She is grim when she remembers the day they learned the Mebane plant would be closed down. "Fletcher called out here at 8:15 in the morning, on November 11, 1992. I'll never forget the date, a Wednesday morning, at 8:15, and when I answered the phone he said, 'You're never gonna believe what just happened,' and I said, 'What just happened?' and he said' they just called us all into the conference room and said they were closing the factory down. And I said 'Fletcher, you're lying.' And he said, 'You better believe me.' His voice was shaking. He said, 'They are talking to the men now.' I was floored. I wanted to tell Steve, but I wasn't gonna tell him anything till I thought it out."

She told him later that morning. He got quiet and sat there a long time and then finally said, "I've been waiting for it." Margaret's mouth quivers when she recounts this story. She has to work to keep from crying. "Steve said it was kinda like waiting for the other shoe to drop. He had never said that before, but that's what he said that morning."

The next days were filled with concern. Everyone kept calling Margaret with questions about their insurance, severance pay, benefits, pension. She had no idea what the terms of the closing would be, so all she could do was be supportive. One longtime employee of the company was so upset that his wife called Margaret and asked in an extremely agitated voice, "Can you please talk to Bill?" Margaret went over there and talked to him for an hour. "People were so dreadfully, dreadfully upset. You just hurt so bad for the people. I knew I was gonna be alright but for the others to be without income and their life insurance when they had family dependent on them, it was just a real hard time."

At the actual time of the announcement, Margaret was on leave, taking care of Steve who had pneumonia. She had asked to quit but Robin Hart, who had replaced Richard Hinkle as president of the Mebane plant, insisted that she take a

leave instead. Margaret theorizes that Robin must have known when she asked that the plant was going to close because, had she quit when she wanted to, she would have been ineligible for severance benefits. He was protecting her.

After the announcement, she went into work every day from 9 to 12 to help close the plant. "It was a very sad time to see it taken apart piece by piece. I think it was Robert Riley who said it was hard seeing something that had been built up over a hundred years taken apart piece by piece. But that's what happened."

Margaret spent the next several months talking to people about the shutdown and wondering if Hickory had bought the company with the intention of shutting it down. She isn't sure, and suggests there's evidence both ways. On the one hand, she watched Hickory pour money into the Mebane plant, buying new equipment, new kilns, computerizing the main office, and making other material investments. But, Margaret also notes, Hickory never put a cent into the building itself. After the closing, the new equipment was moved to the main Hickory plant in High Point and everything else was sold off. What couldn't be sold—like the old patterns used to make White furniture—was dismantled and destroyed.

The visual symbol of the end of White Furniture Company was the dwindling of the time cards. Where once there had been two hundred, there were gradually fewer and fewer cards, until finally there were only fifty, then twenty and ten, mostly cards of the people kept on as part of the skeleton crew who closed the plant and did the final clean-up.

One day Margaret's brother Fletcher called and asked if she would like to accompany him on a last tour of the plant. It was June of 1993. "He took me all through the factory and it was just really weird to go through—and you could about hear the voices and see the men working, playing, laughing. We talked about who worked where and talked about the old days when the cabinet room was downstairs, and we went from department to department reminiscing. It hurt to see the thing you'd watched after for so many years desecrated."

On Fletcher Holmes's last day at Hickory-White, he called his sister Margaret and told her to bring Steve down. "He wanted Steve to have a last chance to come in, and he'd taken a chair into his old office and let him sit as long as he wanted to. Steve went out and got a glass of water and came back and said, 'I'm ready to go now.' Fletcher locked the door and that was it."

Chapter Three

James

When you drive up to James Gilland's house, the first thing you notice are two spiffy Ford Falcons from the mid-sixties.[1] With gleaming chrome bumpers and whitewalls as clean as cotton balls, these are classics, refurbished with care. In the yard, there's a third Falcon, white, about the same vintage as the others but rusty now around the edges. This car hasn't been restored; it's an original. James bought it in 1965 and drove it over 260,000 miles. He's a man who knows a good thing when he sees it and works to make it last.

It's not just the cars. It's a way of life for James. When you ask him about his job at White's, he answers with his philosophy of work: "Changing jobs is one of the worst things that anybody can do today as a young person. The best thing to do is start looking when you're young and find a job that you're really interested in, one that you like, that you think you can work with. It's just like getting married. Somebody that you think you can live with the rest of your life. A job is the same way."

Yet despite James's unswerving company loyalty and his belief in longevity and stability, he also provides an interesting counterbalance to Margaret's story of life at White Furniture. They share a deep company pride and agree on most things so far as White's is concerned, but James is more realistic about the low wages and

Opposite: James at home

benefits paid by White's and other North Carolina furniture companies. He is aware that other kinds of businesses in the area paid more. Yet he stayed at White's his entire career. "I liked my job, and I liked the people I worked for."

James's background is the kind that teaches realism. He was born in 1927 in Newport, Tennessee, a mountainous part of the state about fifteen miles from the North Carolina border. His father died when he was five. It was during the Depression, and all the kids had to find some kind of work to help put groceries on the table, mainly picking beans for Stokely's can factory. "They had this big bottom land with just rows and rows of beans. That helped out a whole lot," he remembers. Since his mother was a widow, she was able to draw welfare. "It's called Social Services now because 'welfare' downgrades the people some. But they called it welfare then, and she drew a check. With five kids she got a cash check of twenty-six dollars a month." As the only boy in the family, he was thrust early into the role of man of the house. He stopped going to school when he was eleven in order to work full-time. "We grew up working together," is all he'll say about it, his voice somber but without self-pity.

James worked a variety of agricultural and factory jobs until he was drafted at eighteen and sent to Germany. It was 1945, and, with the war in Europe already over, he served as a member of the occupation forces in Nuremberg. There he met a young German woman named Erika and fell in love at first sight. He defied the sneers of other soldiers who felt it was a "disgrace to the American uniform" to be seen walking with a German. He asked Erika to marry him and together they persevered through all of the military and State Department red tape, including "a stack of papers about like a Sears and Roebuck catalogue."

Shortly after returning to the United States, James moved with Erika and their baby daughter to Mebane, where they shared a house with an old army buddy. Under the G.I. Bill, James received training in cabinetmaking and upholstery and was able to find work as an upholsterer at White's Hillsborough plant. It was 1951, and America's postwar economic boom was in full swing. "I went to work down there. I upholstered and packed the chairs," James says. "We had so much work sometimes I would have to holler for help in order to do it. I was working nine hours a day and four hours on Saturday; forty-nine hours a week." At the time, unskilled workers at White's made eighty cents an hour, a nickel above minimum wage. He felt lucky to be receiving $1.10, although, he adds, White's rarely gave

raises and, when they did, it was sometimes as low as four or five cents an hour. He knew some people who received a penny raise.

By the late 1950s, he transferred to the plant in Mebane where he and his wife were building a house. After six years with White's, his salary had risen to only $1.23 an hour, and he was determined to fight for a raise. "I really got tired of working for nothing. That's just the way it was." He tells the story of how he went to his supervisor, the notoriously unbending Phonse Bean, and threatened to take a job at General Electric or one of the other factories opening in the area if Phonse wouldn't give him more money:

"'James, you're as good a worker as I've got here,' Mr. Bean began. 'I figured up your pay.' So what he did, he went down and he figured up cutting was so much an hour and sewing was so much an hour. Part-time work back in the cabinet room was so much an hour. Upholstering was so much an hour, and, if I packed chairs, why, so much an hour. He had me figure up about five different jobs. Then he totaled all of that up. Of course, the lower pay job pulled the upholstering pay down because upholstering was the best. He said, 'Really, by you doing so many jobs, it cuts your high-level pay down to lower pay, to medium grade. Actually, the way I got it figured, you're fifteen cents overpaid now an hour. But I'm going to give you a nickel raise—because I think you're worth it.'"

James laughs out loud when he tells this story, his voice a mixture of admiration and incredulity. It's a story that sums up the atmosphere that prevailed at White's while Mr. Bean was the plant supervisor. Yet he decided to stay on at White's, even though he had opportunities to receive better benefits and bigger raises working at other companies in the area. He ended up staying for a total of forty-one years, eventually becoming supervisor of White's upholstery operation. "Yep, I took it and I went on," he says, then rationalizes a little. "A nickel at that time, that was pretty good."

James is someone who knows the value of a nickel. Other people might consider him frugal to a fault, but, for him, it is a point of personal pride that he chose to stay in a low-paying job because he liked it. Like others, he cherished the company's emphasis on craftsmanship and the sense of respect he felt as someone who was doing his job well. "I don't think if you're dissatisfied on a job, you can give a man an honest day's work to begin with. If you're happy on a job, then you're a whole lot more apt to do your best on that job, to try to do it right and whatnot," he says, again moving to an abstract level. He's disdainful of people who don't care about their jobs or who do not feel loyalty to their companies. "There's a lot of

others that just come and go. A lot of times you get people that way. All they want to do is just make four o'clock on Friday."

He is also proud that he has lived modestly, paying as he goes, a cash-and-carry philosophy not so different from that of the plant's owners. He and his wife even built a house without taking out a loan. They made it with their own hands, digging the foundation, laying the blocks, working each evening under artificial lights until ten or eleven o'clock. "There was never any interest paid on anything in the house. Me and my wife built the whole thing. My wife was working in the daytime. She mixed my cement and carried blocks for me. I'd lay them; we worked together that way. Sometimes I would get up in the morning and work an hour or two. If I got the blocks laid before we were able to save money to buy another load, I'd get out and dig stumps or something. We cleared the land here; it was all big trees. We just worked like that together. About two years, why, we had the roof on it; had it closed in." He built his house while working overtime at White's. "I didn't know what anything was but work," he laughs.

A rambling two-story cinder-block house, painted a cheery yellow, it is hard to believe that it was built by hand by a husband and wife who worked full-time factory jobs and who learned how to build as they went. Decades later, it still looks solid and comfortable. Touring the house, one becomes aware that the couple designed this house to suit their own tastes and priorities. An eat-in kitchen is the hub of the house with an adjoining formal dining room. The dining room is large enough for a huge White table and three full-size breakfronts filled with china. Another door off the kitchen leads into a roomy, sun-filled family room with comfortable sofas and easy chairs. There is a formal living room, too, but it doesn't have the lived-in charm of the other rooms. The most remarkable feature of this room is the nineteenth-century staircase leading to the bedrooms on the second floor. James explains that it was salvaged from the old White house that stood across from the factory. Solid walnut, the stairway would have been destroyed if he hadn't claimed it and fitted it to his house.

A large man, who carries his sixty-nine years handsomely, James's most notable features are his huge, powerful hands. It is easy to imagine those hands building his house or, now, pruning the shrubs and fruit trees in his yard or plowing and weeding the impeccable vegetable garden next to the house. It is also easy to imagine such hands sawing the wood and hammering together the various outbuildings that have sprung up around the house—a large garage that serves as a storage area as well as two carports, a small barn, toolshed, woodworking shop, chicken coop,

and gardening shed. It is harder to imagine those hands holding a needle, yet that is what he did for forty-one years at White's—making seat cushions and chair backs for White's dining-room furniture. And it is what he is doing now, skillfully, even gracefully, hemming a pair of pants in preparation for an upcoming wedding. The needle dips in and out of the dark cloth. "My mama taught me how to sew early on," he laughs, "and I never stopped."

Except for the occasional hem, he's mostly given up sewing. "Forty-one years is enough," he says simply. He has enough to do with tending his house and garden as well as the small farm he runs outside of town. Right now, the house is a mess because he is pulling everything out of storage and marking it, getting rid of some things, deciding which of his three children will get what. A widower now, he is aided in his task by the granddaughter of one of his best friends from the White days. This teenager is staying with him until she goes off on a trip to Brazil. She describes herself as his "adopted granddaughter," and explains that the two families have been close her whole life. When he introduces her, it is simply as "my granddaughter," giving her an affectionate wink when he says so. She beams with pleasure.

"Please excuse the mess," he apologizes over and over. It's clear he would rather that strangers see it in better condition. He loves this house, and his sharp blue eyes shine when he is complimented on it, the airiness of the rooms, all of the light, the ingenious flow of the rooms. His voice is so full of pride and excitement when he talks about building his house that he makes it feel like yesterday that a returned G.I. and his young German war bride were pouring cement together or hammering nails into roof shingles. He tells the story of how a White Furniture customer for whom he had upholstered chairs came to visit one day. She was eager to see the house that he and his wife had built by hand. After he showed her around, she pronounced her verdict: "It's a beautiful house," she said. "It's not a house," James answered proudly. "We didn't build a house. We built a home."

As soon as they had a roof overhead, James used his Christmas bonus from White's to make two purchases: first a television set for his growing family and then an electric stove. "One was for enjoyment, and the other one was to be able to eat." Over the years, he also used bonus money and other savings to invest in some White furniture—mostly discontinued items that he bought a piece at a time: a table and chairs, a buffet, a corner china cabinet. He wanted to own good furniture, furniture made by himself and his coworkers, furniture that was made with the highest degree of craftsmanship and the finest quality woods. "We had

cherry, walnut, mahogany, sycamore, and butternut. Different suites, they used different lumbers. If they run a cherry suite, all of their posts would be cherry. Just like that buffet over there, the solid posts down the corners and the door frames and everything would be made out of cherry." Very few companies made furniture that carefully, with premium-grade hardwoods throughout. James notes that later, after Hickory took over, the White quality changed, too. "They made it out of poplar or gum and just finished it cherry. That's a whole lot cheaper lumber."

Although he was disappointed that his pay wasn't higher, he was not willing to organize or to join a union when the United Furniture Workers Association tried to organize at White's. James subscribes to the theory that Ford Motor Company subsidized the union activity because Ford wanted southern workers to earn higher wages so they could afford to buy more cars. He's not rancorous, just matter of fact, when he says this; he *agrees* the wages were too low to afford such luxuries as new cars. Nor is he dismissive or angry when he talks about those who sided with the union. In principle, he agreed with most of the union demands, but he didn't join because he thought the union would fail at White's and he feared that a strike might make things worse for him and the other workers. Again, his personal concern about debt figured in his opposition to the union. He had friends who worked at Western Electric during a lengthy strike there and they "never caught up with all their bills. Some of them had to borrow money. It took years after they went back to work to ever get straightened back out."

As talk of a wildcat strike heated up in 1965–66, James distanced himself from the organizers. When they came to him bragging about how they were going to tell Steve White and Steve Millender how to run their company, James just laughed at them. "I told one of the boys that worked for me, 'You don't tell them people how to do nothing. The company belongs to them. As far as that goes, they've got money. They could close the plant down now and live, they've got money.'" James was among the workers who voted against the strike and defeated the attempt to unionize the plant. "We all said we got to work in order to put bread on the table."

After the union was voted down at White's, the owners let the matter quietly drop. "All was forgotten," James says, echoing Margaret's comment that the White workers were never punished for their labor organizing. Other workers also insist that the White management never held it against any of the workers who had organized. Neither, they add hastily, did White's attempt to improve conditions and wages in response to the union organizers' demands.

James also offers a tempered view of the company's paternalism. The Hard Luck Fund is one example. While Margaret extols the fund as an example of the company's concern for its workers, James is more realistic about how much the fund could accomplish, observing that payments from the Hard Luck Fund amounted to only a portion of normal wages. Similarly, he notes that benefits and insurance improved only gradually and modestly at White's during the seventies and eighties—until after the buyout. Under Hickory-White, benefits, wages, and basic working conditions (from the installation of more modern equipment) improved much more rapidly. "We had pretty good insurance at the end after Hickory bought it. They upgraded a whole lot. They had to raise the premium, but who would mind paying an extra dollar a week if you got a whole lot better benefits?"

White's strength was in intangibles—relative autonomy for the workers and a sense of job security that amounted to a guarantee of lifetime employment (never put in writing but rarely violated). James repeats the local lore that the only openings at White's resulted from a death or a retirement. No one quit. No one was ever laid off. It was a trade-off, and the philosophy that kept it going was that White's was a family-owned business and workers were part of that family. Not surprisingly, White's was especially good at symbolic, celebratory occasions, such as the annual Christmas dinner for the employees and their spouses, presided over by Steve White and always paid for by the company. It was held at a restaurant or, more often, it was a catered affair in the school gym. James enjoyed it: "I thought it was good just to clean up and put on your Sunday clothes." Door prizes were handed out. "One time I got a fishing outfit. Another time I got a handsaw. I got twenty dollars a couple of times."

Hickory brought better wages, benefits, and machinery as well as a more businesslike, less paternalistic, attitude. The only social events at Hickory were simple affairs, such as summer picnics in the park with games for the families. There were a few Christmas dinners, but these were paid for out of the Hard Luck Fund. James suspects that the Hickory managers were eager to get rid of the fund. After a few Christmas parties and bonuses paid to retirees, the $62,000 fund was depleted, and the whole concept of a Hard Luck Fund quietly dropped.

James is clear about the benefits and the drawbacks of both the White system based on mutual worker-employer loyalties and Hickory's emphasis on the bottom line. Although, as an expert upholsterer, he appreciated his autonomy at White's as well as the premium White's placed on quality, he feels that some of White's reliance on traditional ways of doing business resulted in declining profits and, ulti-

mately, led the shareholders to approve the company's sale to Hickory. White's "was overstaffed with employees, and the employees that were being paid for a day's work, a lot of them wasn't doing a day's work. You had more people on the job than you really needed." The much-prized autonomy of White's workers meant that no one was keeping track of waste and inefficiency. When there was a downturn in the furniture industry, White's just couldn't compete.

After the buyout, Hickory both trimmed the workforce and brought in faster, more efficient equipment. "Hickory pulled the old machinery out and started putting in either new or rebuilt machinery — secondhand — good machinery. They upgraded the machine room tremendously. That gave them the opportunity to produce more furniture than White's." On the other hand, James is critical when he notes that Hickory was so concerned with greater productivity that the quality of the furniture suffered. He grows animated when he describes the difference between White furniture and that produced by Hickory but still sold under the White label. His hands trace his words on a piece of furniture as he speaks. "Take a buffet shelf that goes behind closed doors. White's used chip core which was better than solid wood because solid wood would warp and crack, and the joints would eventually over the years begin to separate a little. They'd use chip core and they would band it with maybe two- or three-inch strips all the way around. Then they would veneer the top and bottom of that. But Hickory kept doing away with the high process — techniques that really produced good furniture — because you couldn't see them unless you opened a door." Instead of finishing the shelf with a wood veneer the way White's did, "they had a banding machine that would glue a plastic band around it. Eventually that stuff would start coming off. Finally it just wasn't White's furniture anymore."

James retired just as soon as he turned sixty-five. In order to celebrate a long life of work, he and his wife made reservations to fly to Europe. He had served longer than any other supervisor, and everyone was sure he would be back working at the plant as soon as he returned from Europe, but he insisted he would not. "'You're the oldest one here now,' they said, 'you're what holds this place together. They'd have to close down and sell out after you leave.'" Ironically, the prediction turned out to be true. He left for Europe in May of 1992 and, before the end of the year, White's was being closed down. By May of 1993, White Furniture Company of Mebane no longer existed.

"I enjoyed my work. I enjoyed working there. If I hadn't enjoyed it, I'd have probably quit and went to G.E. In fact, back in '55, '56, somewhere along there, I was offered a job at Burlington. A friend of mine was the line foreman down there.

He had about a dozen people working under him, and he tried to get me to go down there. I said, 'No, we like it at White's. We're good friends with the family and all.'"

James has no regrets about staying at White's for over four decades. "Some of them jumped about and are still in a whole lot worse a shape today than I am by staying here." But he emphasizes again that his wages improved considerably after the buyout and so did the benefits. He especially credits Mike Robinson, the chief financial officer at Hickory-White, for coming in and straightening out salary inequities that existed under the old system. "Old Phonse Bean had pets," he says. "And sometimes you got paid more if you were one of them." Mike made up charts of everyone's salaries and immediately put in place a system of accelerated rewards for good workers who were earning below scale. Rapid increases at the end of his career mean that James now has a decent pension. He lives comfortably now, and his farm, in the midst of an area that is being snapped up by developers at several thousand dollars an acre, could make a handsome inheritance for his daughters.

James and his wife Erika lived frugally but comfortably in Mebane until her death in 1993. When he talks about her, it is with pride in the partnership they forged together. "By her being German, she was raised up during war times. She was only eighteen years old when I met her. She was raised up when people tried to save what they made, and just use what they had to use. We tried that here. We've never paid a penny of interest on anything that we've ever bought in the building of the house or anything we've ever bought since then. We figured that if it was worth having, it's worth waiting for, so we waited till we got the money and paid for it."

It was Erika who made it possible for them to buy the Ford Falcon in 1965. He saw it sitting on the lot of a local car dealership, but, at $1,650, it was out of James's price range. His voice goes dreamy as he recalls the first time he saw the car. "It had an all-leather interior on it and what they called a deluxe turn wheel," he smiles. "Large hubcaps, whitewall tires. It's got the 170 engine in it, six-cylinder, what they called a small six."

His eyes sparkle when he tells the story of how Erika was determined to see what she could do. She went down and talked to the salesman. "'I'm interested in the car,' she said. 'We've got $1,500 saved up in the bank. We'll give the $1,500 for it.'" The salesman insisted he couldn't sell for a penny less than $1,650. Erika insisted, "'Well, I've got my husband's payroll check here. There's thirty-five dollars left from it—his paycheck—and that's all the money we got. The other is in

the bank, and I can draw it out Monday, $1,535.'" The salesman offered her a loan for the difference but she was firm: "'We've got nothing in the house that we went in debt for. We don't intend going in debt for this either. This is my top offer, $1,535.' So before she got out the door he said, 'Wait a minute. We'll take it.' She drew out everything we had and paid for that. We started saving all over again."

Later, he bought and refurbished two more Falcons, painting one fire-engine red, the other icy blue. No longer driven, Erika's Falcon sits proudly next to the house, near the vegetable garden, a venerable symbol of the way he and Erika have lived their lives.

James moves quickly from the story of buying the Falcon to his account of why White Furniture went in the red and had to be sold to outside investors. He is certain that the managers weren't fully doing their jobs near the end. "Mr. Bean, when he run it, he run it with an iron hand." When his son, Bernie, took over, "he was really too good a guy to push somebody. He let the supervisors of each department get away with murder. They could just go and tell him they needed another hand, and he would just hire one." James is convinced that, by the last decade or two of the company's operation, there was too much waste and inefficiency. "I was supervisor of my department. When Hickory bought it they told us that there was going to be a whole lot of changes made. They would come in about once every other week or so and just walk through the plant and see how the workforce was working. They took over in June, and then in September they laid off fifty workers at one time. They said the plant was overstocked with labor."

He compares White's before the buyout with a family buying on credit. "They had more money going out than they had coming in, which is very easy to do in any kind of business. You can do that with your household finances as well. All you have to do is to go out and buy more than you got money coming in to pay for. No matter what, you're going to have to sell some of it or do something to be able to make the payments on the rest of it."

In keeping with James's sense of frugality and worth, he also believes that the Whites should have gotten more money for their company when they did decide to sell. "Hickory bought it for a song anyway. They didn't buy it, they stole it. I think it was $5.1 million or something like that, but that included the Hillsborough plant, twelve acres of land right here just on the other side of me, and the plant in Mebane. All of it for $5 million. When they took over, White's had approximately $6 million in back orders and the warehouse was full of furniture. All they had to do was ship it out."

He understands why Hickory chose to replace virtually all of the former White

supervisors. "If I told you to do something, I wouldn't want you standing in the back telling me, 'Well, I've been here thirty years and that ain't the way that we been doing it.' So some way or another they were weeded out." Yet, at the same time, James understands the negative side of this downsizing. "They lost a lot of their old hands that was used to making good furniture. Then they started hiring whoever they could get to replace them. And a lot of them don't care. Eight hours' pay, why, that's all that matters."

James disagrees with the view that, after a period of emphasizing production, there was a change in attitude at Hickory-White and an attempt to restore White's former quality. For him, Robin Hart, Hickory-White's second CEO, was even worse than the first president, Richard Hinkle. "Not to run him down or anything like that, but I don't think Robin Hart was qualified for the type of furniture that White's was used to making and had the name for making. A whole lot of the furniture was downgraded. It was more or less to say the faster we can get it out and sell it, the quicker we'll get the money in for it. As long as Richard Hinkle was there he would come in a short-sleeve shirt and a khaki pair of pants—him president of the outfit—and he would go and work in the rubbing room, packing room, just like a regular worker and show them how he wanted it done. He would be right there not only showing, but he would be there doing it. The other fellow that took over, he sat in his office most of the time, and I doubt if he walked through the plant once a week."

The new management philosophy was about increasing productivity, speeding up the line. "When Hickory took over, if it was off an eighth of an inch, why, that didn't make any difference, we'd just cut the drawer a little bit and make it fit. The hole, if it were an eighth of an inch too big, we'd drive a thumbtack under each side of it." The workers were expected to make these cost-cutting moves. James hesitantly confesses that he was part of the new economy: "I ain't only seen it happen," he says, laughing sheepishly. "I've done it."

It seems fitting and right that James Gilland—the supervisor who had been there longest at the time of the closing—became the unofficial historian of White Furniture Company. While the plant was being cleaned out before the sale in 1985, James came across a small collection of old advertisements, brochures, an old ledger book, and even a scrapbook of clippings about the achievement of White Furniture—especially dozens of stories from all over the country about how White Furniture had been chosen to make the furniture for the

officers' and enlisted men's quarters in the Panama Canal in 1906. These materials were in the trash heap, slated to be discarded, but James, ever frugal, retrieved them.

He sits in the comfortable living room that he built with his own hands, the White dining-room set behind him. Out in front of the house is Erika's Falcon. He reads from an early White catalogue that pretentiously describes furniture making through the "cavalcade of time," from the biblical era to the American Revolution and culminating in White Furniture Company of Mebane, North Carolina. He is a modest man who gets a kick out of the hyperbole of the White ad copy. "This issue," he holds up an old catalogue, "consists of twenty-six pages full of illustrations, hot stuff, and timely matters 'from the birth of Job down to Thanksgiving Day in this year of grace, 1905.'" He laughs out loud, a deep, full, inviting laugh.

He and his wife made a good life for themselves and their family in Mebane by working hard and saving with vigilance and persistence. A child of the Depression and a war bride, they were able to make ends meet through their two factory jobs. But what if James had been fifty when White's closed instead of sixty-five? What would have happened to him then? A life of hard work and harder frugalities could have ended disastrously. James knows he is one of the luckier ones.

He picks up a catalogue from 1927, the year he was born. "The White Furniture Company of Mebane, North Carolina, Ideal for Forty-Seven Years," he reads out loud. "The best equipped, most efficient furniture factory in the United States." He starts to laugh again, "I tell you that's putting it on, ain't it?"

Sanding bed frame, cabinet room

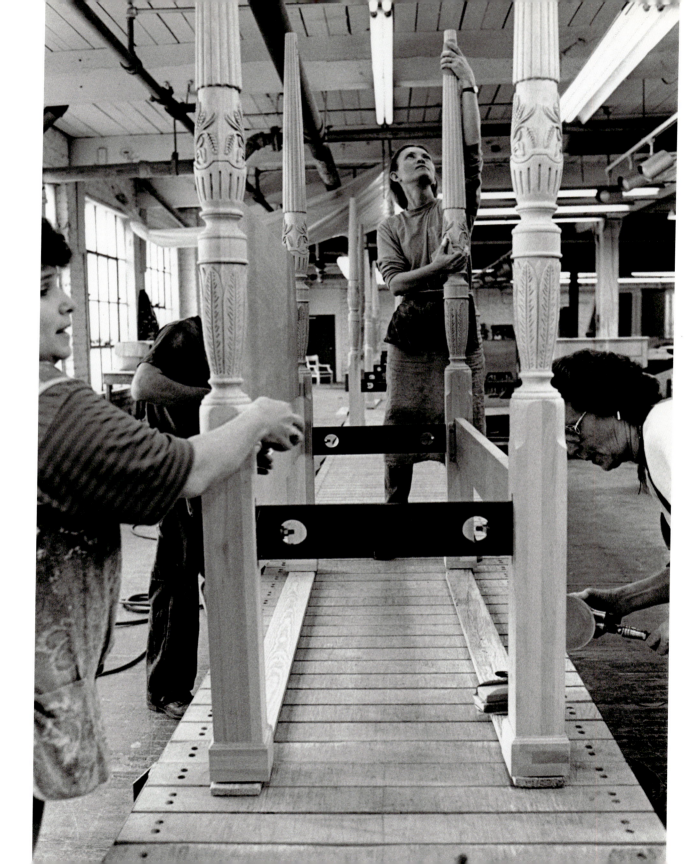

Harry by his window
drawings, finishing
department

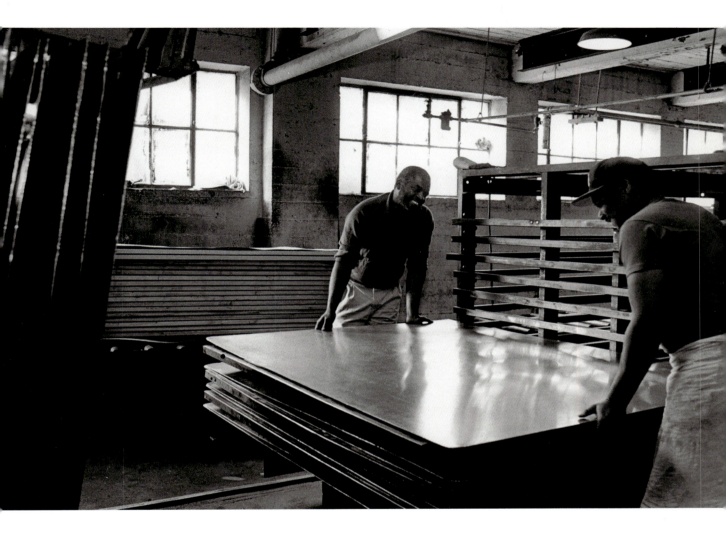

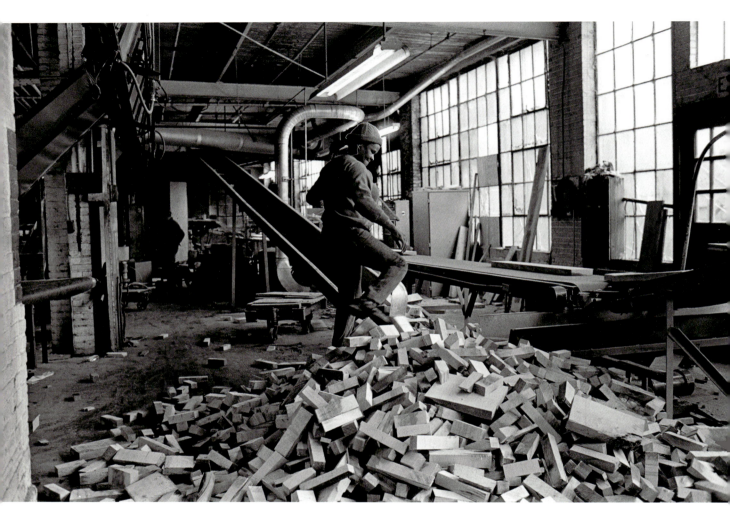

Above: Annette "feeding the hog," rough mill

Opposite: Quitting time

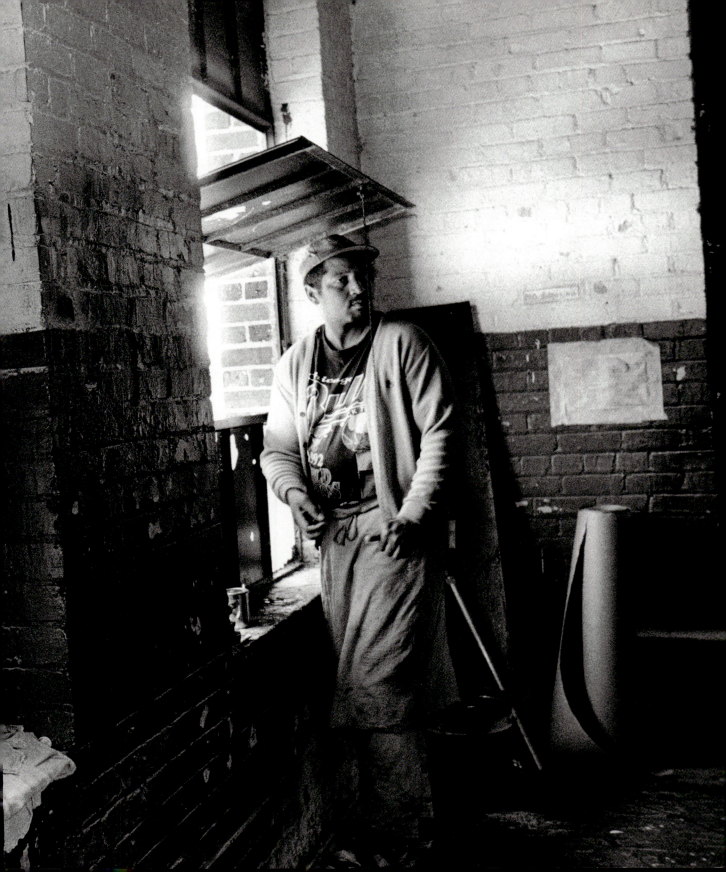

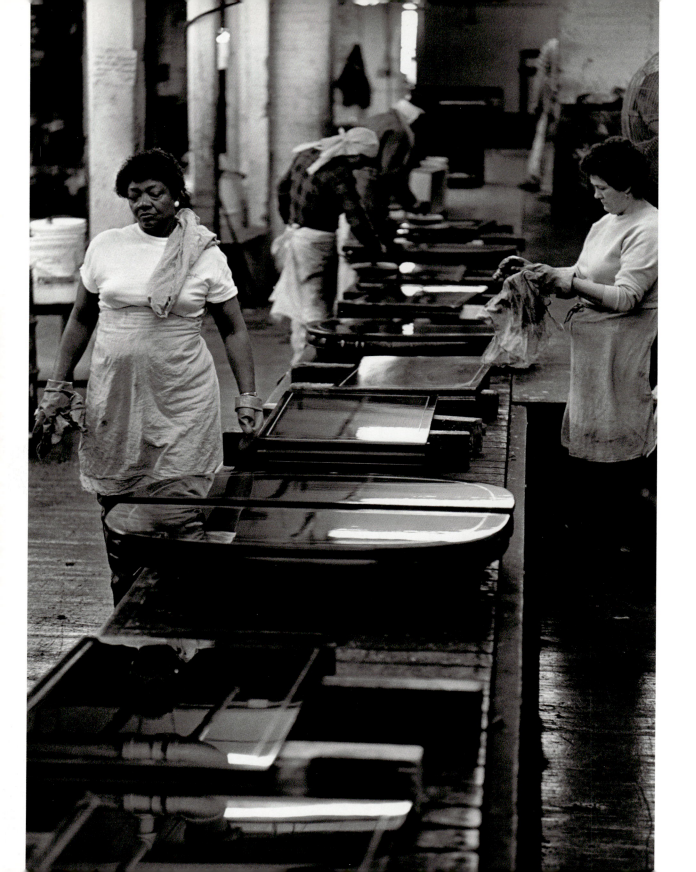

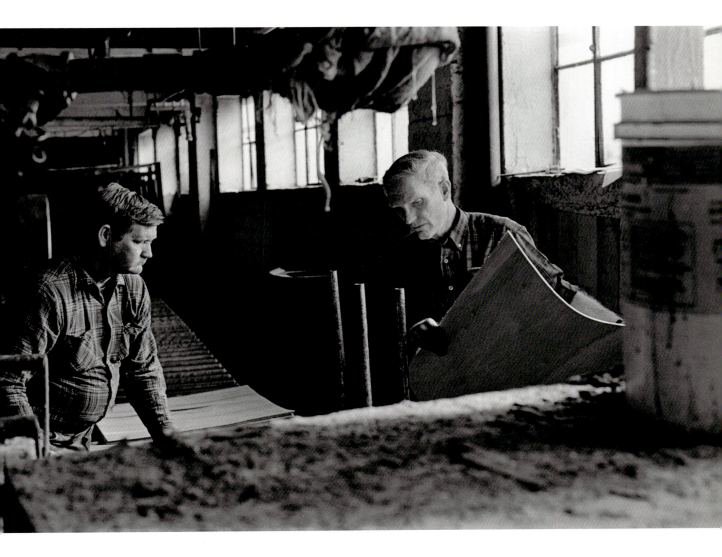

Above: Peanut and Robert, veneer department

Opposite: Jane and Moriah on the rubbing line

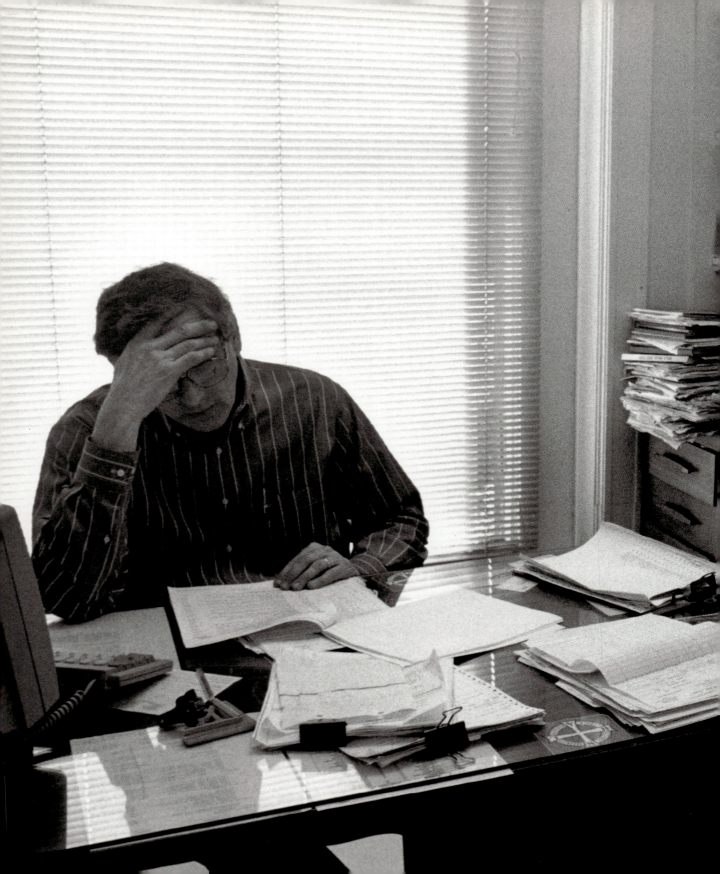

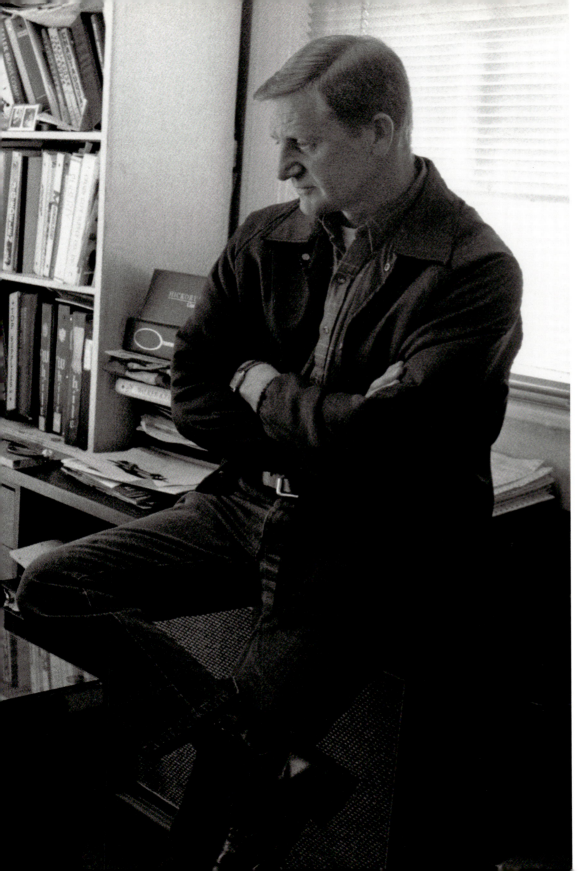

Fletcher and Avery

Overleaf:
Destroying templates
and patterns, machine
room

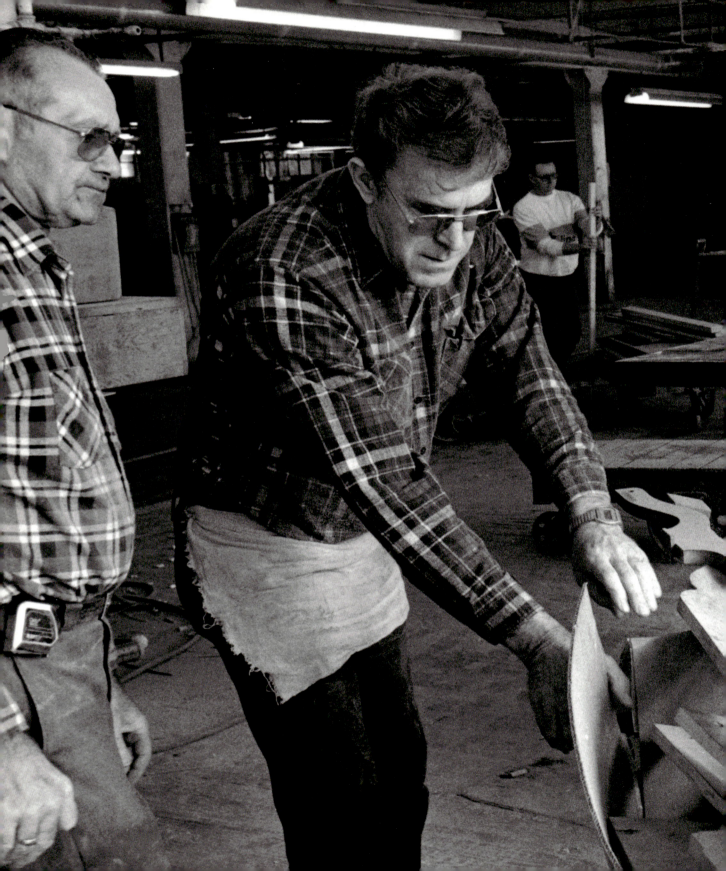

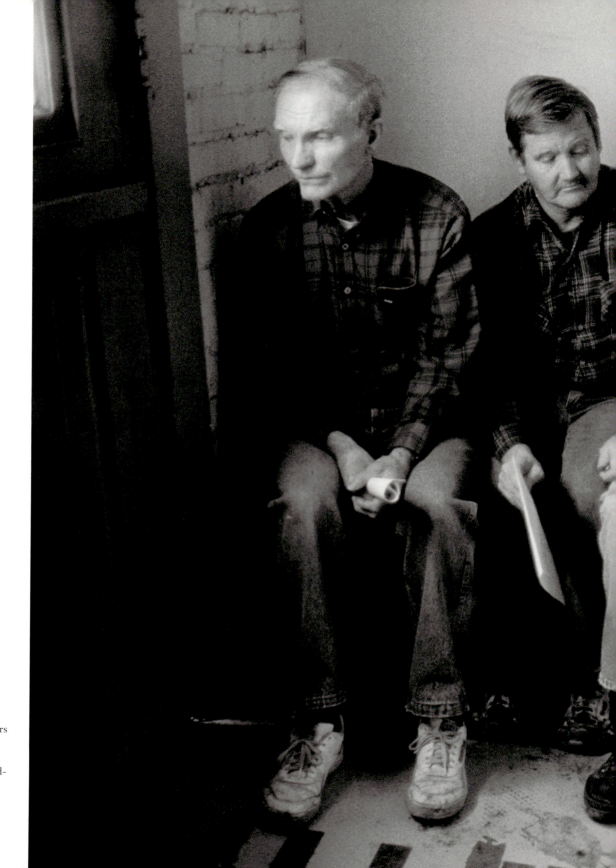

Workers with
their pension papers

Overleaf:
Jane in the rub-and-
pack department,
the month before
closing

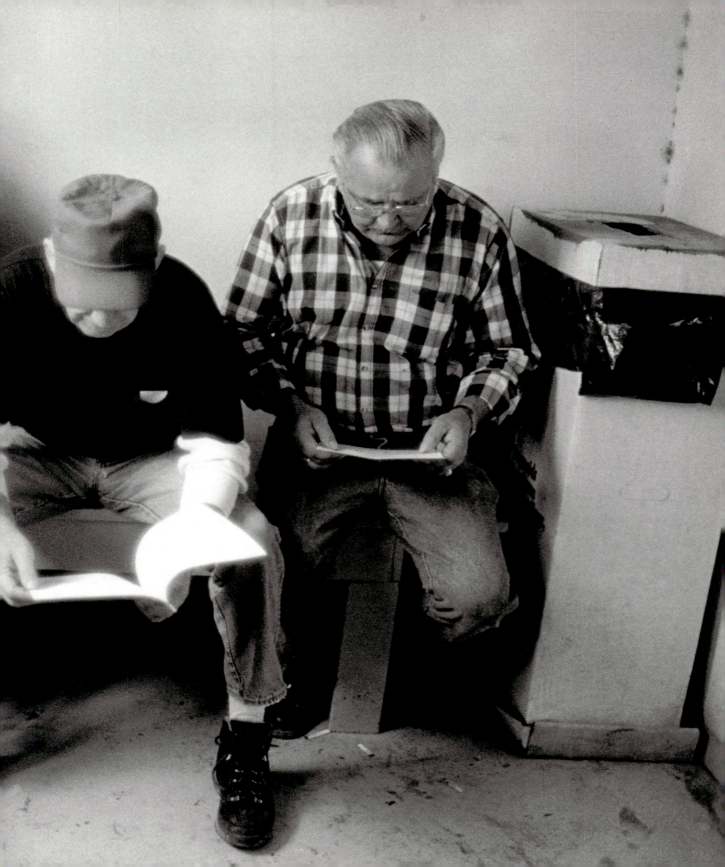

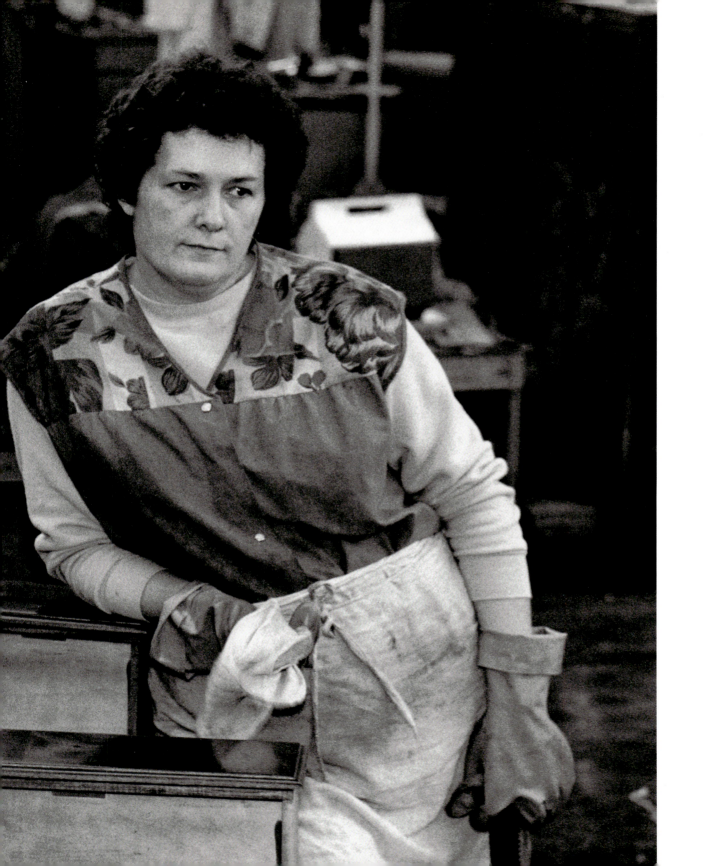

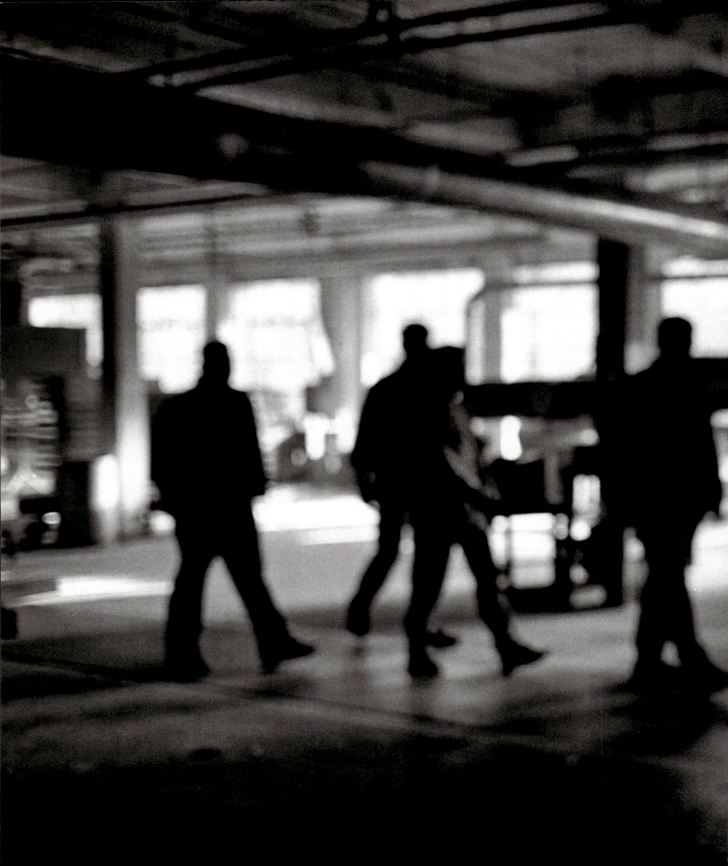

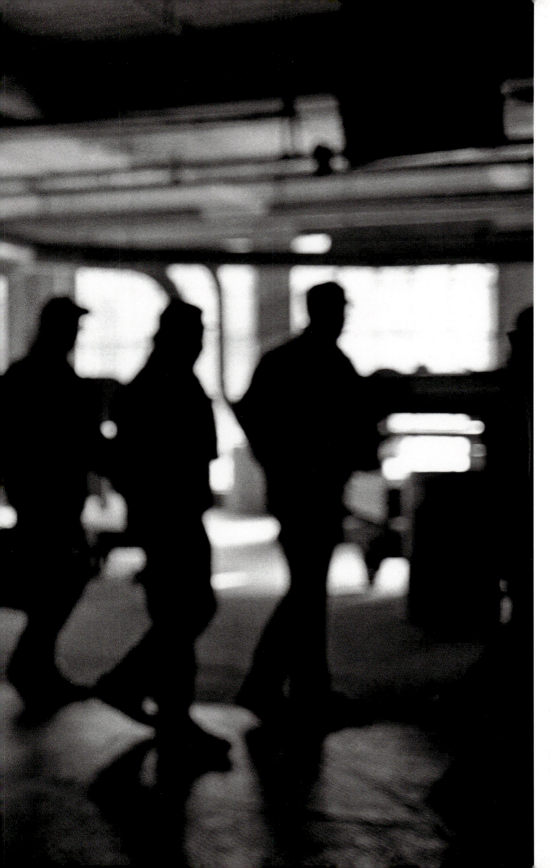

Quitting time, sanding room

Overleaf: "Nellie was here, now she gone," finishing department

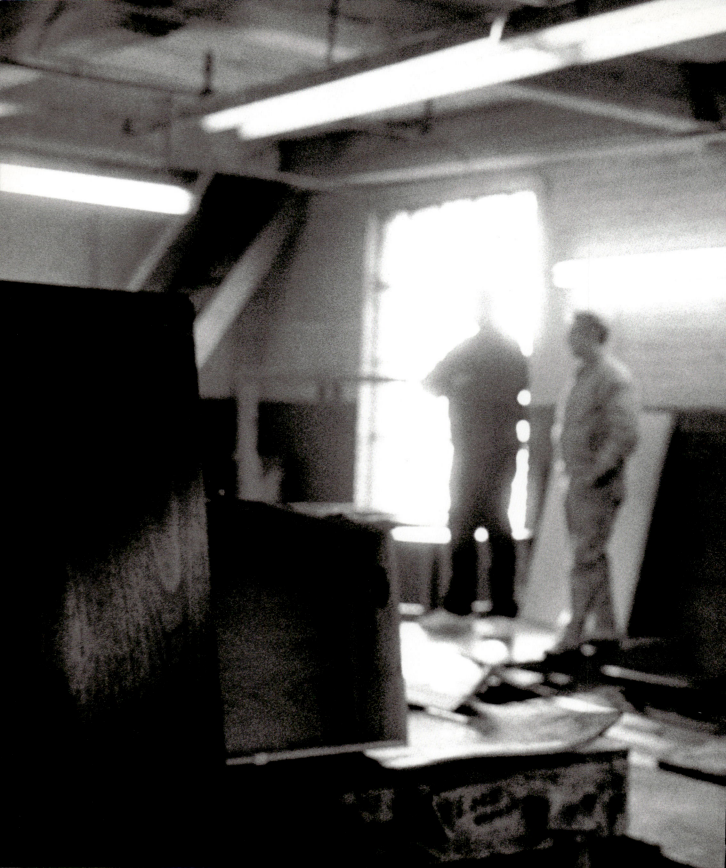

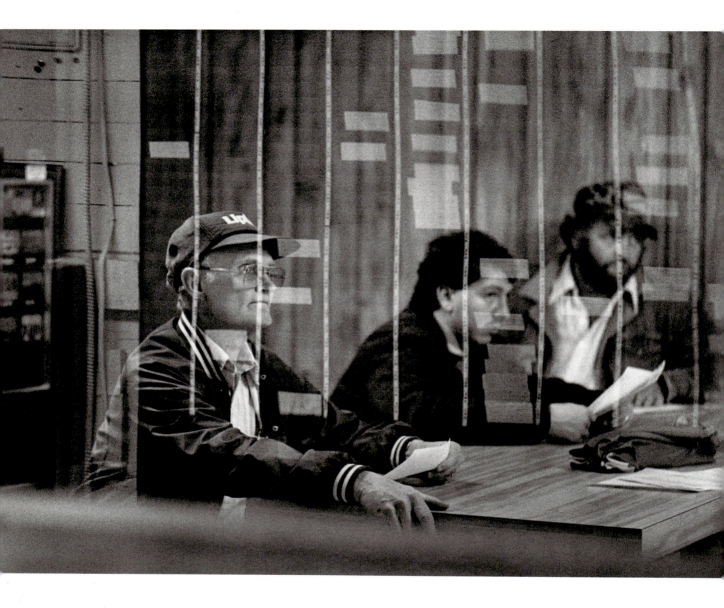

Above: Receiving severance papers

Opposite: James at home, the summer after
the closing

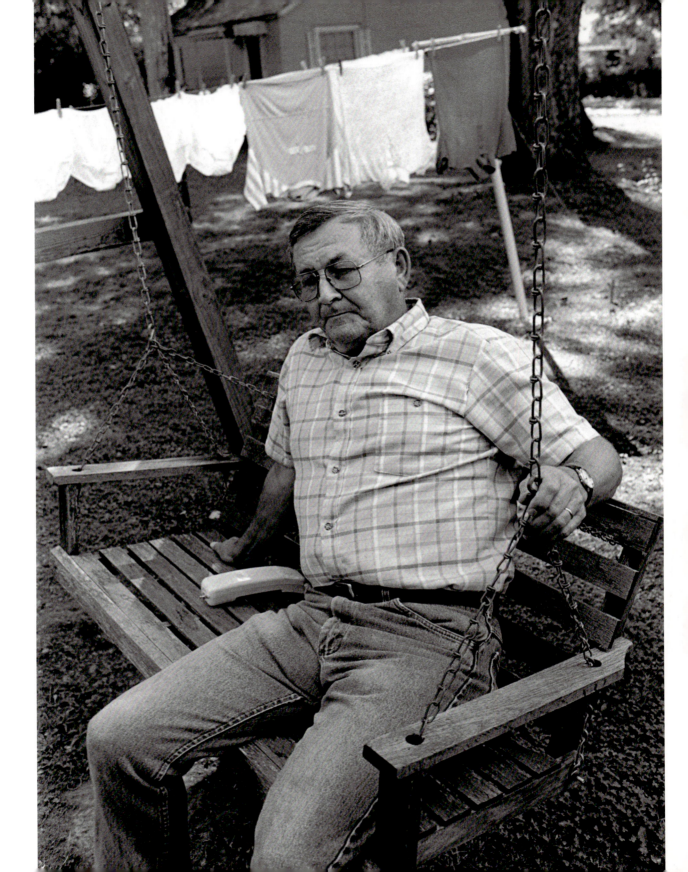

Chapter Four

Don

"To see those people just feather out of there . . ."[1] Don McCall's musical voice trails off into silence when he describes the way people drifted out of the plant during the final weeks of White Furniture Company, one by one, a little aimlessly, like falling feathers. Supervisor of the sanding department when word came that the plant would close, Don had to deal not only with his own anxieties about the future but also with those of the men and women who worked for him. He reaches for another metaphor to describe the final days at White's. "You could see them the last time they hit that clock, and it's just like, you know, their feet dropped on the floor and their hearts."

Don's identification with the workers is complicated by his own position as a supervisor, a pivotal position between management and labor. To complicate his point of view even further, he was hired in 1990 by Robin Hart, the president of the Mebane plant under Hickory-White. Don had worked for Robin at a previous job, and the two were friends. This automatically made a number of the workers suspicious of Don since they considered Robin the villain of the story, the man who symbolized Hickory-White's preference for quantity not quality, production not product. There was even a (false) rumor going around that Don was the new plant president's nephew. A sensitive man, attuned to both other people and his own inner life, Don is aware of these complexities. Yet these divided loyalties are not what remain most important to him. What haunts him, still, is that he had to

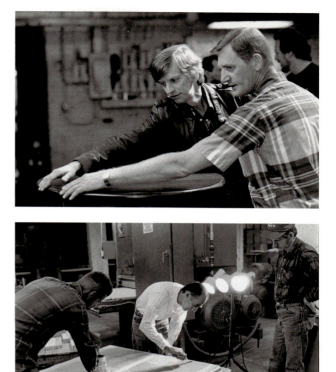

Top: Don and Avery, finishing department. *Bottom:* Carlos, Little Man, and Don, sanding room.

tell those who worked for him that White Furniture would be closed down.

When he recalls the closing, it is as if he is back there. "You know some of them will never be able to do anything else. Some of them are too old to go anywhere else. They're working because they had to. They couldn't afford to live on social security or didn't have enough income to live without that job. You know there is no way they are going to get another one unless it is as night watchman or sweeping the floor somewhere. That's the part that really hurts." The final days of the company were excruciating. "Every time two or three more would go, and two or three more would go," he says slowly. "You say good-bye and it hurts, and you do it over and over and over and over."

Some longtime White employees would be surprised to learn how deeply the closing of the White Furniture Company affected Don McCall's life and his sense of himself. From some perspectives, he was part of the problem, part of the lean, youthful new management team brought in by Hickory to tell White's veteran workers how they should do things. Don was a key player in the new Hickory-White regime. Why should *he* care what happened to White's? An outsider, why would it even matter to him what happened to this old Mebane firm?

It is true that Don's work history differed dramatically from that of the long-term White employees. He is much more typical of today's industrial workers and of middle managers in general who must live with constant job insecurity. He has had a number of different jobs, and has experienced more than one layoff. This work history, however, hardly made him immune to the pain of the closing and certainly does not mean, as some have suggested of all of the supervisors brought in by Hickory-White, that he was hired specifically to help orchestrate the closing. Don occupies an ambiguous position in the White story, for if there were truth to the theory that Hickory bought White's with the intention of shutting it down,

then either Don McCall knew he was being brought in as a hatchet man or he was deceived by the powers-that-be, just like the other White workers.

But even those who subscribe to the most cynical account of Hickory's scheme and Don's part in it admit that they liked Don as a person. As a symbol, he may stand for what went wrong after the buyout, but, as a person, he was warmly admired and respected. He is known for quick wit and good humor as well as self-deprecating modesty. Sandy-haired, with piercing dark blue eyes, of medium height, and wiry rather than muscular, Don has an impish smile and a mobile face that registers what he's thinking before he says it. And he thinks a lot. There is a quiet thoughtfulness about the way he analyzes people and situations. He has a philosophical disposition and many ideas to offer about furniture, business, and what happened at White's.

Don was born in 1951 in Brevard, in the mountainous western part of North Carolina, where he learned his basic values. His father was the night watchman at Brevard College until he died. The family was large, and, like many of the White workers, Don grew up poor. "I learned a lot about sharing and loving and having to do without," Don recalls. "I think it was probably one of the better things I ever learned in my life. Makes you a lot more self-reliant."

When he started in the furniture business in 1975, at the age of twenty-four, he had no idea how much he would come to love woodworking or how much it would shape his life. Just out of the army, he answered a blind ad for a job as a furniture repairman. Although he had only repaired machinery before, the supervisor at Silver Furniture saw his potential and offered him a job. "I knew what furniture looked like, but I sure didn't know how to make it or repair it or do anything with it. Nothing. I couldn't have told you the color of wood or the kinds of wood if you'd hit me on the head with it."

His previous jobs had been as a textile worker and driving a tractor trailer in the military, but once he started working in a furniture company, he knew that's where he wanted to stay. "I've been in textile mills and a lot of other kinds of factories. You don't get that sense of family in those other places. You get more a self-centered individual that wants to work and not be bothered." Many furniture workers share his view that woodworking is different from other forms of factory work, that furniture workers are less alienated, more cooperative than other blue-collar industrial workers. "I never have been in a woodworking plant that the people didn't really bond close," Don says. He stayed in woodworking "because of the people. None of them were rich. You can't get rich making furniture unless you are

the owner or something like that. They were all tight knit. It was a family-type atmosphere all the time. You got to know the people. You worked around them. They knew you and they cared."

He especially likes the way furniture makers consider themselves artisans. "It's more a trade than a job." The beauty of working with and transforming wood has something to do with this, Don is convinced; it makes people responsive to one another and more committed to the quality of the product than in most other industries. "It rolls from the top of the organization all the way down. Most woodworking plants, the guys, all of them, are right out on the floor talking to you and seeing how you are doing. No other manufacturing facility I've ever been in does that. They are too involved in production."

At Silver Furniture Company, he worked hard, fifty and sixty hours a week, while taking advantage of the G.I. Bill to go to night school to earn his associate's degree from a junior college. Robin Hart, the plant manager at Silver, was impressed by how rapidly Don rose within the organization. It took only three months at Silver for Don to be promoted to supervisor of the grandfather clock line. A short while later, Don became supervisor of the forty-four person frame assembly and sanding department. He stayed at Silver for over eight years and, over that time, became friends with Robin. Occasionally they went hunting or fishing together. They developed a lot of respect for and trust in each other.

But Don decided to move on when he was offered a more lucrative job with better benefits at Home Crest Furniture in Goshen, Indiana. "It was the hardest one decision to leave that company that I have ever made in my life," Don says of leaving Silver. "I cried when I left that place because of the ties I had. I thought I was bettering myself. I had a chance to go on and increase my knowledge of woodworking and increase my education and increase my earning potential for my family." As a middle manager, he believed that advancement often entails making strategic moves early in one's career. Yet Don also mourned the loss of his coworkers and promised to keep in touch with his friends at Silver after moving on.

Even Robin had to agree that this move was right. Robin's approval meant a lot to Don. "He didn't try to buy me back. He saw that I was doing better for myself and better than he could give me. I guess that's when I gained a lot of respect for that man right there." The day Don left, they gave him a farewell dinner, a silver dollar for each of the years he had been there, and a Seiko watch. "Robin was supposed to give me the wristwatch and couldn't do it. He was sitting in the back crying. He had somebody else bring it up to give it to me. He was that kind of person."

In Don's new job, he was part of a team hired by Home Crest Furniture to start up a plant in Clinton, Tennessee. It was as challenging a job as Don had hoped. Only a few of the new supervisors and a handful of hourly workers had actual experience in woodworking, so it was Don's job to set up his part of the operation and train everyone. Don also took advantage of Home Crest's offer to pay for courses in management resource planning and human relations. He took a Dale Carnegie seminar to improve his communication skills and learned a completely new computer system in order to design the computer-driven operation. Once the plant was up and running, Don focused on interpersonal relations with and among his workers. He developed strong ideas about what makes a good supervisor. "You've got to be willing to talk to people the way you want to be talked to. You've got to treat them like a person. They are not a number, they are not a piece of wood."

The operation worked virtually without flaw, but the entire furniture industry fell into a major slump in the late eighties. In December 1989, Don had to lay off the whole second shift at Home Crest and half of the first. He found this a wrenching experience. "After putting so much work into that place, getting it started, getting everybody trained, and then seeing it go out the door . . ." He can't finish the sentence. He did the company's dirty work for them — and then he received word that he was being laid off, too. "It felt like I had been violated."

Don started collecting unemployment benefits but, as he jokes, "I didn't even get a decent vacation" before the call came from his old boss at Silver, Robin Hart. Robin told Don that he had been hired by Hickory to reorganize the White plants in Hillsborough and Mebane, and he wanted Don to come to North Carolina to reorganize and supervise the sanding room in the Mebane plant. "I don't even know how he found out that I was unemployed unless he got a hold of one of the guys at Silver and talked to them. But he called me and asked me to come down there. He said he had a job he wanted to give me."

Don was eager to stay in the furniture business and delighted when he received Robin's call. But, less than a month away from his own experience of laying off and being laid off, he was wary about starting at a company that had just changed hands. He refused to make the move to Mebane without doing research into the company's history and its current financial prospects. All of the paper looked good; this seemed to be a strong and solvent company. But he also insisted on visiting the area in order to tour both the Hillsborough and Mebane plants.

He liked the people he met at White's, and he liked the look of the sanding department at the Mebane operation. The first room beyond the time clock, the

sanding room was one of the most pleasant spaces at the entire factory. With a bay of windows on one side, the sanding room was bathed in a constant glow of light from the street as well as from fluorescent and track lights overhead. Fine dust from the sanding process filtered through the bright air only to be sucked away by vacuuming machines. There was a constant light noise from the sanding machines, not jarring or clanging like in the machine room, but a smooth whir, soothing and almost calm. At quitting time, you could see everyone as they exited through the sanding department, their bodies silhouetted against the windows.

He started at White's in January 1990. He is adamant that he learned the news of the closing the same day his employees did, and that he was as shocked as they were. It sickened him to think that he would have to help supervise a closing. "You walk in the door of a company that has been running almost continuously for a hundred years, and your job security feels fairly certain, you know. You don't think it's going to shut down in three years."

Don's sense of devastation is still fresh, even several years later. Unlike many of the other White workers, he knew he would be able to find some kind of job, yet the closing undermined his deepest values and beliefs about what it means to be a supervisor and about what moral bonds and mutual responsibilities are necessary between workers and the company they work for. "You have to understand what it means to be a supervisor, number one," he says. "You have a responsibility, and a company has a responsibility to each and every person that works for you, to show them that you're going to do the best thing that you can do for them. You're going to keep them trained. You're going to keep them employed. You're not going to pull their feet out from under them. You know that job is what supports their family, pays their bills, puts their kids through school, buys their house, pays for taxes, buys the food they eat. You have to understand that. When you understand that, you can be a good supervisor. But when you understand that and you have something happen like shutting down that plant, you know that their whole life is changed completely. You know that the company you worked for pulled the rug out from under them."

Yet when Don gives his version of the closing, it is different from that of most of the old-timers at White's, mainly because of his close association and past experience with Robin Hart. Others were quick to blame Robin and are convinced that he knew about the closing the whole time. Many people believed that he was hired expressly to close down the Hillsborough and Mebane operations. Don is positive that Robin (who was sixty-two at the time of the closing) was not the kind of person who would have chosen to end his career on such an unhappy note. Don is

loyal to his former boss, insisting that Robin got a "bum rap" from most of the White employees. "I'm going to tell you, Robin did not know when he was hired that the plant was going to be shut down. When he left Silver, the one thing he said was 'I've got five and a half years until I retire, and I'm going to make it right there at White's.' That was his last words. A man's not going to say that and then go shut down a plant." Like the larger question of Hickory's original motives for buying White's, there is no clear answer to the question of Robin's involvement. But Don's loyalty is unwavering. Robin, in his account, is a martyr.

Don proposes his own candidate for villain of the story. For him, the real villain is Clyde Engle, the man at the very top, a man he never met. Don is both adamant and contradictory about the owner of Acton Corporation (now Sunstates), Hickory's parent company. For Don, the Chicagoan is the epitome of indifference; he never even visited the Mebane plant. Yet in Don's description Engle is also omnipotent, and it was he, not supervisors like Robin Hart, who were responsible for all the changes. In Don's account, Clyde Engle is never praised for being a superb businessman or a successful corporate wheeler-and-dealer: he is an invisible, malign presence whose concern is with the bottom line, not with people, not with furniture, not even with America's larger economic future.

Yet even as Don asserts his theory of the Chicago owner's guilt and Robin's innocence, Don acknowledges Robin's suspect history and the foundation for the rumors about him. Robin "had shut down a Singer [Furniture] plant and another plant for somebody else." Don mitigates this by saying that it was Robin himself who told him this sorry history. "He told it as a joke, and it hurt him to tell it." It was strictly bad luck, Don says, because Robin wasn't the kind of man who enjoyed profiting from the misery of others. On the other hand, whether he knew he was being brought in to close the plant or not, the people who hired Robin certainly knew that he had the experience to manage the closing—not an inconsiderable skill.[2]

Don also insists that Robin handled the closing of White Furniture as decently as possible. "Do you think it could have been done any different or any more humanely?" he asks rhetorically, then answers firmly, "I don't." He notes that the actual terms of the buyout were more generous than required by law and insists that it was Robin (not Hickory-White, not Clyde Engle) who made sure his workers were treated well. The law only requires a sixty-day notice before laying someone off due to a plant closing, but Don credits Robin with extending that notice considerably. "Most of the people got three, four months. Some of them got four

and a half, five months. Some of them didn't leave there until, Lord, June from when we found out in December, I guess, or November. He drug it as long as he could drag it and kept people working. He did that." Don also implicitly gives Robin credit for Hickory-White's offer of free tuition at a community college and other job training programs for the laid-off workers, although, in the end, those services were taken up by only a dozen or so of the workers. Don talks about how people were kept on "shipping stuff out and stripping machinery and doing stuff like that, but he kept everybody there as long as he could. He tried to give them a good, decent chance." He contradicts his earlier statement about the bleak future facing the laid-off workers when he insists that Robin helped people locate new jobs and gave them good recommendations and that "everybody has found a job."

It is hard for Don to talk about his former boss; doing so deeply upsets his sense of responsibility. Don remains particularly disturbed by one fact: Robin later told him that he knew of the closing three months before it was announced but was sworn to secrecy. During those three months, people were making major life decisions based on assurances that White Furniture Company was sound. Employees declined to take jobs elsewhere or purchased new homes in Mebane. Robin had the knowledge to protect them from disastrous decisions, but doing so would have been a violation of the trust put in him by his superiors at Hickory-White and would have hurt the larger company.

Robin was in a bind, having to keep a corporate secret at the expense of his employees' lives. It's the kind of moral quandary that Don sees as central to the job of being a modern-day manager. In fact, whenever Don talks about Robin, it is clear that more is at stake than loyalty to his friend. Don's defensiveness about Robin underscores the contradictions in his own system of values, and one might even say in the larger values of corporate capitalism in late-twentieth-century America. Don represents the dilemma faced by many contemporary managers who feel caught between conflicting value systems. By the traditional (if romanticized) model of business, rewards go to hard work, excellence, and loyalty to one's company. The newer system of rewards is based more insistently and overtly on mobility, taking chances, and a willingness to do whatever will make an operation profitable—including having to pretend the business is perfectly healthy even when you are working behind the scenes to insure a smooth closing.

In this regard, Don's ambivalence resonates with many of us who have not yet accepted the consequences of the cutthroat ethics of buyouts, mergers and acqui-

sitions, and downsizing. These are features of American business that, it is often said, make Wall Street profit at the expense of Main Street. In many media accounts of downsizing, there is an almost schizophrenic attitude, where sympathy for the laid-off worker is balanced with capitalist ideas that a leaner, more efficient workforce leads to greater profits for the company and its shareholders. More to the point, when we don't keep costs down here, business goes offshore — with even greater loss of jobs. What's good for corporate America, this logic goes, is good for everyone — therefore the downsized worker is inevitably represented as, finally, "better off." Don's attitudes exactly mirror his position as a "middle manager," caught in the middle between management and worker, and caught, too, in the sense that his own future is hardly secure.

Don recalls vividly and intensely what it felt like to be called into the head office and be told the Mebane plant was closing. "It was ten o'clock in the morning. They called every supervisor into the conference room. [CEO] Randy Austin came in, Robin Hart came in, and two or three others from corporate came in. They locked the doors, shut everything off. Randy told us then that the plant was closing and that we would be given two months severance pay if we stayed until closing. Some of us would be offered other jobs at Hickory. It would be effective sixty days from that day, that people would start leaving. The supervisors wouldn't leave then, but the people would start leaving in sixty days."

All division supervisors were then instructed to return to their sections and inform their workers that they were to meet in the warehouse in thirty minutes. The division supervisors were strictly instructed not to leak advance notice of what would be announced at the meeting. On his way out of the head office, Don encountered Kay Faulkner. She must have overheard because she was sitting on the steps outside Robin's office, crying, devastated. Don had little to offer but sympathy. "I picked her up and hugged her. I said, 'Just hold on.' She looked up at me with those big old brown eyes and said, 'What am I going to do about my two kids?'"

The thirty minutes until the layoff meeting felt like they would never end. "You're in shock yourself and then you know what it's going to do to everybody that works for you. It's like somebody taking an anvil and setting it on top of your head and just pressing down on it. You can anticipate a lot of things, but you can't anticipate how a person that's sixty years old is going to react. You don't know if somebody's going to have a heart attack or die."

He recounts what happened at the layoff meeting with difficulty, measuring his words. He slips into present tense, as if the announcement were happening now, all

over again. "Your first and foremost thought is, 'What's going to happen to me?' That's just basically being human, but when you know that everybody out there is going to be told, you get a cold feeling deep down in your soul. You know what's going to happen and you know that you don't want it to happen. You know everybody's going to be told and everybody's going to go, oh, and their faces are going to drop, and they are going to wonder and think the same things: What am I going to do next? How am I going to support myself? Where am I going to live? How am I going to buy food?"

When Randy Austin finished making the announcement to the assembled workers, a deathlike silence fell over the room. "Nobody asked question one. Nobody asked one." Don's voice fills with disdain when he describes the CEO's demeanor that day. "There was just not any remorse in his voice, not to us or not to the employees. It was more to me like an act."

Here, for Don, is another good candidate for villain. In telling this part of the story, he now accepts the familiar White narrative that Hickory all along planned to close down White Furniture when it bought it in 1985. He is sure that when Randy Austin took his job at Hickory-White in 1991 he knew all about this plan. "I think he knew the day he was hired that that was part of his job, and he had prepared for it, and he had prepared for it well."

Don says he studied Randy, seeking some kind of emotion, some sign of remorse. "I looked at his face, and I watched his movements for that whole thirty minutes because I wanted to see how he reacted. I looked for signs of weakness. I mean, you can see it, you can see when you are genuine and somebody is really hurting. I didn't feel it. I didn't see it. It may have been there, but I didn't feel it, and I didn't see it, and I looked. I *hunted* for it, as a matter of fact."

If Randy had expressed the tiniest flicker of sadness, it might have redeemed him in Don's eyes. "I turned around and thought how I would have acted if I had to do the same thing. It would have killed me. I could have done it, but I couldn't have left that stage without tears in my eyes. There's no way. A man that cares about the people that works for him, he couldn't have done it."

Yet, to assume Randy's point of view here, one must also wonder what else he could have done. Like Don and Robin, he, too, did someone else's bidding—only on a higher, more powerful level. Even if the decision was ultimately his, he had an owner and shareholders to whom he was responsible. As CEO of the whole Hickory-White operation, Randy had to make tough choices in 1993 when both the Mebane plant and the much larger facility in Hickory were operating on short

time. Would it have been humane to keep the smaller Mebane plant open if it meant jeopardizing the whole corporation? Yet even if closing Mebane made good business sense, how in the world do you tell workers at one plant that they need to be put out of work in order to save other workers' jobs? Would it really have changed anything if he had waxed emotional? The fact remains: for some greater corporate goal, 203 people were out of a job. There is no good way to tell people they are expendable.

After Randy finished what he had to say, he turned the meeting over to Robin who passed out the layoff and pension papers. Robin supervised the closing. He promised that every employee would be talked to, everyone would be counseled. He told them about a tech school that employees would be sent to, about training, unemployment benefits, the details of a layoff. "I don't think anybody really listened, including me," Don says. The meeting ended right before the lunch break. "People went upstairs and sat down. Didn't eat. Didn't do nothing. Just thought."

Again, Don grows quiet. "I want to compare this with something, and it's not a good comparison, but basically I felt the same way both times. I was in the room when my Dad died and I didn't realize it. I seen the monitors go straight line. I had enough sense to know that he was dead, but I walked back to the room where my wife was at, and it took the doctor coming in and saying it for me to realize it. And the plant closing was the same thing. I mean, you knew it was happening, but until somebody said this is the final blow you didn't really want to accept it. To me it hit me the same way. It was a death, a death of a family of people, of a company."

Amazingly, after the lunch break, every single person from Don's department came back to work. "They didn't want to do much. I didn't blame them. I didn't want to do much either." The people in the sanding department asked him questions—about unemployment, pensions, health benefits, job prospects elsewhere. People wondered if they had to stay on the job until they were specifically told to go in order to be entitled to their severance pay or if they could start drawing unemployment benefits while they were collecting severance pay or if they had to wait until after. Although he refrains from blaming Robin even here, it is obvious that he is still bitter that he had been left completely uninformed by his own supervisors and had no answers for the men and women who worked for him. It would be several days before any of the details of the closing were worked out and the employees were given satisfactory answers to their anxious survival questions. He felt he had let his people down, and that he had been let down, too.

He left the plant as soon as it was closing time that day and headed for Papa Joe's, the local bar. "It was a real emotional drunk that night," he laughs joylessly.

"A big bunch of us went down there and just sat and talked and drunk a couple of beers and tried to figure out what we had done. About all the supervisors were down there. Several hourly employees were down there. It was one way of coping, of relieving stress and just feeling numb. Nowhere to go and nothing to do. Not really wanting to go anywhere or do anything. It's total numbness. Like somebody took your head and pulled your brain out and you're just walking around with nothing up there."

The closing brought the workers together. "The only person who could really help you understand is the person sitting beside you that went through the same thing." Yet he confesses that solidarity with the other workers wasn't enough. He never felt more helpless in his life. "Being laid off and being told the plant was shutting down are two different feelings. I was mad when I got laid off. I didn't get mad at the shutdown. There was nobody to get mad at."

He sympathized with his friends who had to leave the bar that night and face their families. Divorced, he was exempt from having to do that night what many of his coworkers faced. "You know, probably the hardest thing that anybody has ever done in their life is to go home and tell them, 'Kids, you know, I don't have a job in two months. How am I going to feed you and pay the bills?'"

In retrospect, Don feels he now has a better grasp on all that happened. "The truth was that place was bought to be sold," he says with certainty. "When they bought White—all of White—which was both plants—there was enough material stocked and/or piece parts to make material to ship. They paid for the plant with what was in it. They made money on the sale of the land down in Hillsborough. They'll make money on the sale of the land up at Mebane. Somebody will buy it. They will pay big money for a lot that big inside the city limits. It was a money-making proposition from the start."

Don insists that the big surprise was that the aging operation actually started making money again under Hickory. In fact, he was certain that the Mebane plant was operating in the black. As a supervisor, he had to go over monthly statements indicating how his department was faring. If a department made 10 percent over the company's goal, there would be a bonus. "The first year I was there I got a three-thousand-dollar bonus. You don't get that kind of a bonus if you're losing money." He admits that there were no bonuses for the subsequent two years, but is certain that the company was still making money. He says Hickory laid off workers and brought in supervisors like Robin and himself who streamlined the operation. There was also an upturn in the building trade and the furniture began selling again. But, most of all, the White workers worked hard. They had enormous

pride and wanted to show the new owners that they could do whatever was demanded of them, including keeping up with the new production quotas.

"I think the first couple of years basically it was a tax write-off, or it was supposed to be. I don't think they expected to make money." Don speculates that turning a profit may have been the kiss of death for the Mebane operation. This wasn't what the head corporation needed or wanted from its latest acquisition. "You make money by losing money. You take a sixty-plus-million-dollar corporation, which is what Hickory Manufacturing and White together was, you can afford to write off one, two, three, four, five million dollars a year on your taxes and make money by doing it because of depreciation for five years."

Once again, there is an inconsistency in the stories here. While Don insists White was running in the black at the time of the closing, managers at Hickory's corporate headquarters scoff at this, insisting that the White operation was running way in the red, to the tune of over a million dollars a year. Since Hickory-White is privately owned, there is no way to reconcile these two figures. Additionally, since Hickory-White borrowed money against the company's purchase price right at the start, it is not clear how that debt was accounted for. White's finances became so intertwined with the finances of the Sunstates conglomerate that bought it that there is no way of isolating the Mebane plant's own profit and loss. Simply put, Don's view is different from that of the Hickory owners—and vice versa.

Don proposes that beyond Randy Austin, even beyond the corporate owner in Chicago, the real villain in the closing of White Furniture Company is a tax system that makes it possible to profit through buyouts, hostile takeovers, and corporate consolidations offset by corporate loss. Strengthened during the high-rolling corporate climate of the eighties and the Reagan-Bush administrations, this system is designed for the megacorporation, not for the small business. "It's what they call accelerated depreciation. You can depreciate over five years. Most companies do that and then they turn right back around and buy a new piece of equipment to start all over again. If they make money on top of that, that's a write-off plus the money. So there's no way they could have lost, no way."

Sunstates, Don insists, "was making more money by losing money." They did not put any extra money into the factory building itself, but, instead, stripped the plant to nothing, and either sold the equipment or sent it to Hickory's main factory. Don's story is similar to Margaret's—Hickory must have recouped what they put into the operation. "The total cash outlay—they probably paid five and a half

million dollars for the whole thing and made twenty," he estimates. At the time of the sale, "the wood yard was full of mahogany and cherry, oak, or whatever they were making at the time. It was full. The plant was full. Their purchase price was there. The day they bought that plant, they made money by just buying it."

From a wider, corporate perspective, Don concedes that it was "a smart business move, a very smart business move." From a human and civic perspective, however, what Hickory Manufacturing did to White Furniture Company, its employees, and the town of Mebane, North Carolina, was immoral and destructive. The economic base of the community was undermined with that one sale. Over two hundred men and women out of work in a town of fewer than four thousand is catastrophic. For a moment, Don returns to the idea that Clyde Engle is the real villain of the story. "That's who shut the doors to that plant. It wasn't Randy Austin, truthfully. It wasn't nobody else. It was the guy that controlled the money that owned the place. He shut it down. Everybody else carries the blame on their shoulders, but in all actuality it falls to one person and that one person alone, the man that owned it, the man that never did come and see anybody."

Don here again feels a need to personify what are basically abstract, structural forces. He has sophisticated knowledge and ideas about corporate practices and government policies, yet, like all of us, he finds it difficult to think too long about the fact that the whole, larger system might be veering dangerously out of control. It is preferable to believe in villainy, to think one man did it. Whether it is Clyde or Randy or Robin (or Don, for that matter), if there is a villain, someone at the top who is abusing his power, then he can be replaced and everything will be fine. It is easier, certainly, to conceive of changing one man than to try to figure out a way to change the entire corporate structure of global capital in postindustrial America.

Don has nothing good or sympathetic to say about this mysterious, invisible outsider from Chicago. "The man that owns that company or companies does not care about the people that work for him, does not care about their families, does not care whether they live or die. All he cares about is the dollar bill. He didn't see the people. As far as I know he never toured the plant. I never met him. I never seen him. He never come down there and seen the people that were actually in that plant. He never had to look at their faces. He never had to answer their questions. All he seen was a dollar bill going by, and he has been known for buying places and shutting them down. If a person can do that he is a heartless son of a bitch. That's no joke."

Don finds mitigating circumstances and explanations for the other managers at Hickory but he shows no mercy toward the owner in Chicago. Engle made a profit on the sale of a famous, old company and on the unemployment of over five hundred good and dedicated workers. "He should have had to walk through that place and look at those people going out," Don insists. And some day, Don is absolutely certain, that Chicago corporate executive will be forced to see the faces of the White workers. "He will see their faces when he walks through the gates of hell because you don't go to heaven and do people that way."

Don says that, after the closing, Randy Austin offered him a job at Hickory-White. Since his kids lived elsewhere with their mother, nothing tied him to Mebane. He was free to move, but, along with Robin Hart, he declined the offer to work at Hickory. "I laughed in their face. I told them, 'No way!' I didn't trust him, I didn't trust them. I did not trust that company at all. They've still got four companies besides Hickory, but I wasn't going to put any part of me into a company that just said, 'Hey, we're shutting the doors on everybody here. We don't care.'"

Don now lives in Brevard, North Carolina, the town where he was born. The ideals and ambitions that motivated his career for a quarter of a century have changed radically. He's even given up on the furniture industry, his first love. He's not sure he wants to feel the closeness to his coworkers that he used to experience in woodworking plants. Businesses close, you get laid off. Or, worse, as a manager, it's your job to let everyone else go on your own way out of the plant.

Right after the closing, Don moved back to his hometown and worked in the parts department at the John Johnson Ford dealership in Brevard. Later, he switched jobs and worked in a local shop detailing cars for affluent visitors on vacation at resorts or summer homes in the area. Now his mother is very ill, possibly dying, and he takes care of her all day and works the second shift at a Frigidaire plant across the border in Tennessee. He's not a manager at Frigidaire. He's just another worker, on the line with the next person. He's anticipating a plant layoff at Frigidaire any day now, but this time it won't be his job to deliver the bad news.

Don is forty-four years old, the age at which many managers would be reaching the height of their careers and earning potential. He is a born leader, a man of intelligence and ability. He should be a supervisor somewhere, now, but that's not

what he wants any more. He has made a conscious choice to work at jobs below his level of skill and capability. When pressed, when reminded that he was a brilliant boss, much loved and admired, he is insistent that he'll never fire another human being so long as he lives. "That's what a manager does," he says definitively. "You get paid an awful lot of money to do the dirty work, to tell people things you don't want to say and they don't want to hear." His voice is so firm and assured that there is no contradicting him. It is clear he has thought this through.

He talks eloquently about how, in today's economy, any managerial job he takes might well require him to do all over again what he had to do at White's. He refuses the option. He's a man who tried the new economy's game and lost. He doesn't want to play any more. "I was in Vietnam. I closed a factory. I don't ever want to be a manager again."

When he talks about the grueling physical and emotional labor of taking care of his ailing mother, it sounds like he is looking for expiation. "I'm cooking, cleaning, everything. I've gotta do it. She raised up eight of us. She worked hard her whole life. I'm paying her back." It is almost as if taking care of her, in her last days, has helped him to put his world back into perspective again. He knows what counts and what doesn't.

For now at least, he is living simply: he works, he takes care of his mother, he writes poetry, and he enjoys the beauty around him. "I love Brevard to death," he says. "The scenery is just breathtaking year round," he gestures to the mountains that surround Brevard. "And the people here. You get such a diverse influx of people in the summer that you can find somebody to talk anytime you want to. I really like that," he smiles. "It's nice."

One thing he talks about to anyone who will listen is how bankrupt the system of business is these days. He is concerned now that Brevard's last factory — a chemical plant that employs 2,500 workers — is about to close down. Soon, he says, the biggest employer here will be the county. The only other business is tourism. Government and leisure. "How can you survive," Don asks, "with an economy based on air?"

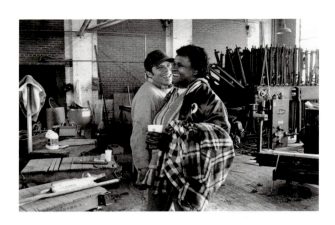

Chapter Five

Annette

Left to right:
Annette with
Hilario, rough
mill. Annette
with Tonie,
rough mill.
Annette on the
end-cutter.

Annette Foust Patterson lives in a small bungalow on Foust Road, a dirt road off Third Street, a main road into town.[1] The asphalt siding needs repair, the porch sits slightly askew. Once, this was her family's farm, but now the yard is bare soil, patchy with crabgrass, and debris raked into piles. Her nearest neighbors are mostly relatives, African Americans like herself working hard to make ends meet. All around them are suburban-style housing developments, mostly inhabited by middle-class white people. Nearby, even more affluent golf and retirement communities are springing up.

A divorced mother of three, a grandmother, and an aunt, Annette supports her extended family by arduous, manual labor. Hired by the new management team brought in by Hickory-White, she was one of only two women in the rough mill, where the raw lumber entered the factory, sometimes with the bark still on, and had to be stripped, sorted, cut, planed, and sometimes glued. The work was both physically grueling and mentally demanding. And it was the best-paying job she ever held.

Both before and after working at White's, she has held blue-collar jobs more typical of our late twentieth century—temporary work, shift work, and work where you can never count on your hours or your pay—twenty hours one week, sixty the next, as needed by the factory. Because the area of North Carolina along I-85 has become increasingly prosperous and suburbanized, the cost of living has risen dramatically in the past two decades. Wages have, too. What this means is that many factories—especially the textile mills—have moved abroad rather than pay higher wages, leaving a surplus of industrial workers who have little choice but

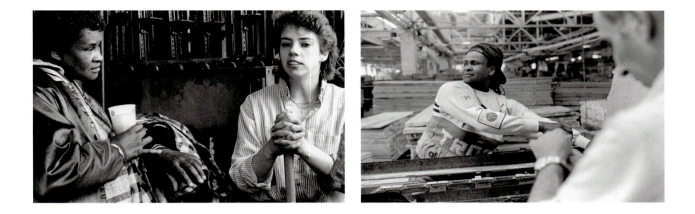

to take jobs at the few remaining factories and mills, typically part-time work with no benefits. Like many other blue-collar workers in the area, Annette must supplement her factory work with service-sector work, mostly slinging burgers. Since the closing of the Mebane plant, she has had to work two jobs to make a wage equivalent to what she earned at Hickory-White. For a while she had a full-time factory job plus a supplementary job at a fast-food restaurant, working virtually around the clock for two or three days in a row, with only a few hours to nap between shifts.

Annette was born in Mebane in 1951. Her father worked as a logger and also raised farm animals and corn, tomatoes, and other vegetables. As kids, Annette and her twin brother, Andy, did a lot of chores. "We chopped gardens, we took care of pigs," Annette says. "This was part of our job while Daddy was at work. The kids done it. You got up and worked." She is proud of having worked her whole life. "A lot of kids never did have to work for their money. My mom and dad put us out there: don't steal, make your money. We always have, since we were little bitty something."

Annette's first job outside her own family's farm was at an egg ranch. She was eleven or twelve at the time, and she would go into the long chicken houses and gather eggs or she would help hold down chickens that were being vaccinated and debeaked. She worked alongside her mother at the chicken farm and, throughout her life, has often worked with her parents or her brothers and sister. In 1968, when the North Carolina schools were integrated, she went by bus to school in Graham, the next town over, but she always held jobs on weekends and after school.

She dropped out of school in the tenth grade. "I didn't like school, no way." She laughs heartily when she says this. There is nothing coy or giggly in her manner.

She is tall and muscular, with broad shoulders and powerful sinewy arms, strong hands, the fingers long and tapered. Her deep set eyes are piercing, but it is her physical strength that one notices most. She has the straight-backed, confident swagger of someone who has spent her life working with her muscles, someone who knows she can count on her body. "You needed a lot of stuff for school, and my parents couldn't afford to send me. I just dropped out and stayed at home and started working," she explains matter-of-factly. "I guess you'd call it survival."

She married young and went to live with her husband in Liberty, North Carolina, where their children were born. Later, after the marriage broke up, Annette moved back to Mebane with her kids and lived on the same land where she was raised. Immediately before coming to White's, she worked at a hosiery mill as a "boarder" — the person who shapes the heel and toe of socks before sending them into a steam booth for pressing.

She tried to get a job at White's for a long time and finally succeeded in 1990. A girlfriend working there told her they were hiring and so she went down, filled out an application, passed the drug screening test, and began her job. As it turned out, she was one of the last people hired by Hickory-White. She had heard that others were being laid off there, but she never anticipated that the whole operation in Mebane would be sold off and shut down. "I was there for about two years and six months before the closing started on me."

She was hired to work in the rough mill. Only one other woman was working in that department at the time, and management thought that hiring a second woman might encourage the first to stay on. The male workers themselves had other ideas: the rough mill was difficult, arduous, and potentially dangerous work — *men's* work, they said — and they resented the encroachment of women into their territory. The first woman quit about a month after Annette arrived, leaving Annette to negotiate alone an array of psychological hazards ranging from sullen resentment to outright sexual harassment while also doing all the grueling physical labor that the men did. She inspected the lumber for flaws, graded its quality, and made decisions about whether it could or could not be used in the furniture. She worked the panel flow, gluing wood pieces together (typically to make plywood cores for veneered furniture), and sending them on through the enormous high-pressure and high-heat glue machine.

One man in particular was determined to get her out of there. He ridiculed her while also harassing her. "I want to call him a sexual-ist, what you call a guy when he wants to make plays on you." He kept asking her out, tried to fondle her on the

job, and made insinuating and insulting remarks. "Me and him had a little conflict because he wanted to play and I said, 'I don't do that.'"

Annette suspects that a different kind of woman might have ignored him or just "let him pit, pat, and play and do. I had to straighten him out." She went to her supervisor directly and informed him of the problem. He had words with the harasser and made sure the problem stopped.

Annette is proud of her good relationships with her other male coworkers, but they, too, gave her a hard time because she was a woman, testing her mettle in what amounted to initiation rituals. "They thought they actually could run me away," she laughs. When they refused to give her rides to work, she got herself a bike and rode the two miles to White's in snow, in rain, in summer heat. Some of her coworkers were "going right by my door, right by the road I stayed on and wouldn't give me a ride to work. They wouldn't let me ride with them. I said, 'Well, I'm going to get there.'" She was determined to prove she could work as hard as they did. "There were no jobs back there that I minded doing. I'd do all of them. I'd do anything. I didn't mind. I was in there lifting and doing right along with them. Just like if the conveyor got stopped up I would get over there and unstop it with everybody else. I think they finally seen that, 'Hey, she's going to stay.'" With a rueful laugh, she adds, "Guess I had to get in there and put my feet down, be one of the guys, and that's what I did." Annette insists it was her upbringing that contributed to her determination and capability. She was raised with a strict set of values and was not treated any differently or any more gently because she was female. "I was brought up with a lot of brothers, and I was a hard worker." She was always "a kind of a tomboy," and the other kids used to joke about those "Foust girls . . . they can throw a log and turn a hog." She used the same feistiness at White's, showing the other workers that "I'm here to do the job that you do."

When Annette tells this story, her voice is as steady as her gaze. She is not an overtly aggressive woman. Her manner is unassuming, even shy. But there's a timbre of defiance and pride in her voice as she sits quietly and self-contained on the porch, sipping water to calm a lingering winter cough, reminiscing about what she had to do to gain the respect of the men, both white and black, with whom she worked. Her speech is punctuated with a warm smile and a ready laugh. She has the aura of someone who knows what she likes and doesn't like and who is used to talking straight. Her enthusiasm is palpable when she speaks of her work in the rough mill. Her favorite job was tailing the ripsaw—running measured lengths of lumber into the turning saw blade: "You had to use your wits, your speed, and keep

your eyes, you know. You had to be ready at all times. This is the job that I was hired for. I loved it."

Since there was no formal job training at Hickory-White, she learned on the job from her coworkers. Her partner, Kirk Worth, taught her how to tail the ripsaw as well as how to run the saw itself. He would run the saw for a while and she would tail, and then they'd switch. "Me and him worked together good. We had an understanding. Sometimes we talked junk to each other. Sometimes we'd rib each other. He was okay." They grew close on the job. "He'd look out for me or tell me something or whatever."

Tailing the ripsaw required a range of skills. She had to inspect the wood for worm holes, splits, or rough places and then sort the wood by quality into various hand trucks. If she found a piece of wood unusable, she threw it over her head onto a conveyer belt that would take the wood into the hog, a huge, clamorous grinding machine that chopped the wood up and made it into chips. If she deemed the wood acceptable, she would guide it rapidly, carefully, and precisely into the ripsaw. While working the saw, she had to make various judgment calls and assessments about how to set it for the different lengths and kinds of wood. "They gave me a chance to learn, and I did. I tried to learn everything I could about the place."

One thing that continued on at Hickory-White from the old days at White's was some measure of autonomy. The supervisor "didn't stand over you and work with you." But he did make sure that the line moved quickly and, as Annette learned from old-timers at White's, the line was moving faster than ever. Sometimes there were mistakes due to the pressure to produce so rapidly. In extreme cases, the mistakes were bad enough that part of the line had to be shut down and all the workers from that part of the factory were sent home early, without pay. "Everybody got to go home," she laughs wryly. "Everybody paid for one person's mistake."

Everyone complains that production was moving at too high a pace. Others complain that the standards of what was or was not acceptable wood were lower at Hickory-White so there was no clear line between good and bad wood as there had been at White's, and the ambiguity made it harder to make judgments. Annette has no grounds for comparison since she was hired after the sale, but she knows that the furniture she made was "very expensive," far too expensive for her to even consider owning, but it was also of the highest quality. "It made you feel good, you know, when they said, 'Look at this piece of furniture!' I felt like I was part of cutting the wood to make this furniture. I cut the length of the wood and

made sure the wood was good-quality wood, planed it down to make it smooth, made sure it was glued together right, and all this. See, I was all a part of this, right from a piece of lumber to a piece of furniture, you know, going up the line. I was a big part of that."

Yet, often on the job, she wondered how the company could continue to produce beautiful furniture while pressuring the workers to produce so much so fast. "Sometimes I'd have three or four trucks sitting around me. At other times I had six trucks. You really didn't have time to stop and think about what to do with the wood. When this wood come down, you had to know what you wanted to do with it then because it was coming one right after another."

There were bound to be mistakes. "How you going to put quality and quantity together? You can't do that. I believe this was our problem. A lot of times we got sent home because they were trying to put quality and quantity all in one." Nor was the work speedup detrimental to quality only. "The way they'd be running the wood, you're going to get hurt if you don't watch out."

Even without the speedup, working conditions were harsh, by any standards. In the rough mill the noise was incessant. "The wood would come down to you. You know, they had these doors that went slam, slam, slam. This is all down the line all day. Your saw was making a loud and grinding noise. The wood was coming on the table, hitting the table. That was making noise. Like I said, things started running. It was a real noisy place." And you had to be careful, even with the distractions and the fast pace. "You had to look over your head because of the wood coming down. See, if a piece of that wood had fallen off that conveyor belt up over your head, that could kill you. You had to watch out for that. You had to make sure you didn't get your hand in that conveyor belt coming down that chain to that saw. You had to kind of keep your eyes open and watch out for a lot of things. It was a dangerous place back there." Once she was hurt on the job when a piece of wood kicked back from the saw blade, badly bruising her leg. She iced it down and went back to work.

Working with both black and white workers, Annette insists she encountered relatively little racism in everyday interactions. But there was institutional racism that favored white workers when it came to deciding who would be awarded overtime hours. She was eager to work on Saturdays, but she saw white men and women get Saturday work instead. "That's the only favoritism I seen between the black and white. Everybody was treated about equal." She insists that she never heard any of her black colleagues complain that they weren't allowed to do things

because they were black. At breaks, black and white people sat together, mostly with the same people that they worked with. Even at lunch, she insists, the biggest division was between smokers and nonsmokers, rather than blacks and whites.

Annette's picture of race relations at White's might be a little too rosy. In the photographs it is clear that, most of the time, blacks sat with blacks and whites with whites during lunch hour. Leaving the plant, people also tended to divide up racially. A number of workers who use the word "friend" to describe a work partner of a different race also say that, outside of work, they almost never spent time together. And both black and white employees note that White's was slow to promote blacks to positions of authority. When Annette and other black workers talk about the relatively few incidents of overt racism at White's, it may be that they are simply speaking relative to the more overt racism that prevailed outside the factory. Indisputably, within the plant men and women of different races worked together and came to depend upon and respect one another in the process.

Like the other White workers, Annette heard lots of different and contradictory rumors about why the plant was closing. She heard some people say that the furniture wasn't selling because it was too expensive and there wasn't enough volume in high-end furniture any more—the official explanation offered by Randy Austin at the time of the closing. Others blamed the closing on loss of quality in the furniture and the high rate of returns experienced by Hickory-White. Still others had more global explanations for the failure. When word of the buyout first was announced, rumor had it that the new buyers were Japanese. After the owner turned out to be an American (albeit a "Yankee"), others held on to the "evil alien" idea by insisting that they were being displaced by foreign workers. Since imported furniture grew to almost one-fifth of the U.S. furniture market during the eighties, this explanation was not entirely inaccurate. Annette says that some people even blamed the plant closing on the election of Bill Clinton a few weeks before (an illogical enough explanation but symptomatic of the Republican politics of many of the plant's workers as well as many of the supervisors and the old and new owners).

Annette is not sure which of these explanations to believe, but she is certain that her life changed drastically with the closing of White's. She remembers clearly the day that she was called from her job tailing the ripsaw to hear the announcement that White Furniture Company was closing. "A sadness come over everybody's face like, 'What are we going to do now?'" she says quietly. "You could see the hurt."

There was more camaraderie on the job after the announcement than before. People realized it was all over and they wouldn't be working together any more. "When we heard that we was going to be separated, we got close. Some who wouldn't even take up time with you started talking to you and spending time. It drew us close together when we found out we weren't going to have a job and we were going to be separated."

There was anxiety, too. Echoing a comment made by Don McCall, Annette says that she worried about her coworkers, especially some of the older men in the machine room. "It really bothered me because I'm saying now, what are they going to do, who's going to hire them, what kind of job are they going to do because, you see, they had age on them then, and who's going to hire these people, you know, and give them a job? They were saying the same thing, 'I done put all these years in at this plant and now what am I going to do?'" For herself, she was less worried. "I'm a person, I'm going to work. I always think positive, never think negative. I'm going to work. I'm going to find something to do. I'll survive."

She stayed on at White's almost until the end. After the lumber quit coming through the rough mill, she took it back out of the department to the yard, stacking it there in the same neat piles that it used to be in before it was fed into the plant. In the final days, someone from Southern Electric, a manufacturer of electric motors, came in and showed the White workers a video and said they would take on some of the White workers.[2] Annette filled out one of the applications. She was out in the yard stacking lumber when one of her coworkers came and told her that someone from Southern Electric had just called to offer Annette a job.

She didn't miss even a day's work, moving directly to the new job the next morning, where she worked as a connector, attaching wires to motors. "It was really a mind job," she says, one that required thought and precision under stressful circumstances. It was also extremely physical, requiring lifting of the heavy motors. And it proved to be a demoralizing experience. "I felt good about going to Southern Electric," she says, but "I didn't know I was going into what I was going into."

Of the ten or so White workers who transferred to Southern Electric, Annette was one of only three or four who stayed on for more than a few months. She experienced none of the job pride or camaraderie that she had experienced at White's. "We worked hard at White's. We had to work hard and fast, but it really was a difference. I just really enjoyed my work at White's. I really did. They pushed me at White's, too, but I was working with somebody at White's, you know." Even more demoralizing than the absence of a team effort at Southern Electric was the lack of

autonomy. At White's, "they didn't have nobody standing around watching me, getting on my back that I wasn't moving fast enough or I wasn't doing this fast enough." At Southern Electric, a supervisor stood over the workers, criticizing them. He was "always standing around somewhere watching." He liked to say that he was "weeding his people out."

Annette talks about her experience at Southern Electric with reluctance. The foreman was a white man from Georgia, a real "slave driver," she calls him. Here the racism and sexism were far more overt than they had been at White's, and there is still bitterness in her voice and defiance when she says she stayed on only because "I'm stubborn, bull-headed." Her voice breaks when she says this, belying the toughness and determination of her words. This foreman broke her spirit. "I have seen women cry from where he had put them on tension. He made them cry."

Under stress from his mistreatment, she went to personnel to complain, but they sided with her supervisor. "The same day that I took him to personnel he sat up there and grinned in my face and stuff and talked nice in front of the personnel manager." He denied that he was singling out Annette for harsh treatment, but she knew he would harass her again as soon as she went back to the line. She hated working for him. "I will never forget that man," she says soberly. "When you do your best on the job and then you still got somebody dogging you, it really hurts. And I was that person that was doing my best, but it wasn't good enough."

She worked one-and-a-half shifts, twelve hours at a time, from four in the afternoon until four in the morning. "You stayed that whole night until the first shift come back the next morning. I mean, this is six days a week." Again her voice cracks. "But it just seems like I wouldn't get enough quality work that he wanted."

She kept trying, but her perseverance went unrewarded. After two years, she was laid off right before a paid vacation that was due her. After talking to another girl in another department, she learned that they had done the same thing to her, laid her off right before she was due for her two-week paid vacation.

Annette ended up returning to the same hosiery mill where she had worked before she took her job at White's. "I went back there the same day they laid me off. I always found something to do so I wouldn't have to file for unemployment." But the hosiery factory, too, was beset with economic problems and had to lay off all of its newest employees within months after Annette returned to work there. She immediately went to work at Craftique, another furniture company in the area, where she continues to work now.

Many White workers moved on to Craftique but at reduced wages and with unpredictable hours. For Annette, the change in her earnings was dramatic. Be-

tween 1990 when she started at White's and 1992 when the plant closed, Annette's wages went from $5.50 an hour to $7.25. At Craftique she makes only $6.25 an hour and there are weeks or even whole months when Craftique is on "short time" when she works only half time or less. At White's, she was on short time some weeks, but not nearly as often as at Craftique. And at White's she had a pension plan, insurance, optional dental insurance, and a bonus plan. It was enough to support herself and her kids. Working at Craftique, she had to take on a second job at Burger King to make ends meet. Standing on her feet all night after working hard at the furniture plant all day proved too much. She was forced to quit the second job when her legs began to give out.

"I always have worked to take care of my kids," she says. Yet, in the last two years, no matter how she tries, she has not been able to earn enough money to pay her bills, to keep up with her kids' school expenses or their medical bills. She knew she would have to do something drastic because she "got to where I couldn't sleep at night just trying to figure out how I was going to make it from day to day. Oh, yeah, I went through something." She leaves a long pause. "I would start thinking foolish. I say, you know, it might be best if I wasn't here. I was actually thinking suicide, I was."

She asked Robin Smith, her supervisor at Craftique who had been with her at White's, for advice. He suggested that she file for a Chapter 13 to get rid of the debt hanging over her from the constant layoffs and reduced hours. She went to a lawyer to do the paperwork. "I had to pay him a hundred and eighty dollars, which I did. I had to go to budget meetings. Had to go to court in Greensboro. Had to go up there and get everything set up." A friend warned her that it would be humiliating, "'Annette, they are going to make you feel low,'" but she had no choice. Once she filed, "it actually felt like something rose up off of my chest."

Annette mourns the closing of White Furniture for herself, for her coworkers, and for the town of Mebane. "I think they lost a piece of Mebane when they closed down," she says. She fears that the same thing is happening all over the state, with fewer viable places to work all the time. At Craftique, with shorter and shorter hours, she worries, too. "I'm just thinking, well, maybe they are going to end up closing because of the way they are going. The hours, you can't get no hours. Everything is so slow over there, I'm thinking, they might end up closing." There are even rumors about a new bypass road around downtown Mebane that will run right through where the Craftique plant is now. She says most of the other workers at Craftique don't like to talk about it, but they are worried, too. And there are few other choices. She insists it is much harder to find work today than it was a decade

ago. Even the hosiery mills aren't hiring now. Most of the industrial jobs left are part-time and temporary, where they call workers only as they need them, and pay the lowest salaries they can. "No benefits, no nothing," Annette says. "In temporary, when that company gets through using you up, you know you're going to be the first one they fire, and then here you are without a job." The new industries that are coming into the county seek out younger and more skilled workers than Annette. The only jobs she can count on are at fast-food outlets, paying minimum wage and no benefits.

She has not lost pride in her ability to work, but she wonders how long she will be able to support herself and her family in Mebane. "I have been taught to work for what I want. That's the way I was raised up. No job is never too hard, really. If you really want to work, you can do it, and that's the attitude I go in with." But will and determination don't mean anything if there aren't jobs or if workers don't possess adequate education or vocational skills for the jobs that are available. One of Annette's best friends, Tony G., has just quit working. She has given up. "Said she could make more off welfare than trying to work." There is a tone of resignation in Annette's voice when she says this.

The land around Annette's home is getting more valuable every day. Unfortunately, since her land is co-owned with her brothers, she's not free to sell it. At some point, this situation might resolve itself and Annette will be able to sell, but, right now, she is being squeezed on all sides. It is clear that the local entrepreneurs want her land and they want her out of there. Her old frame house and dusty yard are an embarrassment to the owners of the tidy, brick, suburban tract houses who live just on the other side of the poplar trees.

In the late nineteenth century, new land use laws and land taxes burdened small-scale farmers to the point that many had to sell their land and, eventually, exchange farm life for the factories. This was, after all, part of the design, the drive to industrialize the "New South" in the last decades of the nineteenth century. New companies like White's profited from precisely these laws and conditions. Now Alamance County, where Mebane is located, is again offering tax and other incentives in order to attract new industries to the area, primarily high-tech or so-called clean industries that require a skilled and typically young workforce. Manual laborers like Annette have fewer and fewer places to turn.

She finds the new economics and the middle-class culture of gentrified Mebane overwhelming. She claims taxes have gone up on her property over the years, and she hates the new land use laws that restrict what she can and can't do. "You had a

pile of brush you wanted to burn, you could burn it. Let your dogs, cats run loose. You ain't supposed to have nothing running free. Everything is supposed to be shut up." What was once a rural dirt farm where she could do whatever she wanted is now considered a pocket of poverty, a blight on the newly suburbanized landscape.

She knows some people would call what is happening in Mebane "progress." She is remarkably savvy about how her situation relates to larger economic conditions. And she is sure trouble is brewing. The growth is too fast. Too many people are being displaced. She is worried about her town. Sociologists ask, in more academic terms, the same questions that disturb Annette. What happens to workers after deindustrialization? Can a society exist without a solid, blue-collar economic base? Is unrestricted development good? Do we want a country where affluent people live in class-segregated communities with private security systems or even gates that keep out people who once were responsible workers but who, deprived of their jobs, have joined the growing ranks of the desperate poor?

"Mebane is something now. It is just something," Annette sighs with disgust. "I wonder what my mom and dad would say if they were still living and could see the way things is going now." She is reflective for a moment, almost motionless. When she speaks again, her tone is mournful. "We used to go walking in the woods," she says. "You just can't go nowhere to walk no more. Houses, houses, everywhere."

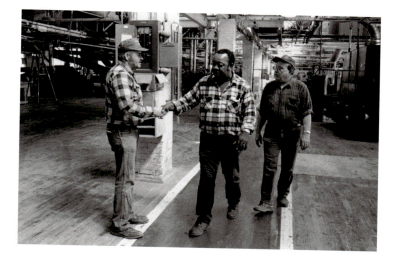

Chapter Six

Robert

John and Coy
with Robert
(center) on
his final day
of work

Robert Riley, former supervisor of the shipping department at White Furniture Company, today works full-time driving a point-to-point van at the University of North Carolina and part-time at the local Wal-Mart.[1] At fifty-nine, he earns less working two jobs than he used to make at White's. Yet he feels lucky to have any work at all. Like Don McCall and Annette Patterson, Robert has been forced to master the logic of labor in the nineties — temp work, underemployment, layoffs, plant closings, job insecurity. He differs from Don and Annette in that these insecurities are new to him. He worked virtually his entire career at White's and he assumed that White's was where his career would end. Instead, he is a man caught in the middle, too old to start a new career, too young to retire.

Born in Mebane in 1937, Robert was determined to succeed despite the reality of being an African American under segregation. He began at White's Hillsborough plant in 1962, "a young man," he says, "and I was aggressive." The jobs, lunch-room, and bathroom facilities were still segregated. "Colored" signs hung over the drinking fountains. He started out as a laborer in the yard, mostly carrying ten- and twelve-foot boards to and from the drying kiln. He worked his way up to become the first African American supervisor at White Furniture Company. "I tried to do them a real good job, and I had pride in myself. They didn't give me

anything. They opened up the door and I got in myself. My work record along with some other things got me in that position. I worked my fanny off."

His pride is clear when he talks about what it took to rise in the company, but he is also quick to give credit to one white man who was willing to take a stand, his supervisor H. Ted Smith. "He believed in an honest day's work. He didn't ask you to do it and he be over yonder on the golf course or somewhere fishing. Nobody put in any more time at our plant than our superintendent. Not only that, he was steadily walking and he was steadily talking. You knew right then where the man was coming from—you don't have to eat a whole cow to know you're eating beef. He was a good, solid, firm, and devoted man. He's one of the greatest men that I've ever worked with."

Robert acknowledges that some of the white employees resented his promotion but says he didn't dwell on that. He knew he was doing a good job, and he knew his supervisor would back him up. "He was such a strong and devoted man that he made it a lot easier for me. He was right there to say, 'Look, anytime you run into a problem, I'm somewhere within hollering distance. I can be there in just a minute or two.' So, you felt like you were always protected."

Like many older employees, Robert prized his personal relationships with other White employees as well as with the company's owners. "I had been working for about twenty-five years with people that I knew. I knew the president. I knew the family." Alarmed to learn of the buyout plans and worried that the anonymous new owner might not keep him on, he was relieved to be retained as supervisor of the shipping department at the Hillsborough plant. But all too soon an even deeper fear was realized when Hickory-White announced it would close the Hillsborough facility. Robert saw the plant through its final days and was among those responsible for shutting it down in 1991. The closing of the Hillsborough factory left him reeling. After he moved to the Mebane plant, he wondered how long it might be before he'd be helping to close down that facility, too.

Working for Hickory-White, he was also perturbed by a variety of changes. Like virtually all of the longtime employees, he hated the new emphasis on quantity over quality. Employee relations, once the hallmark of White Furniture Company, turned sour. The atmosphere at Hickory-White, he says, was charged with anxiety and animosity. When he was demoted from his supervisor's position to a nonsupervisory job in charge of deliveries between the Mebane plant and other facilities in the area, he was almost relieved. Driving the truck gave him a little distance from the pressure-cooker atmosphere building within the plant.

As it turned out, Robert helped dismantle the Mebane plant, too. He worked until April 15, 1993, as part of the skeleton crew responsible for closing down that facility. He was one of the very last workers to leave. Had he quit sooner, he would not have been eligible for the two-week severance package offered to nonsupervisory employees. He broke down the line. He dismantled the machinery, readying it for auction. He cleaned and swept floors in the empty factory. He found the task devastating. "As they were tearing this place apart and selling it off," Robert says, "it was like they were tearing us apart inside and selling us off in pieces."

His words express poignantly what so many White employees felt about their relationship to this company. They viewed the company as an extension of themselves—and vice versa. Closing down the factory, they felt as if their lives were closing down. With the destruction of the forms that had been used to make furniture that was no longer in production, any fantasy that the old White Furniture Company could exist again was destroyed. Overstocked parts such as chair legs or drawers were also burned up. What wasn't useful was discarded—and that's how the workers felt about themselves. "We're talking about people who lost their jobs and had to change their lifestyle, who don't know how the next paycheck is going to come, how the bills are going to be paid."

Losing a job is, in and of itself, a traumatic experience; to watch something you worked for and helped to create be destroyed is completely demoralizing. "I stayed there and saw the furniture move on out. I even helped put the machinery on skids and helped skid it out the back door," he says slowly. "It was like a part of you dying." His melodious voice turns dull—deathlike—when he says this. He is not just speaking metaphorically.

A man of abundant personal warmth and deep wisdom, Robert is a self-described optimist, someone who sees the bad but who prefers to concentrate on the brighter side. But there has been little that is bright in his work life in the time since the closing. He acknowledges that Hickory had good benefits and was fair in crediting people's pension accounts. But he resents the system for allotting pensions. People who had worked ten years or less were given a lump sum at the closing. People who were over sixty-two could collect pension checks immediately. But the pensions of longtime employees like Robert were frozen until they turned sixty-two. With so many workers in this latter category, Robert points out, Hickory-White could keep the pension money, collect interest on it, borrow against it, or invest it elsewhere. Robert wishes he had that prerogative. He is confident of his ability to save and invest and, had he been given his pension money in

a lump sum, he could have profited from this money and possibly avoided the humiliation of working in jobs far below his abilities. "Those that were able to retire, it didn't bother them too much. But, those like me that had been there thirty-one years and had to start all over again . . . " He doesn't finish the thought. "It was an adjustment," he says stoically, "that I never thought I would have to make."

At first he went around to the different corporations in the area seeing what he could find. "Today there are so many people out there looking for jobs. A lot of the places, you don't get any closer than the guard. They don't even take applications. If they need people, they call temporary." A man whose heart and soul are invested in the older values of loyalty and trust, Robert reluctantly acquiesced to the reality of work in the nineties, signing up with a temporary service. "That's how you get in. You have to work something like three to five hundred hours with that service before you can get a permanent job. Some people just get discouraged and tired after working so hard and so long." He despises the whole system of temp labor and the way the temporary firms exploit workers: "They take a percentage of your money for nothing." Yet he is philosophical: "The job market today is a lot different than what it was years ago. It's something that I hope I never have to experience again. You have to be strong."

After working temp jobs for several months, Robert was offered a full-time job in February of 1994. He knows he is more fortunate than most. Five years away from retirement, Robert knows he could be doing worse than driving a van for a large university. Still, there's no security at this job, so he's kept his part-time position maintaining the plants and flowers in the garden department at Wal-Mart, working nights until after the store closes and sometimes on the weekends, too.

A man who has spent his entire life defining himself by his ability to work well and to work hard, Robert did not plan to end his working life like this. He has always believed that virtue is rewarded but working two jobs at age fifty-nine is hardly a just reward for a life of good, loyal, skillful work. An implicit bond has been broken, and something inside Robert has broken, too. The dignity remains, the strength of character and the quick wit, but there is disillusionment just beneath the surface.

His pride now focuses on his home, his garden, and his family. He lives in a frame ranch-style house on a slight hill overlooking Mebane's gently rolling land. The house and yard are immaculate, yet the word that comes to mind first when you see Robert's home is "comfortable." A huge covered deck off the kitchen feels

almost like an outdoor room, with comfy garden chairs, a chaise, a love seat, a table and chairs for outdoor meals. The view from the deck is one of the prettiest in the area, and it is clear the deck was carefully sited not only for the scenery but also to shade out the hot sun while catching the slightest breeze. From the deck, you see the enormous garden that Robert plows, weeds, and plants on his one day off. Beyond the garden, you can watch a bulldozer break ground for the new house where his son and his fiancée will be living soon.

Robert and his wife, Cordelia Bernice, have made a good life for themselves here. He would prefer to emphasize their successes rather than dwell on the fact that he now works jobs that provide neither the monetary rewards nor the pride he had working at White's. Cordelia is more outspoken. A closing affects an entire family, she says. She doesn't like it at all that Robert works a second job. She says that they have always been best friends; they've always been a team. While he worked at White's, she worked a full-time factory job at A. O. Smith, but the time they spent together after their long work days was always precious. Together, they raised two great kids who continue to bring them joy. But now, Cordelia says, when she comes home from her job, she is alone. She wishes Robert would drop the part-time job, but he's afraid to. He knows he has no seniority at his full-time job, no security there, and he knows state universities are all suffering from funding cutbacks these days. He feels he needs the Wal-Mart job as a backup, in case he's suddenly out of full-time work again. He reminds her that he'll be able to retire in just a few years and then they will have more time together. But she is worried about him; she is concerned about what so much toil is costing his health. She looks at him with a mixture of tenderness and anxiety. "He works and works and never stops."

He is uncomfortable focusing on the difficulties of his present life. He is not a man who enjoys the role of victim or martyr. Like other White workers, he idealizes his past life at White's, at least partly because his present work life falls short. He says he meets interesting people driving the van at the university. Just the other day, he met a pilot who offered to take him up in his plane and show him what his house and land look like from the air. Robert even finds satisfactions at the Wal-Mart job, remarking that it calls upon all the knowledge of horticulture that he has gleaned over the years he has cultivated and improved his garden.

What's missing, he says, is that neither of these jobs offers the values that were embodied at White's. And it is these values that he feels are missing in society in general these days. A devoted family man who wanted his children to get ahead in

the world, he was pleased to be able to help both of his kids find summer work at White's when they were growing up because he wanted them to experience the skill, loyalty, and caring that the White workers exemplified. "It was a real good experience for my kids when they were in school to work during the summer months. They kind of enjoyed it. Dusty, but they enjoyed it. I enjoyed them working rather than having them playing in the summertime, too." He feels certain that lessons they learned at White's serve them as adults but is less certain that there are employers out there now who reward these virtues.

He is concerned for this new generation. He knows that what happened at White's is happening everywhere, but he isn't sure that the younger generation understands how much things have changed. For him, the main difference is in who is loyal to whom. In the old system, he insists, the primary relationship was between a worker and an employer; in the new system, it is between a company's management and its shareholders. "The worker is out of the picture now," he says. He also insists that it is the responsibility of people who know the old system to speak up about how things have changed. "We know how things used to be, how they should be. Now we have to figure out where we go from here."

Robert remembers vividly his last day on the job. The last pieces of furniture made at the Mebane plant were the samples for the International Home Furnishings Exhibition at High Point. Ironically, future orders for this furniture would be filled by Hickory-White at their main plant in Hickory, North Carolina. He drove the samples to High Point, unloaded them, and delivered them to the Hickory-White showroom. In High Point, he recognized several people he had worked with at White Furniture Company. "I remember that night as I was pulling out and they all ran out and said, 'Robert, we are going to miss you.' I said, 'Yeah, and I'm going to miss you people, too.' Coming down the road there, it was a beautiful night. I think it was on a Thursday night. I kind of looked up at the stars, and there were just several things going through my mind, you know, when will I be back this way again, will I ever see these same people again?" He pauses a second. "I ain't seen none of those people since I left."

When he reflects back on his life at White's, it is with unalloyed pride. "I can remember, Lord have mercy, when I went to White's I didn't have anything and I don't have anything now, but I was able to pay for my home, and I was able to raise two beautiful children. What little we've got, we got it through White's. Oh, yes,

a lot of beautiful memories. That's what makes it hurt so bad, to see all those beautiful memories come to a screeching halt and they are no more. Some of the best people in the world. That's what makes the memories. There were a lot of good times there."

These memories of the "good old days" all center on the White Furniture Company — not Hickory-White, not White Furniture Company of Mebane, just White's, a symbol as much as a company. "We believed in building the best furniture humans could build — furniture that you'd be proud of forever and a day," he says, his deep, expressive voice filled with company pride but also tinged with regret that comes from knowing that "we" do not exist any more. "I was there when it was all gone," he says of the closing. "I haven't been back. It's nothing but just four walls now."

Like many of the White workers, Robert is sure Hickory bought White's in order to shut it down. "I really think deep down that Hickory had a plan when they bought White's. I think part of the plan was White's old, fine name. They've got it now. You see, that name didn't die when we died. It went on to Hickory."

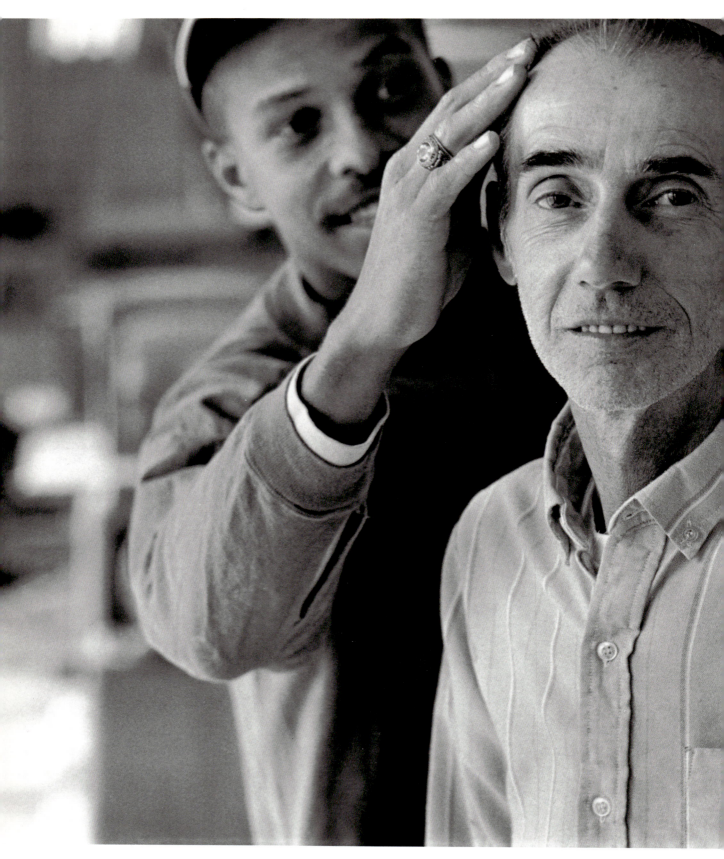

Carlos pretending to fix Little Man's hair
for the photograph

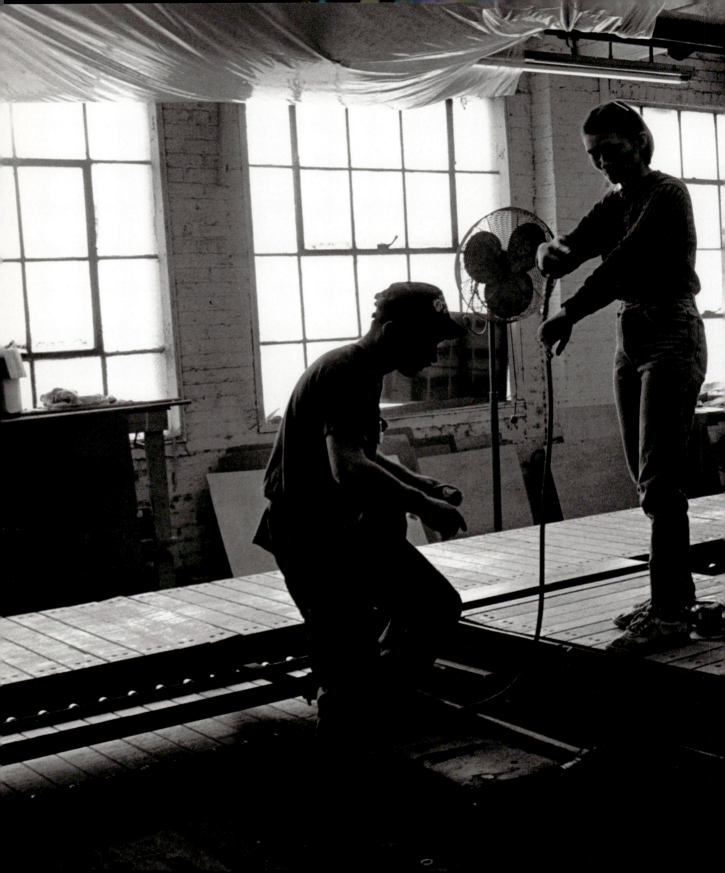

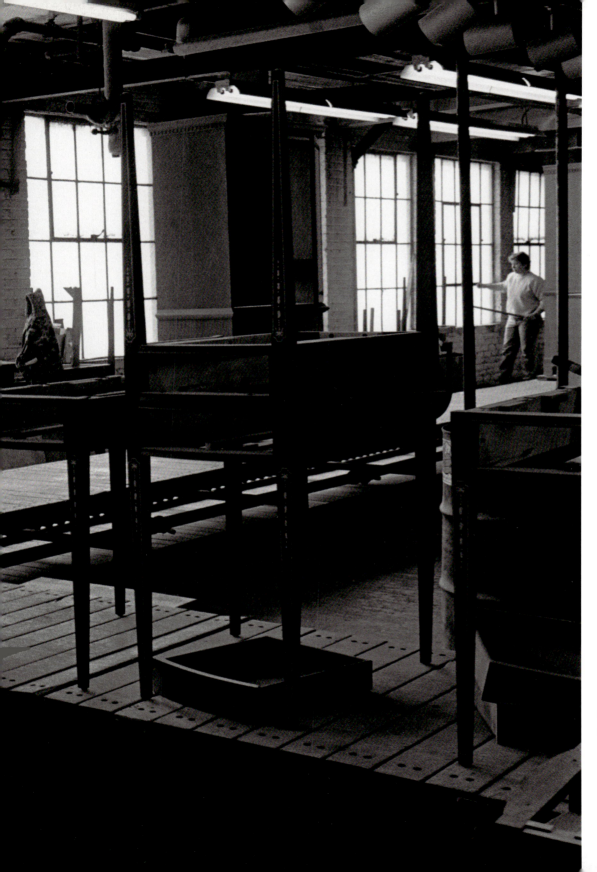

Quitting time,
cabinet room

Smitty and Buck, break time

Above: Possum at home, the summer
after the closing

Opposite: Auctioning cutting blades,
machine room

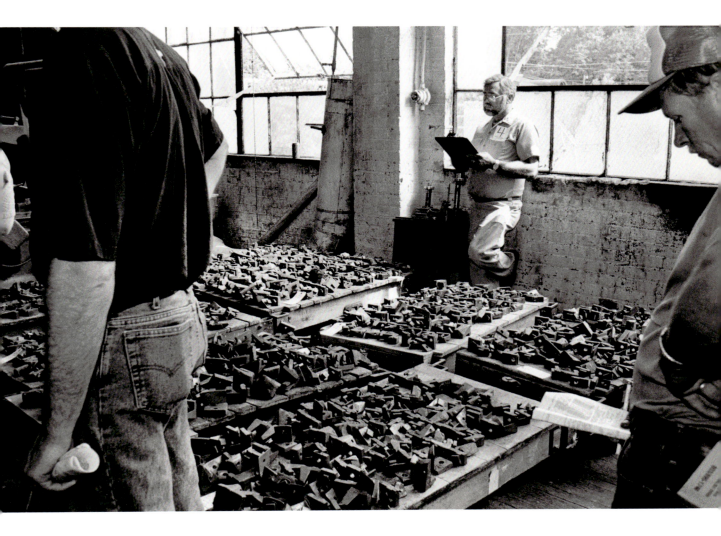

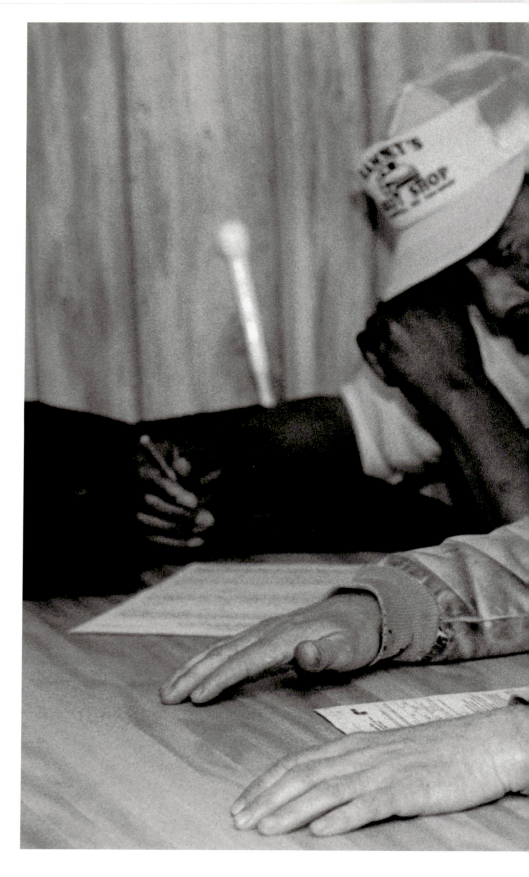

Collie, Carlton, and Linda signing
severance papers

Little Man with his grandson, the summer
after the closing

Overleaf: Avery sweeping the cabinet room
floor on his final day of work

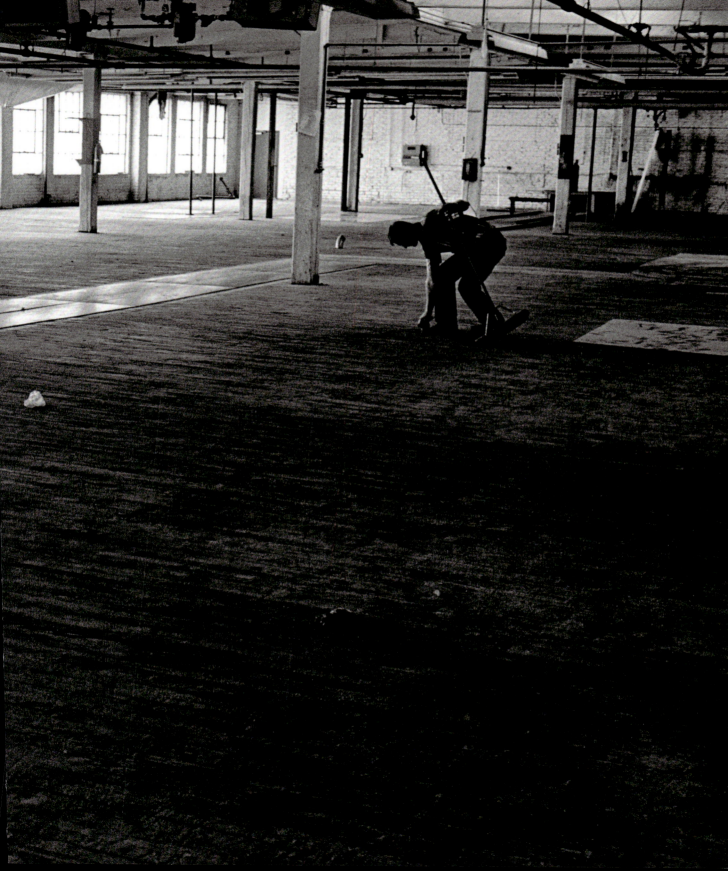

Chapter Seven

Reunion

obert Riley was among the first people Bill Bamberger contacted when he began to plan the Mebane showing of his photographs of the White Furniture Company. For six weeks, seventy-six of Bill's photographs would be on display at the old Jones Department Store in downtown Mebane but, before he opened the exhibit to the public, Bill wanted to hold an event for the former White workers. At a special employees' reception, they could see all the photographs printed and mounted and they would be able to get together as a group for the first time since the closing of the plant.

It was important to Bill that the employees themselves have input into how this reception might work. Robert didn't want his involvement with White Furniture to end with breaking down the plant and was delighted to serve on the planning committee. The photographic exhibit would help the White Furniture Company to live again, at least for a little while.

Four other longtime White employees agreed to join the planning committee: James Blalock, who worked in the sanding department; Fletcher Holmes, from the main office; Vickie Jacobs, representing the rub-and-pack department; and Ronnie Sykes, who had worked in several departments and who ran the stockroom at the time of the closing. Together with Robert, head of shipping, they represented a cross-section of the various departments at White's. They met with Bill, helped plan the employee reception, and helped select which image would be on the

The old Jones Department Store, March 1993

poster for the exhibit that would open officially in Mebane on March 12, 1994. They also worked to get the word out to as many of the former White workers as possible.

There was a groundswell of local support for both the reception and the exhibit as a whole. The owner of the defunct Jones Department Store in the center of downtown, a block from the old White Furniture building, donated the use of the vacant building for the two months the exhibit would run. Bringing the building up to code in time for the opening became a communal project and many people in Mebane pitched in to make it happen. Several local banks gave cash contributions; the town newspaper offered free ads and lots of advance coverage for the exhibit. A lumber company supplied plywood, the gas company ran heat into the building, electricians redid the wiring for the track lighting donated by a local electrical store. For the reception itself, the new McDonald's at the Mebane interchange off I-85 donated biscuits and coffee while Warren's, the venerable old drugstore across the street, offered free ice cream cones from its soda fountain to the former White workers and their families.

One of the former White employees suggested that they hold the reception on a Saturday morning since this would be the best time to guarantee a good showing from factory workers. He was right. Over 130 people—well over half of the work force from the Mebane plant—came to meet one another again and to see Bill's photographs on display. Some workers, like Robert, brought their entire family. Others came straight from work. Craftique Furniture gave several former White workers permission to take an extended break so they could see the exhibit. They came in their Craftique work clothes. Others came on their way to shopping or other Saturday errands, looking crisp and neat in their casual clothes, like people going to a company picnic.

The atmosphere was charged. The moods kept changing. At first, it felt like a reunion. People were excited to see coworkers they hadn't seen in at least a year. There was a lot of laughter. People talked, hugged, exchanged news of where they were working now, what was happening with their families. And, of course, they looked at Bill's photographs. Often people would walk around the handsome gallery space, stopping to admire photographs of themselves and their friends at their old jobs. It was common for two or three people to cluster excitedly around a photograph. "Everybody was in a joyful mood," Annette Patterson remembers. "Everybody was walking around and kids running around, and everybody was

looking at pictures, 'Look over here on the wall. Yeah, that's what we done.'" She felt proud to see herself in the photographs on display, and she was happy to learn that Bill planned to donate a collection of the White photographs to the town of Mebane to be put on permanent display. Some day, she says, when she is an old woman and her little granddaughter is grown and ready to get married, she will bring her to see the photographs and she will say, "*That* was your grandma."

On a table against one wall of the exhibit space sat books of the proofs of Bill's photographs, about three hundred proofs all together. Small crowds formed around these tables, with everyone paging through the books to find themselves and their friends, telling more stories.

Gradually, after the initial excitement of reunion started to subside, a more somber mood settled over the crowd. Emotions that hadn't been visited since the closing were suddenly evoked again, and people began to feel the impact of the photographs of the closing. "It was heart-wrenching," says Margaret Holmes White. "The saddest photograph was Avery Apple's picture when his eyes looked so sad and then the one of the men when they got their pension papers where they looked like they were in a daze. Their faces . . . I remember seeing so many faces. . . . I'm sure mine looked the same way."

People began telling about their last day at White's. Since the layoffs came without warning, with one or two people called away from their department and then presented with severance papers, there had been little opportunity to exchange stories or to bid a formal farewell to the men and women they had worked with, some of them twenty or thirty years. The employees' reception was a reunion but it was also a chance, finally, to say good-bye.

After everyone had an opportunity to meet and talk and see the photographs, there was a prepared program. Kathy Nasstrom, of the Southern Oral History Program at the University of North Carolina, spoke about what it meant to be able to interview the former workers and to record for posterity their words about the daily craft, camaraderie, and community they had experienced at White's. Bill talked about being a photographer during the final months of the company's existence and the warm friendships he had made. Margaret Holmes White recited a brief history of White Furniture Company, resuming her role as spokesperson for Steve and other members of the White family. Her account was solemn, respectful, official. After the desecration of the closing, the reception was an occasion to pay tribute.

The five employees on the planning committee were invited to speak. Vickie Jacobs felt too overcome with emotion to talk. She couldn't be persuaded to change her mind, so it ended up being just the four men, all longtime employees of the company, who paid tribute to what had been White's.

They took turns. One man would move away from the crowd, then walk down the small ramp to the middle of the floor. He would stand there alone, looking out at his former coworkers, and he would speak. No one had notes. Each worker stood and talked, surrounded by photographs of the White factory and the people who worked there, surrounded by the workers themselves, together again. When he finished, there was applause and he would merge back into his place in the crowd, and then the next man would come down the ramp into the center of the room. All around the room, people worked to keep their emotions in check.

When it was Robert Riley's turn, his voice broke, and it was as if everyone had been given permission to feel what they had been holding back. There were quiet tears. People hugged one another. Some of the women clasped hands.

The four workers spoke for everyone present. They celebrated survival and chronicled regret. They rejoiced in this reunion of old friends and yet recognized that this might be the last time they would all be together. They commemorated what White's had meant to the community during its 111-year existence and also, indisputably, realized they were officiating at a memorial service for the company, the town, and the workers.

If the reception had begun as a reunion, it ended as a wake. It was a wake for the old White Furniture Company. It was a wake for the community that had formed within the confines of that enormous building and for the relationships that had been sustained by work and, without the contingency of work, had disappeared, leaving an emptiness.

As happens when referring to the dead, there was sometimes a hesitance to use the proper name of the company, but the "it" was always understood. Sometimes, when a former White worker tried to speak, his statement would be interrupted by an unexpected welling up of emotion and his words would trail off into the air. Everyone in the audience knew how to finish the sentence. Again and again, the workers' speeches bore the contradictory valediction of eulogy—how to move on, how never to forget:

I'm Fletcher Holmes. I was at White's for twenty-nine and a half years. I would like to go back and not just remember the ones that were still here when we shut down, but also the ones that went before us that built White Furniture.

It meant so much to each one of the family members. We considered our self as a family. We worked together, played together, joked together. You know, it's bad to build a house and tear it down, but that's what happened. I felt like in '85 when it changed hands that it was downhill from that point on. It was a bad situation. I hope we've all regrouped and gone on with our lives, that we can look back as old friends and hope we will stay friends forever.

I ride up and down the road now going to work, and I think back, years ago, to the ones that are gone. They meant so much; they thought of that place as their home. And I did, too. It's bad, you drive by it now and you see it down. You've got a thousand people probably affected — families — by that shutdown.

We have regrouped and I just hope everyone moves on with their life and can keep all this in their memory forever.

———

I'm James Blalock. I worked for White's Furniture for thirty-eight years. It was a good place to work, and the hardest thing that I ever done was see friends and ones that you worked with for years and liked to just have fun and joke with . . .

We had our ups and downs. They were good times and they were sometimes bad times. I just thank the company that I worked for.

I enjoyed working there, and I just hated to see it close down, but I know it happened and we had to accept it and make the best of it. Thank you.

———

Hey, I'm Ronnie Sykes for those of you who don't know me. I worked at the Hillsborough plant the majority of the time, twenty-seven years. Transferred to Mebane when it closed at Hillsborough.

I want to tell you about when I first started to work. In 1966, when I had graduated from high school, I went to the Hillsborough plant and talked to Mr. Ted Smith about a job. Of course, he said nothing was available. So I went back out and started doing summer work. Two or three months later I was going back through there so I stopped again. And sure enough, Mr. Ted Smith said there was an opening and if I would come back after July 4th, that he would put me to work. So one of two things happened, and Mr. Bob Riley will tell you the same thing — it was

somebody had died or somebody had retired. You were real fortunate if you got a job there. It was great to work there the many years that I did.

There were some wonderful people to work with. It was like a family. All those years that I worked there, the skills that I learned which you wouldn't learn anywhere else, making furniture.

All of us who have gone our separate ways now, well, it's like night and day because most of us are doing something entirely different. What I am doing now is nothing compared to what I used to do.

White Furniture Company will never be dead so long as we have children who have children. You take my son. A lot of things I do at home when I'm working around in my little shop, I do as he's around. I'll show him whether it's a different kind of wood or whether it's maybe boring a hole in cherry that's very brittle and will break unless you bore a hole before you put a screw in it. That my son learns. He knows how to sand with the grain of the wood, and so long as he's alive he can pass that on to his children. White's will always be alive so long as there are people around in this area. Wherever we go, whatever we do, White's will never be dead.

It's just very emotional now just to . . .

You want to put things behind you but being here today and seeing all of you . . .

It is just wonderful to see you again. It's very emotional, but you try to put things like this behind you and go on with your life, like Fletcher said. But it's great to have had that experience to work with you, and I've enjoyed every minute of it. I hope that we will be friends for all the rest of our lives. Thank you.

———

For you that don't know me, I am Robert Riley. I worked at White's for thirty-one years. Over the years I've met a lot of fine people there. I look at all these beautiful pictures here . . .

Isn't it amazing what you can do with a tree?

White's closing to me is kind of like a little poem I heard one time. It was a son and his father having a kind of a contest. The father said to his son, "I'm going out to the barn and I'm going to tack a nail up on the left side for every good deed that you do, and I'm also going to tack a nail up on the right side for every bad deed. In thirty days we will come back and we will weigh those deeds." So in thirty days they went back and, of course, the good deeds outweighed the bad deeds. So the son says to his father, "We'll pull those nails out." So the father took his hammer

and he pulled all the nails out and he said, "Son, now the nails are gone, but the marks are still there."

As I watched Bill Bamberger go through that plant taking picture after picture . . .

Watching that plant being disassembled and the machinery going on out the door . . .

It's long dormant, but the memories are still there.

So the closing is bittersweet. The bitter: I lost my job, and I had to start all over again. But the sweet: I thank God for allowing me to work with such beautiful people as you.

Thank you.

Epilogue

Does Anybody in America *Make* Anything Anymore?

After it was over, James Blalock said that, except for his wedding day, the employees' reception was the single most memorable day of his life. He wasn't alone. By the time the photographs came down from the old Jones Department Store on April 23, 1994, some fourteen hundred people had seen the exhibit. Some of the workers came several times, returning with family and friends. One day, when Bill was looking over the guest book to check who had been through the exhibit recently, he saw the shaky signature of Phonse Bean, the crusty but respected supervisor who, back in the fifties, was notorious for giving raises as low as a penny. Eighty-five years of age and infirm, he hadn't been outside his nursing home for years. No one could believe Phonse had really been there.

Not everyone liked the show. Randy Austin, CEO of Hickory-White Corporation, was invited but decided not to come. He had given Bill permission to photograph the historic plant because he thought it would be good for the community to have documentation of the old-time White workers at their jobs. But when he read and heard about the exhibit in the local media, he felt betrayed and angry. Although he was not named anywhere in the exhibit, he felt as if, implicitly, he were being cast as the villain of the story.

Mike Robinson, CFO at Hickory-White, came to the show but ended up feeling the same way. He thought of himself as a good guy. By his account, White Furniture would have gone belly-up if it hadn't been bought out by Hickory at the eleventh hour. Bankrupt, White's wouldn't have been able to pay pensions to any of those

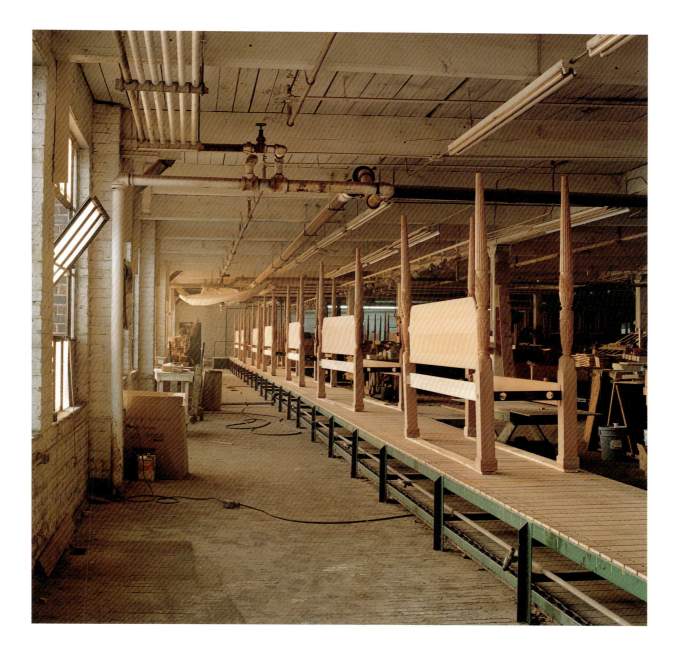

Poster beds, cabinet room

longtime workers. Instead, they all got raises as well as pensions and benefits — better ones than White paid; under his direction, salary inequities were remedied. The company had to be closed for the greater good of the entire Hickory-White operation, he felt, but everyone was treated decently at the closing. He came to the employees' opening, expecting to see beautiful photographs of a fine old plant. Instead, he felt as if he were being indicted. He turned around and left.

Robin Hart, president of the Mebane plant under Hickory-White, came, too. Now living in Tennessee, he was passing through Mebane on his way somewhere else and happened upon the announcement for the show. He called Bill to ask if he could see the photographs. Bill was happy to take him around the old Jones Department Store. Although many people wanted to cast Robin as the bad guy, Bill felt grateful to Robin for allowing him to photograph anywhere he wanted, including at the meeting where the severance papers were handed out. It was an emotional encounter. Robin was voluble at first, stopping at each photograph, reminiscing about each of the workers. As they came to the photographs of the closing, Robin grew quiet. He completed the viewing saying barely a word and then left.

In some ways, these reactions are as telling as the orations by the former White employees at the reception. For they also underscore the conflict that middle managers and even corporate executives find themselves in. CEOs are typically rewarded with handsome bonuses for cutting costs — but cutting costs means laying people off. Of course there are rare individuals who take pleasure in firing people (just as there are murderers or cheats); but, for most, there is no joy in putting a hundred or a thousand or forty thousand people out of work.

Recently, an officer at my local branch bank waved me aside. She knew I was working on a book about the demise of the White Furniture Factory and wondered if I had watched a documentary that had aired the previous night on public television. She said it was about the state of corporate America.

"These executives kept talking about 'downsizing,' but what they were really talking about is making more and more money by getting rid of more and more people like us," she said. "They talked like we were expendable. My husband and I kept saying that's it, that's how we feel. Expendable."

Helen told me that, whenever her bank needs the capital to buy out another bank, dozens and sometimes hundreds of the lowest paid workers lose their jobs.

"They call it mergers and acquisitions," the banker insisted, "but it's really arrogance and greed."

She waved a hand at the piles of paperwork on her desk and on the credenza behind her. Her assistant was laid off six months ago, during the last corporate acquisition. Instead of getting a replacement, Helen must go to "retreats" and seminars with "motivational experts" who teach her how to do her job faster and better.

"I'm fifty-five," she sighed. "Who knows? Next time, it might be my job they're after."

Margaret Holmes White, James Gilland, Don McCall, Annette Patterson, and Robert Riley worked in a factory, not a bank. Yet Helen shares their acute sense of economic uncertainty, their perception that an era of job security and stability is now gone, and their belief that the values they brought to the workforce are no longer prized or rewarded. "No one's loyal anymore, none of these kids who work here now. But why should they be? The bank's not loyal to them either."

By now, more and more of us have had experiences like those described by Helen or the White workers. We have also read the stunning statistics about the economic changes that have happened in America in the last twenty years, especially statistics that document the shrinking of what used to be called the "middle class."[1] From 1979 to 1995, the salary of the median American worker actually dropped 4.6 percent, from $25,896 to $24,700 annually. By contrast, the rich have prospered over the last twenty years—and the very rich have prospered handsomely. According to figures from the Congressional Budget Office, between 1977 and 1989 the top 1 percent of families in the United States had an increase in income of 78 percent. Whereas in 1972, a typical CEO earned 40 times as much as a typical worker, now that figure is 190 times as much.[2] To cite one particularly galling example: AT&T chairman Robert Allen earned $5.2 million in salary and bonuses in 1995—the same year he laid off forty thousand workers.[3]

The prosperity of the super-rich is also mind-boggling in absolute terms: in 1994, the average annual compensation for a CEO in America's four hundred largest corporations was $3.7 million.[4] The middle class shrinks while the gap between America's richest and poorest citizens widens every year.[5] Yet even with such evidence abundant around us, many Americans were shocked when a recent study revealed that the United States now has the biggest disparity between its richest and poorest citizens of any industrialized nation on the globe.

What puzzles people most is how senseless the economy seems from any point of view other than that of the very rich. "Signs of Unexpected Growth Send Markets Tumbling," reads a 1996 *New York Times* headline.[6] The economy booms,

the stock market falters. Productivity rises, wages fall. During the same twenty-year period that the rich got richer, 43 million jobs were eliminated in the United States.[7] Many of these layoffs came from major corporations that merged with other large companies, then scanned their ranks for "redundancy."[8] Megacorporations eliminated smaller competitors by gobbling them up. Or corporations laid off their own employees and then "outsourced" their jobs, contracting work out to smaller companies which hired and fired workers on a per-job basis, often at reduced wages or with no benefits at all. New technologies rendered the skills of countless American workers obsolete while manufacturing jobs went offshore.[9] In 1950, half of the American workforce was employed in the manufacturing sector of the economy. In 1990, manufacturing only employed 20 percent of Americans while service jobs increased to 70 percent of all American employment over the same period. Who gets left out of the picture in the change from an industrial to a service economy? And can a society survive simply by circulating information and servicing people rich enough to afford it? Does anybody in America *make* anything any more?

Despite the fact that other companies paid better, workers stayed at White's out of some combination of job satisfaction, friendship, loyalty, desire for security, and personal pride of craft. To use a formulation that is typically reserved for middle-class rather than for blue-collar workers, they chose to stay at White's because it was a career, not just a job. White's wasn't perfect, and none of the workers says it was. Yet metaphors of death run through the comments so many of the workers make about the closing precisely because people felt that something of themselves died when White Furniture closed.

We are in an era of disposable work and disposable workers. In 1985, when the shareholders feared that White Furniture Company was in trouble, they were able to sell the company for $5.1 million. There was no debt on the factory. There was an enormous stockpile of wood and other raw materials, an inventory of furniture, a backlog of orders. Equally important, there was a 104-year reputation for quality and a workforce where morale was high and craftsmanship and loyalty were palpable.

In 1992, when Hickory-White announced the closing of the Mebane plant, the inventory had been sold, the materials used up. The company's assets had been

used as collateral for loans, and White's reputation as a maker of fine furniture was tarnished. Instead of being a valuable asset that could be sold, the plant that had once been the "White Furniture Company" was simply shut down. The high costs of closing the plant were written off, and by 1992 White Furniture Company had become an entry in the debit column. There was nothing left to sell.

This stark comparison between White's before and after the buyout makes clear the different theories of capital underlying traditional versus new modes of industrialism. While there have always been ways to make money by losing it and ways to buy out and then bankrupt one's competitors, the massive move toward industrial globalization and deregulation in the eighties has made the White story a commonplace of American life. Every worker on the line at White's knew of other stories parallel to White's. This is one reason why it was widely assumed that Clyde Engle bought White Furniture with the intention of closing it down. But if Engle hadn't purchased White's, someone else would have, and the company would have been vulnerable to the same fate.

Engle, ultimately, is a symptom, not the problem itself. A better way of thinking about the whole issue is to ask if the contemporary system of leveraged buyouts works in the long run and, if so, at what costs and to whom. In other words, tax codes and lending practices all favor the big company buying up a small, solid, stable company and then borrowing heavily against its assets and using that borrowed money to invest in more lucrative enterprises, which themselves might be thriving on borrowed funds. In this scenario, the health of the small, stable company is not the major issue. Capital is the issue. If White's had done well, if under new management and with updated machinery, it had turned a profit and been competitive in the furniture business, it would probably exist today. When it continued to flag, when the furniture business continued to yield only modest returns, saving White Furniture was no one's chief priority. It was a loss on the complicated corporate ledger of Sunstates, and it made excellent business sense to get rid of it.

Would White Furniture exist today if Martin Eakes's Self-Help organization had been able to orchestrate an employee buyout? That question is wholly undecided but, assuming competent leadership, it is safe to say that White's would have had a better chance as an employee-run firm than as part of a larger conglomerate—if for no other reason that its existence would have been the primary focus of its owner/employees.

Shareholders want profits. They do not care about tradition, loyalty, or, indeed, other people's jobs. This is true of the large brokers who deal in millions of shares

at a time. But it is also true of small-scale stockholders, including most middle-class Americans who own stocks privately or who participate in pension or other financial plans where their funds are invested in the market. Given the abstractness of an annual report or the daily Dow Jones averages, it is all too easy to forget the human cost of one's rising dividends and all too tempting to focus on short-term gains rather than long-range planning. This may be why a number of important economists today are looking nostalgically to the family-owned business or the employee-owned business as a way to stabilize a particularly volatile market. The dramatic turnaround of United Airlines after an employee buyout is one example, as is the long-standing profit-sharing operation of Motorola. These companies show that it is possible to do good business while also upholding the basic principle of worker productivity rewarded by worker wages.

The success of such ventures restores something to the nation's sense of itself. So do stories like that of Aaron Mordecai Feuerstein, who became a national hero when he decided to rebuild the ninety-year-old Malden Mills textile factory after it burned to the ground on December 11, 1995. The company, begun ninety years ago by Feuerstein's grandfather, employed nearly 2,300 workers in an economically beleaguered area of Massachusetts dotted with abandoned mills.[10] Sixty-nine years old at the time of the fire, Feuerstein could have simply retired. Instead, he rebuilt the plant while paying the salaries and benefits of Malden Mills's employees for two months while the plant was shut down.

When sixty-seven-year-old Will White rebuilt White Furniture Company after a fire in 1923, he was a local hero—but it was hardly national news. Feuerstein's actions have resulted in a flood of letters, contributions of hundreds of thousands of dollars for the idled workers, and accolades from the president of the United States on down. A notably tough businessman, Feuerstein had pulled his company back from the edge of bankruptcy in the treacherous 1980s by switching from conventional textiles to producing Polartec, a high-tech, high-quality polyester fleece, some lines of which are made from recycled plastics. He has kept up with the times, yet the description that continually emerges in media accounts is "throwback." He is compared to business managers of thirty or forty years ago because he believes in a philosophy that now seems almost quaint: "If you pay people a fair amount of money, and give them good benefits to take care of their families, they will produce for you."[11]

Steve White, too, was a local hero. He tried to save the company. He treated workers decently and respectfully. When he passed away, on September 29, 1995,

the entire community mourned. The mayor came to the wake as did other civic leaders from the area. And, of course, dozens and dozens of former White employees came to commemorate the man who, more than any other, represented the old White Furniture Company. They stood solemnly in line, and extended their condolences to the members of the White family. Over and over, they used the same formulation: "My name is ——. I worked at White's for —— years. Your granddaddy was a good man." They wore their employee pins. Some people wore several pins—five years, ten, twenty, thirty. They paid their last respects to Steve, who was buried wearing his fifty-year White Furniture Company employee pin.

In June of 1996, three years after Hickory-White Corporation closed down the old White Furniture factory in Mebane, a rumor began to spread around the town. Paul Hunter, owner of the Deluxe Barbershop one block from the old White Furniture Company, was one of the first to hear the news. He told James Gilland, the retired White upholstery supervisor, and a few other of the White old-timers. After that, word spread more quickly through Mebane: Hickory-White Corporation itself was now up for sale.

In a corporate climate where the big fish eats the little fish, there's always a bigger fish. But there is no satisfaction in knowing that the company that shut down White's is now for sale. Over five hundred workers at the Hickory plant now face uncertainty and, possibly, unemployment. There is also a fear more directly relevant to the White workers, many of whom are concerned about the fate of their pensions. If Hickory-White does not find a buyer, if it should declare bankruptcy, what will happen to the pensions owed to longtime White employees like Margaret, James, and Robert?

Ironically, among those whose future is now uncertain is Randy Austin himself. He insisted that he closed down White Furniture Company in order to save Hickory-White Corporation: "destroying the village to save it," is the Vietnam-era metaphor he used. Like many in the business community, Randy respected the quality and camaraderie at White's but thought, from a business point of view, that the company was a dinosaur, an anachronism from a past that can no longer exist.[12] But is this true? Obviously the lean, mean new way of operating—buying out, merging, closing down—did not save Hickory-White Corporation either.

Certainly the sale of Hickory should make us wonder if the new way of doing things is necessarily the best, even in purely corporate terms. And in larger social,

moral, and psychological terms, the implications are enormous. Does one have to sell the plant—or one's soul—in order to survive? Is there a way to thrive in the contemporary world and still hold to values of loyalty, trust, excellence, quality, and honesty? If not, then we have lost far more than White Furniture Company.

For over a hundred years, the fate of White Furniture Company marked the fate of Mebane. In the 1990s, this is no longer the case. White Furniture is closed. Mebane is doing just fine. It is a town in process, a town with prospects. In the new service and information economy of the 1990s, Mebane is becoming a bedroom community to Raleigh, Durham, and Research Triangle Park—affluent areas in North Carolina that themselves sprawl along I-85 and I-40, like suburbs to a city that doesn't exist. Smart buyers from nearby cities are snatching up real estate, banking on Mebane's investment potential. New residential developments are springing up on the outskirts of town, including an affluent new community stretched along a well-manicured golf course where there used to be tobacco fields and second-growth pine, hickory, and beech forests. The former White Furniture Company has been purchased by a new owner who appreciates the building's historical value and who hopes to renovate it someday. It is mostly a warehouse now, but a few local businesses are already moving in. The ivy has been trimmed back from around the windows; sometimes one sees trucks at the old loading dock. There are hopes that some day the enormous factory building— 240,000 square feet, an entire city block—might be turned into a mall with shops, offices, residences, perhaps even a museum.

But that's for the future. Now, the old White sign hangs above the entrance— an artifact, a memory, a symbol of what has passed. The building remains, but White Furniture Company is gone. For the former White workers, for anyone who has lived long in Mebane, there's no missing the silence at the center of town.

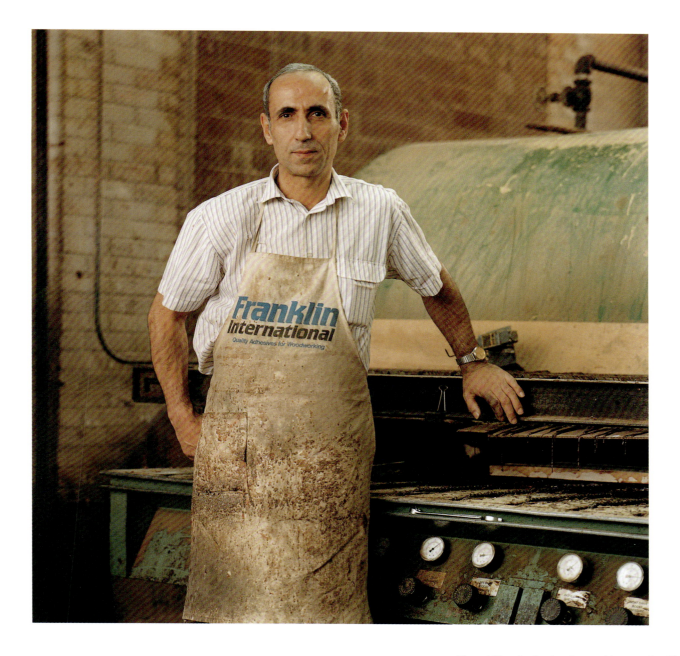

Manuel Carreiro by the glue machine, rough mill

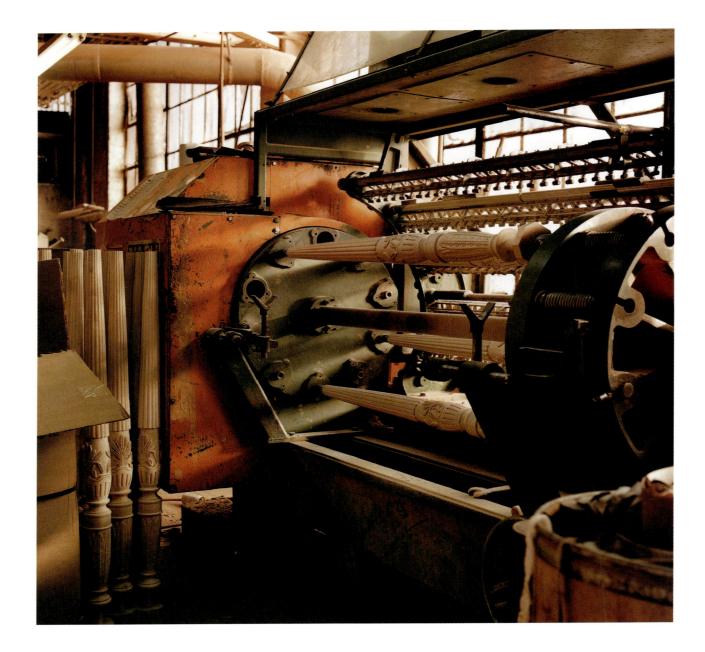

Post sander, machine room

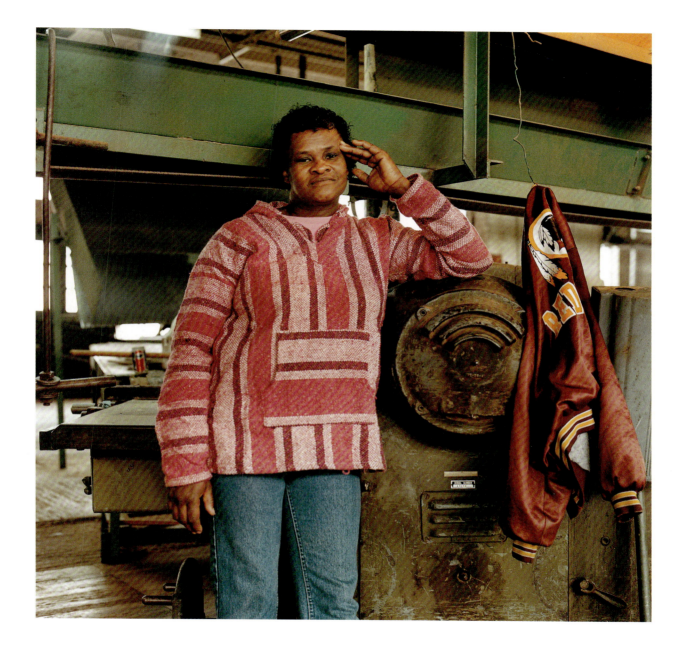

Annette Patterson, rough mill

The rough mill, early morning

The glue machine, rough mill

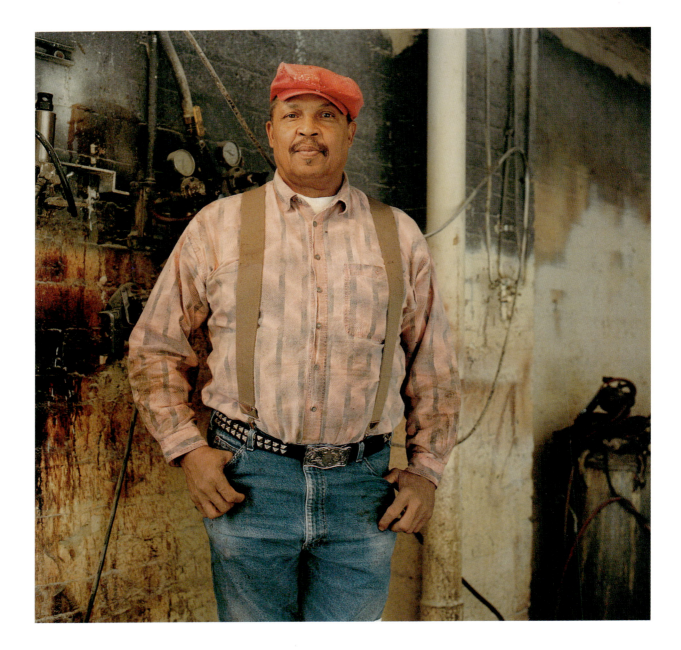

Andrew Badgett in the spray booth, finishing department

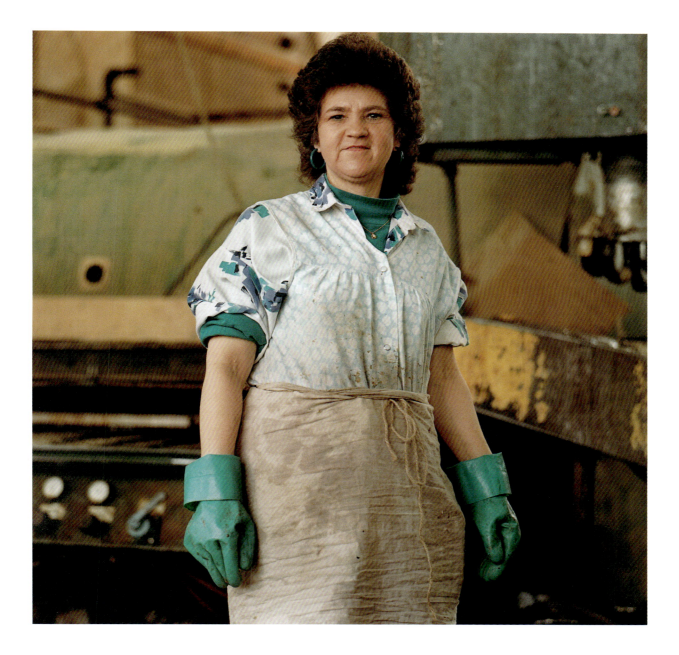

Mary Bumgarner, rough mill

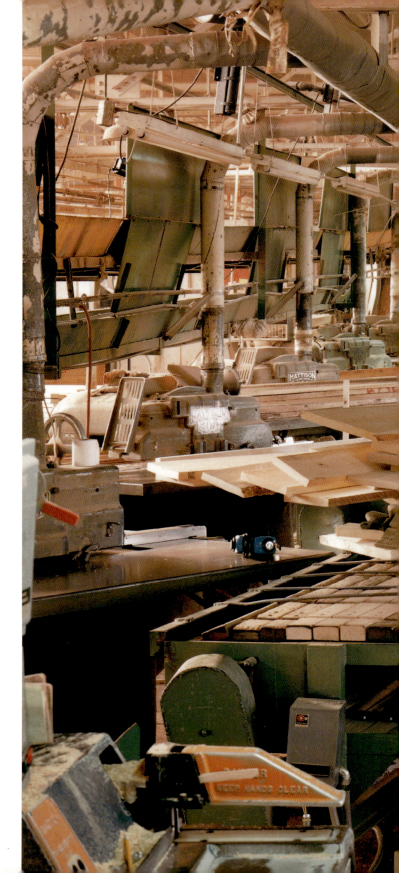

The line, rough mill

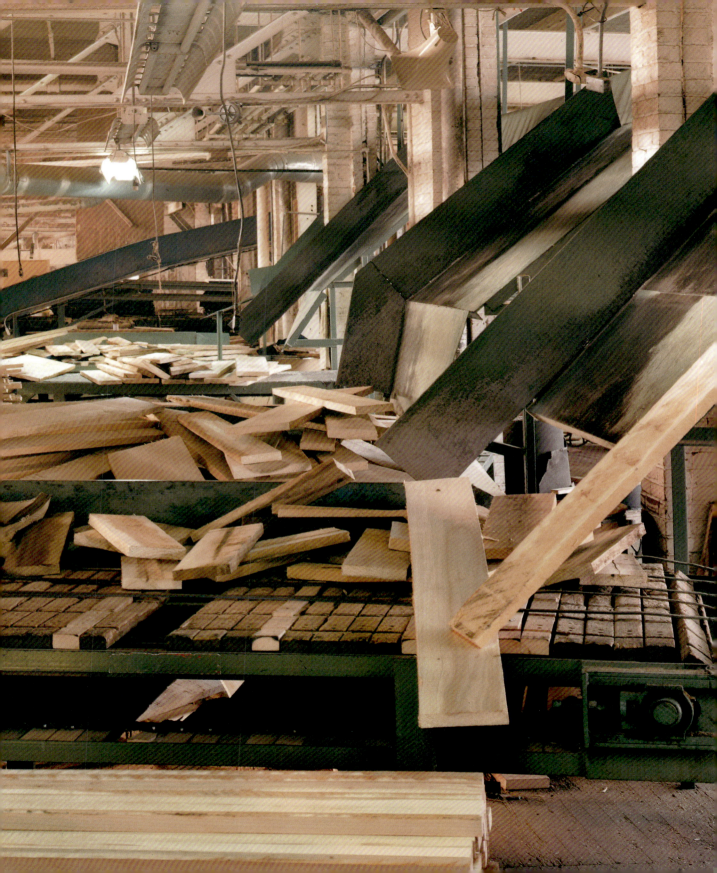

Hilario Maldonado by the glue press, rough mill

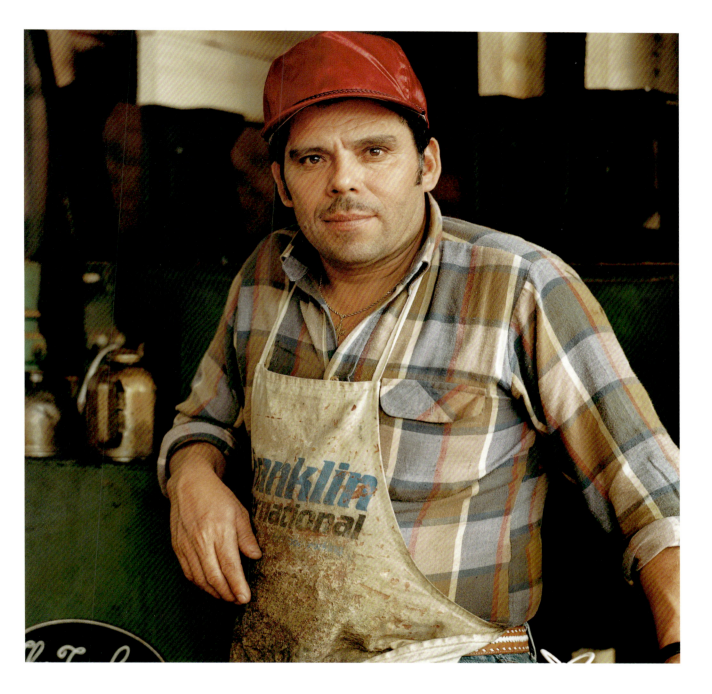

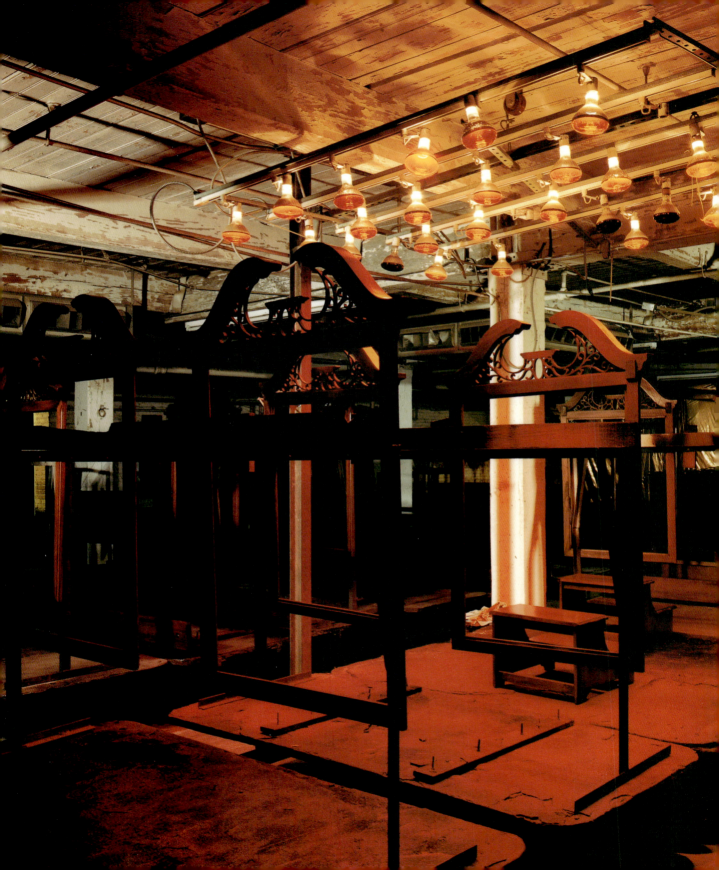

Heat lamps, finishing department

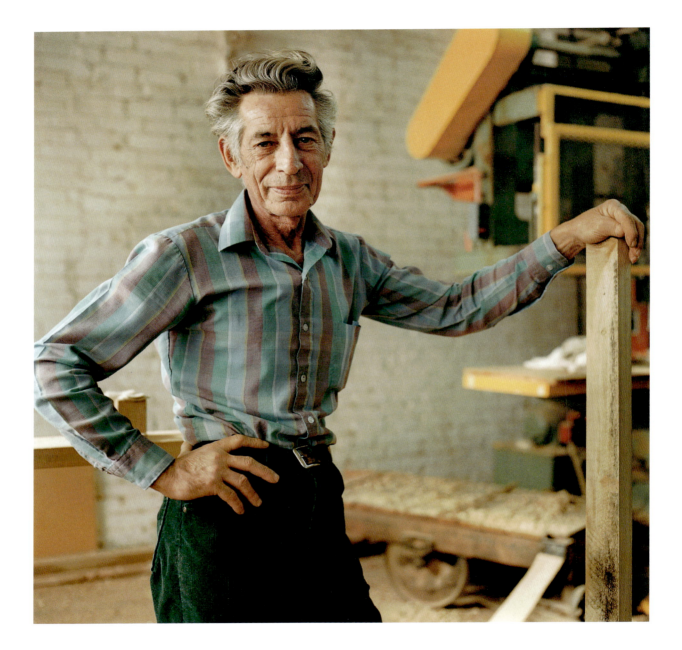

"Smokey" Mitchell, machine room

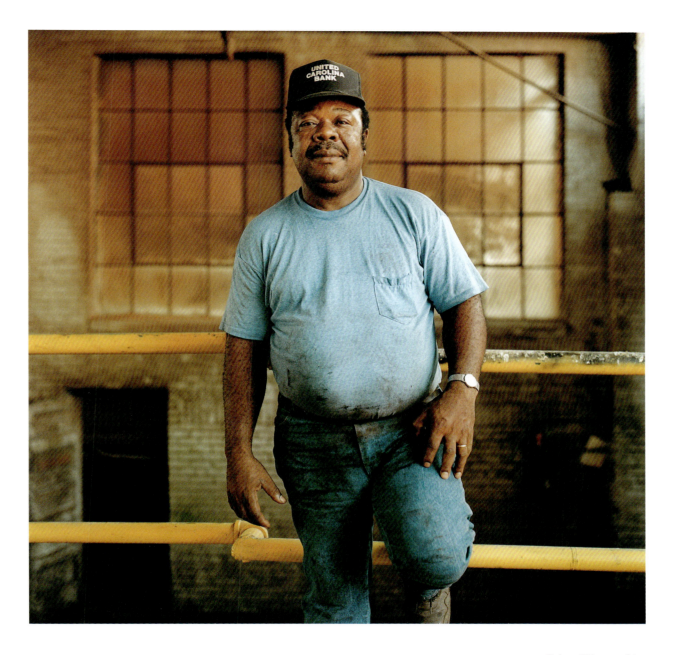

Robert Riley, machine room

Dust-collecting towers

Willie Toran in the yard

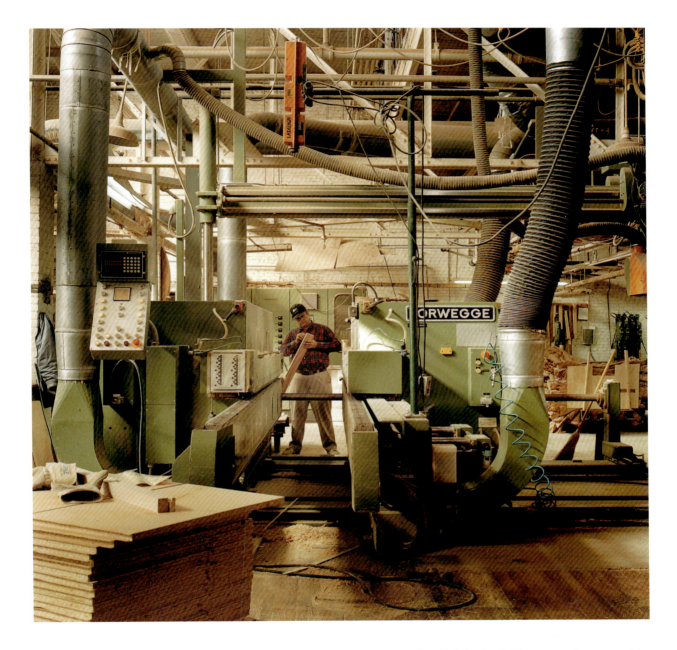

Ronald Parker by the Torwegge end-cutter, machine room

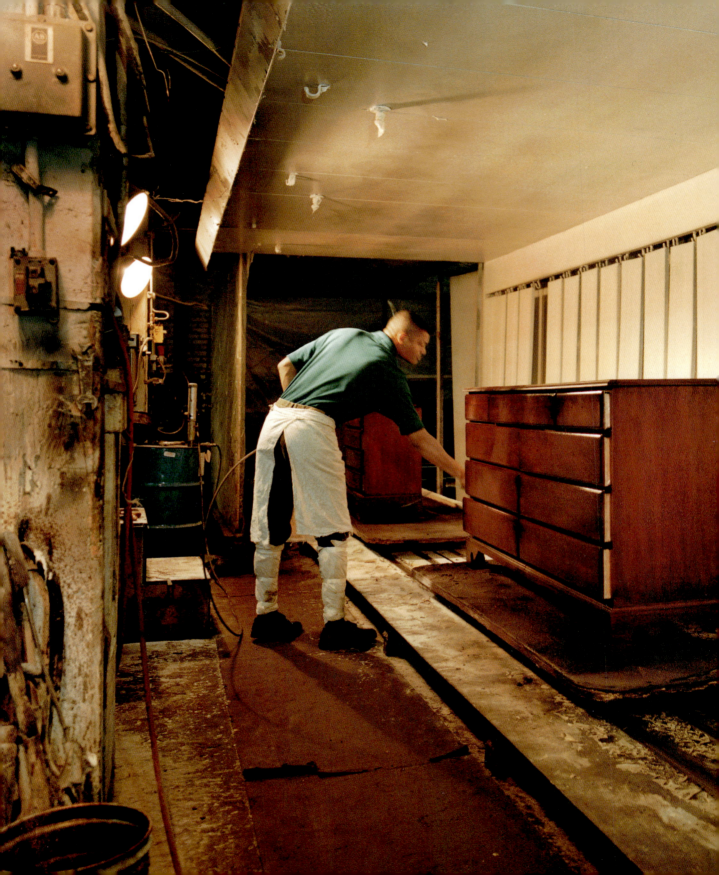

Tyrone Whitfield finishing a dresser

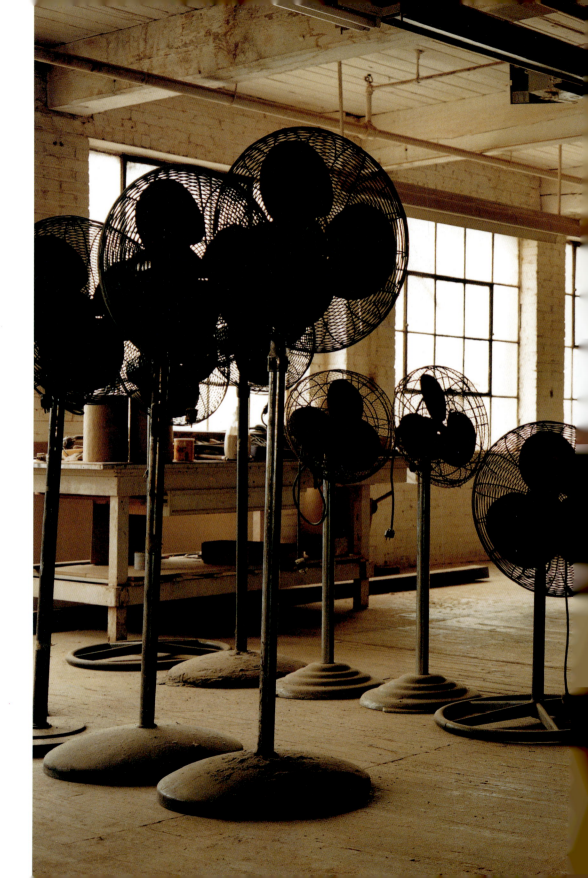

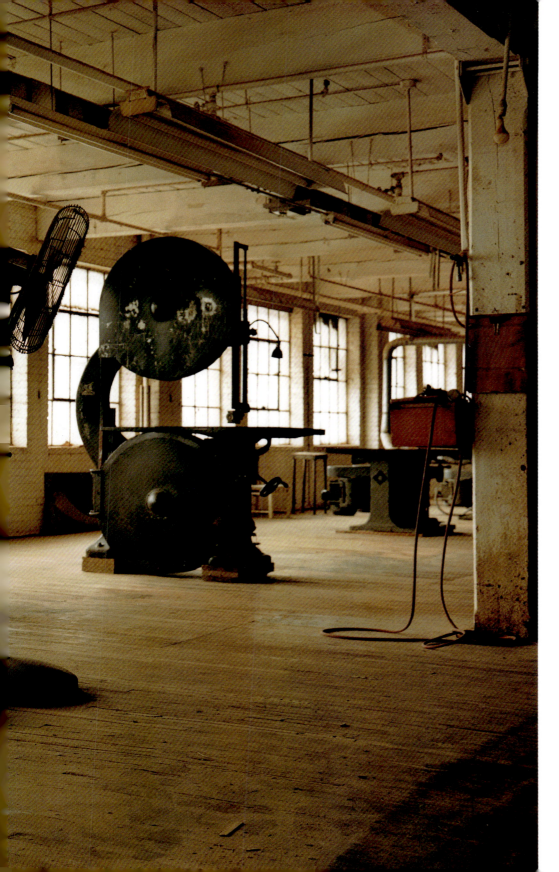

Fans gathered for auction

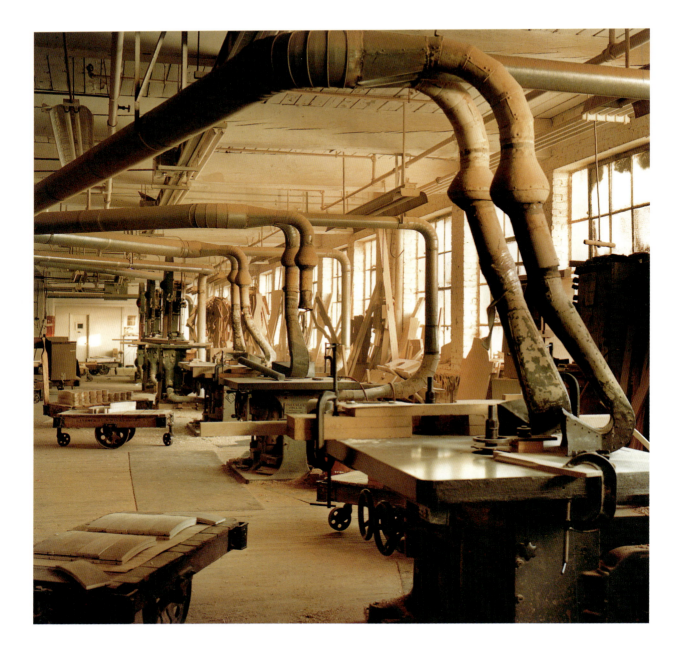

The machine room

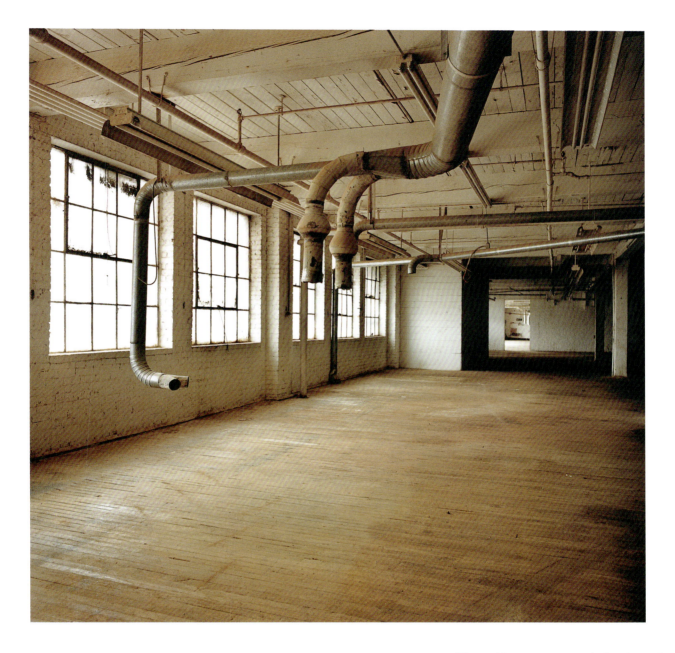

The machine room, one month after the auction

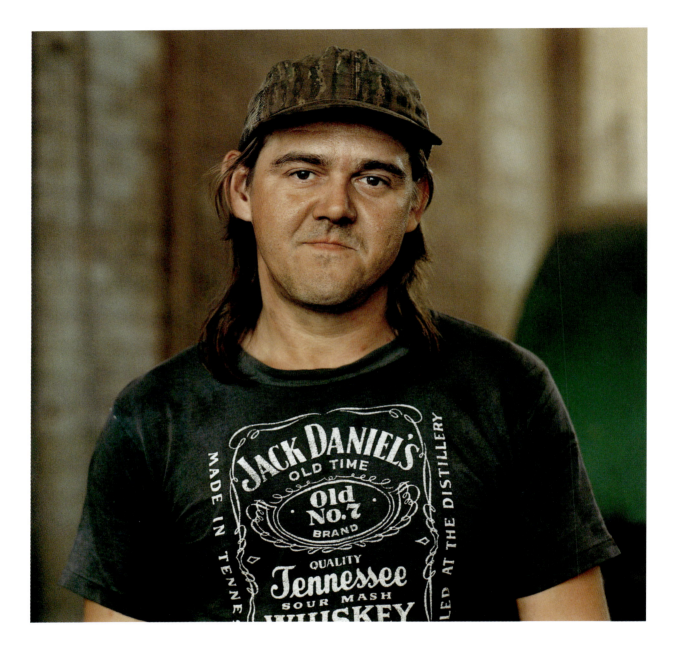

Jimmy Gross on his final day of work

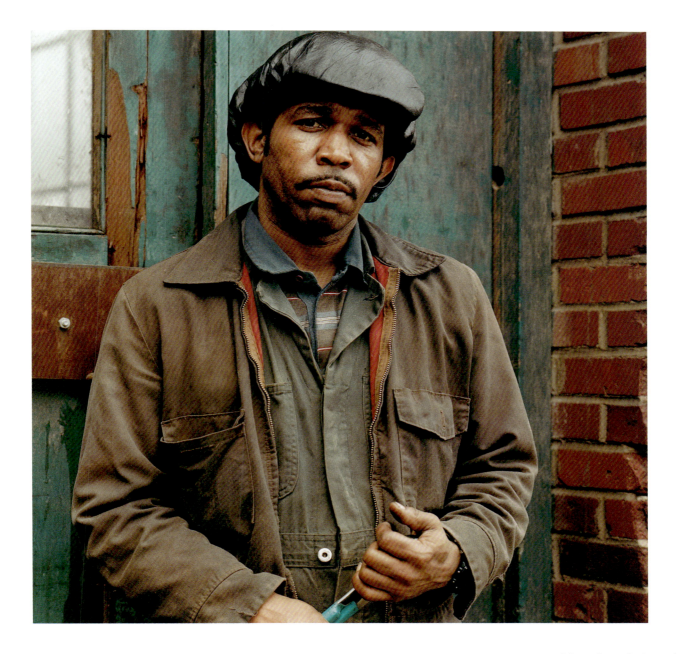

Johnny Swann in the yard

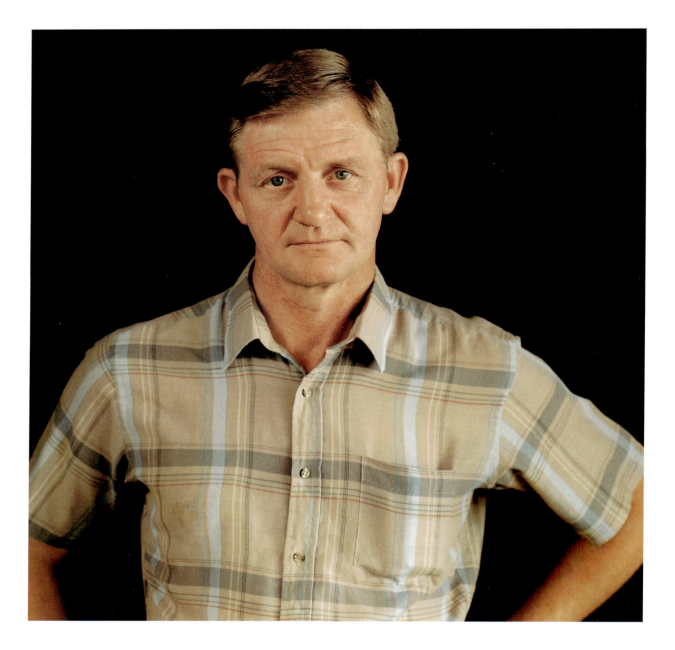

Avery Apple

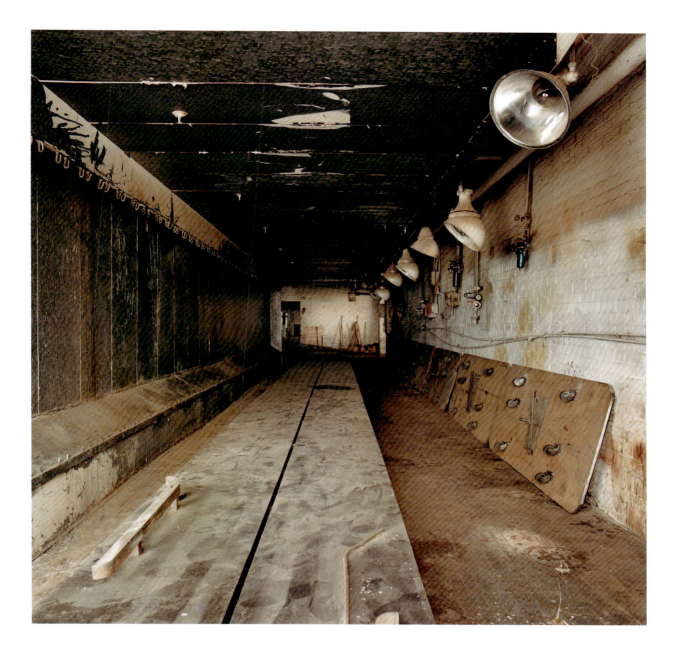

Conveyors in the finishing department, one month after the auction

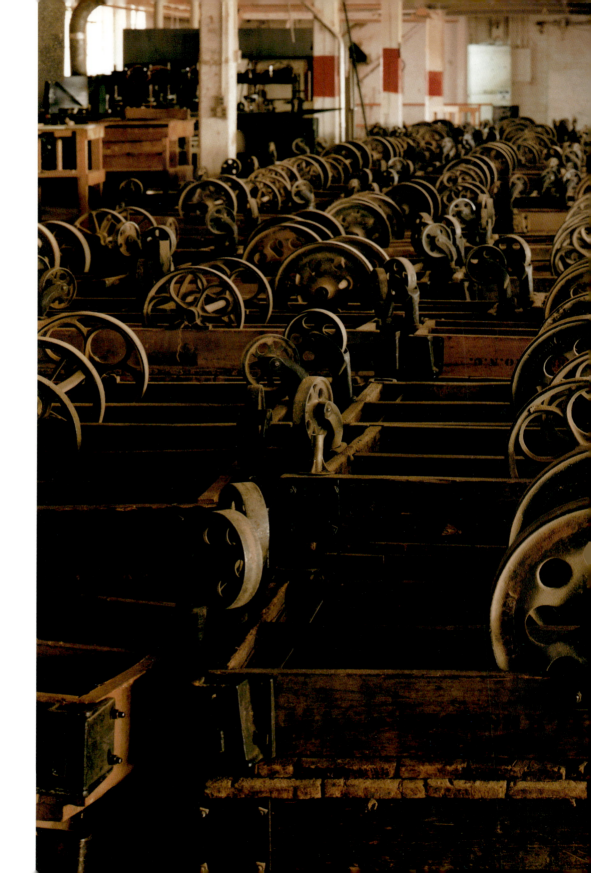

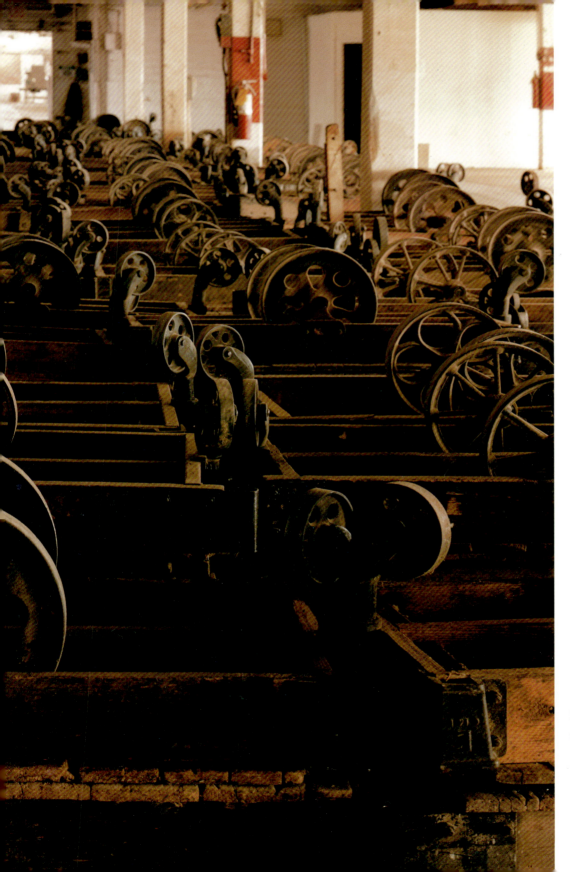

Furniture carts stacked
for auction

James Malone on his final day of work, sanding room

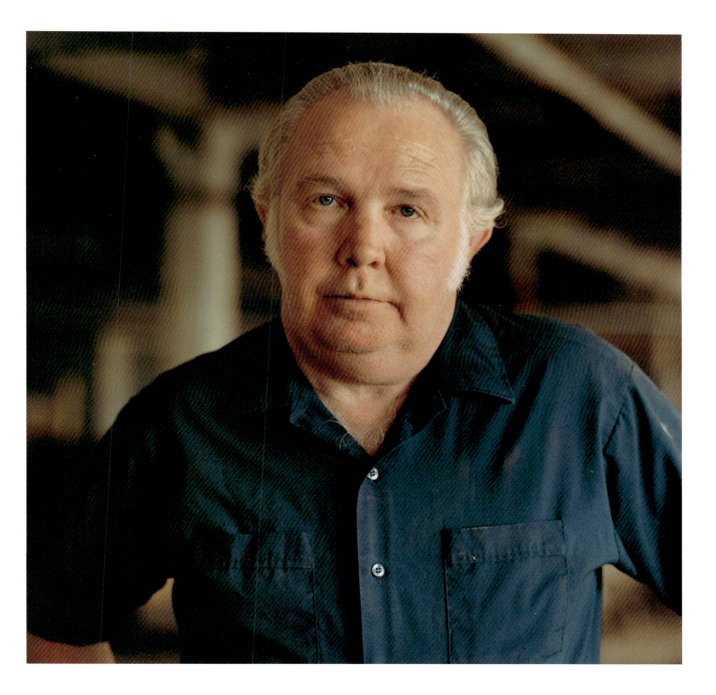

The old loading dock,
after the closing

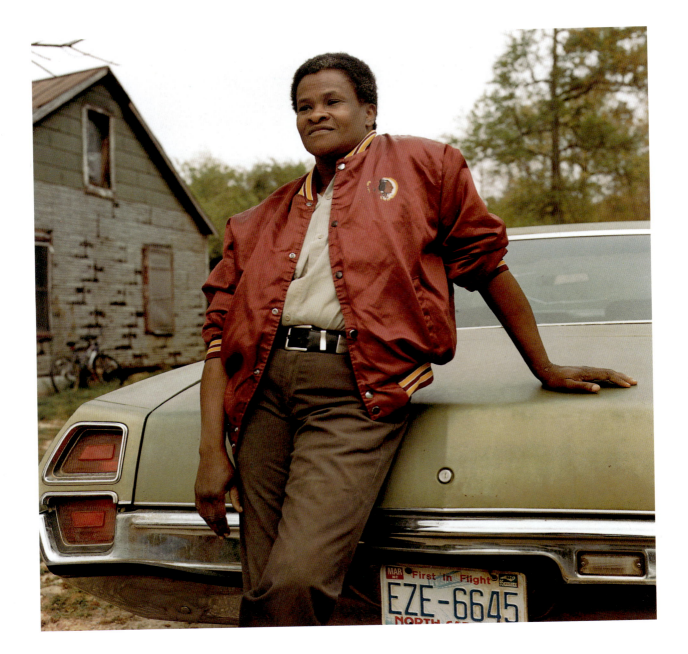

Annette Patterson at home, after the closing

The machine room, one month after the auction

Robert Wynn at home, the summer after the closing

Poster beds and mirrors on conveyors, finishing department

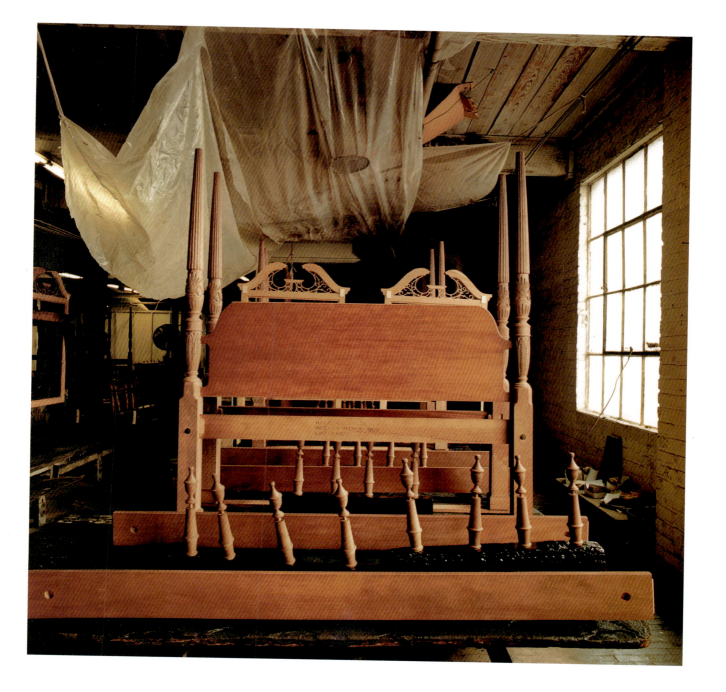

Notes

CHAPTER ONE

The postcard and historic photographs in this chapter are provided courtesy of Stephen A. and Margaret Holmes White.

1. *Burlington News,* July 29, 1980.
2. Cf. Jacquelyn Dowd Hall, James Leloudis, Robert Korstad, Mary Murphy, Lu Ann Jones, and Christopher B. Daly, *Like a Family: The Making of a Southern Cotton Mill World* (Chapel Hill: The University of North Carolina Press, 1987). My discussion of agrarian North Carolina in the 1890s is indebted to chapter 1, "Everything We Had," of this superb study. With some significant differences, much of what Hall et al. have uncovered about the sociology of the adult white male workers who entered the early textile mills parallels that of the first workers in the furniture industry.
3. William Stevens, *Anvil of Adversity: Biography of a Furniture Pioneer* (New York: Popular Library, 1968), p. 41. Only six of the twenty-eight furniture manufacturing companies operating in the Boston area in 1875 survived into the twentieth century. See David N. Thomas, "A History of Southern Furniture," *Furniture South* 46, no. 10, sec. 2 (October 1967), p. 22.
4. N. I. Bienenstock, "A History of American Furniture," *Furniture World,* vol. 148, no. 1 (January 1970), p. 126.
5. Surprisingly, there is no comprehensive history of the furniture industry in America. What

M. Eleanor Craig noted over thirty-five years ago holds true today: most furniture companies have been and many continue to be family-owned businesses that are remarkably secretive about their procedures. Until recently, in North Carolina only Drexel Industries even published an annual report. White Furniture Company never made regular financial disclosures and, on the contrary, has destroyed (or at least kept hidden) many of its books. When shutting down the factory, a cache of old account books, catalogues, newspaper clippings, and so forth were discovered in the trash and would have been thrown out were it not for the intervention of one supervisor, James Gilland, who collected the materials and later donated them to the Southern Oral History Program at the University of North Carolina at Chapel Hill. See also, M. Eleanor Craig, "Recent History of the North Carolina Furniture Manufacturing Industry with Special Attention to Locational Factors," Ph.D. diss., Duke University, 1959, p. iii.
6. In the Piedmont region of North Carolina, between 1880 and 1900, the number of tenant farmers increased by almost a third. See Hall et al., *Like a Family,* p. 6.
7. William S. Powell, in *North Carolina: A Bicentennial History* (New York: W. W. Norton, 1977), p. 170, also points out that tastes for the lighter bright leaf tobacco produced farther east put some of High Point's tobacco planters out of work, contributing to the boom of furniture making in that area.

8. Craig, "Recent History," p. 140.

9. Quoted in David N. Thomas, "Getting Started in High Point," *Forest History* 11 (July 1967), p. 24.

10. Thomas, "Getting Started in High Point," p. 25.

11. Margaret Holmes, "White Furniture Completes First Century," *Mebane Enterprise* (1981). This article was found in an album of clippings about the White Furniture Company compiled by the late Milton McDade, an amateur local historian. Hereafter, it will be referred to as the "McDade album."

12. "Mebane First Site of Continuing Furniture Making Plant," *The E.S.C. Quarterly* (Winter–Spring 1952), pp. 56–57.

13. "Death of Stephen A. White," Raleigh *News and Observer,* May 11, 1908.

14. Kitty Brandon, "White Closing Doors Feb. 15 after 112 Years," *Mebane Enterprise,* February 3, 1993, pp. 1–2.

15. Jacquelyn Dowd Hall and Patty Dilley, "Catawba County, North Carolina," working paper (Chapel Hill: Southern Oral History Program, University of North Carolina, 1980), p. 14. In 1896, Rickel was quoted in a Washington, D.C., newspaper on the comparative advantages of the South over the North: "Our business is more successful and promising than I expected. Orders are coming in from sources we did not expect to reach for some time. We can and do make furniture as good and far cheaper than in the North. We have the best of lumber and low in price. . . . I like the country and the people." This article is from an album of clippings about the White Furniture Company donated to the Southern Oral History Program by James Gilland and referred to, hereafter, as the "Gilland album."

16. As Will White wrote to one of his customers around the turn of the century: "We wrote you prices yesterday. They were very low for first class work. We can fill the order for less by using the lumber as we come to it. But we priced you for strictly first class selected work, kiln dried and heart lumber. We have seen in the short time we have been in the business that to take bills so low that we have to use cheap lumber is not the way to build up a trade." Quoted by Brandon, "White Closing Doors," p. 1.

17. Thomas, "Getting Started in High Point," p. 30.

18. Raleigh *News and Observer,* October 23, 1897.

19. *North Carolina Journal,* August 9, 1908.

20. Unidentified clipping from the Gilland album. Italics added.

21. Quoted in Bruce E. Johnson, *Built for the Ages: A History of the Grove Park Inn* (Asheville, N.C.: Grove Park Inn and Country Club, 1991), p. 19.

22. This version of the story was repeated by an informant who wishes to remain anonymous.

23. Brandon, "White Closing Doors," p. 2.

24. Writing of the British furniture industry, J. L. Oliver noted that "owing to the mechanization of furniture manufacturing in the twentieth century, specialists in one process have tended to displace specialists in one piece" (*The Development and Structure of the Furniture Industry* [Oxford: Pergamon Press, 1966], p. 166). Very much "specialists" and artisans, while also working on an assembly line, furniture workers defy easy categorization.

25. John G. Selby, "Industrial Growth and Worker Protest in a New South City: High Point, North Carolina, 1859–1959," Ph.D. diss., Duke University, 1984, p. 44.

26. David N. Thomas, "A History of Southern Furniture," p. 51.

27. William E. Fulmer, *The Negro in the Furniture Industry,* report no. 28, "The Racial Policies of American Industry" (Philadelphia: University of Pennsylvania Press, 1973), pp. 34–35; see also Lewis L. Lorwin, *The American Federation of Labor* (Washington, D.C.: Brookings Institution, 1933), p. 498; Robert A. Christie, *Empire in Wood* (Ithaca, N.Y.: Cornell University Press, 1956), pp. 110–119; and "Workers Vote for Union at La-Z-Boy's South Carolina Plant," *Home Furnishings Daily,* February 25, 1971, p. 7.

28. Selby, "Industrial Growth and Worker Protest," p. 315.

29. Joe Thompson, interviewed by Patrick Huber, July 18, 1994.

30. Ivey Jones, interviewed by Jefferson Cowie, January 18, 1994.

31. Selby notes that, when historians discuss the failed attempts at labor organizing in the southern furniture industry, they often resort to either psychosocial reasons for the "docility" of the southern workforce or material explanations for why work-

ers have acceded to the desires of management rather than to their own best economic interests. Selby discusses these issues extensively throughout "Industrial Growth and Worker Protest in a New South City."

32. Private conversation with Thomas A. Langford, May 8, 1996.

33. Census records for 1900 in North Carolina report only twenty-three African American "furniture manufactory employees," despite the fact that slaves traditionally made furniture for plantations and were the most highly skilled furniture makers in the antebellum South. Fulmer, *The Negro in the Furniture Industry*, p. 45.

34. Fulmer, *The Negro in the Furniture Industry*, pp. 45–46; and Lorenzo J. Green and Carter G. Woodson, *The Negro Wage Earner* (New York: Van Rees Press, 1930), p. 7.

35. Joe Thompson, interviewed by Patrick Huber, July 18, 1994.

36. Thomas O'Hanlon, "5,350 Companies = a Mixed-Up Furniture Industry," *Fortune,* February 1967, p. 145. "In an age of mass production for mass consumption," O'Hanlon notes with exasperation, "most of the 5,350-odd companies that make up the industry are still insignificant in size, inbred in management, inefficient in production, and inherently opposed to technological change. An air of earnest amateurism pervades the industry." See also Kenneth R. Davis, *Furniture Marketing* (Chapel Hill: The University of North Carolina Press, 1957), pp. 43–46; "Furniture Industry Review," Dominick & Dominick Research Department, November 19, 1970, p. 7; and U. S. Bureau of the Census, *Annual Survey of Manufactures: 1970, General Statistics for Industry Groups and Industries,* M70 (AS)-1, Preliminary Report, 1970.

37. My thanks to Joanna Maitland for providing me with a list of the twenty-eight inductees into the American Furniture Hall of Fame between 1989 and 1994. See also, "Four Inducted into Hall of Fame," *Furniture Today: The Weekly Business Newspaper of the Furniture Industry,* October 30, 1995, p. 1.

38. Craig, "Recent History," p. iii.

39. Conrad Paysour, "Mebane Furniture Makers Keep Up Long Family Tradition," clipping in the McDade album.

40. Eddie Marks, "White Furniture Company: 100 Years of Excellence," clipping in the McDade album.

41. Paysour, "Mebane Furniture Makers."

42. Paysour, "Mebane Furniture Makers."

43. Martin Eakes, interviewed by Jefferson Cowie and Bill Bamberger, October 19, 1994.

44. John C. Boland, "Clyde Engle Wants to be Friendly," *Fortune,* April 30, 1984, p. 185.

45. Boland, "Clyde Engle."

46. Martin Eakes, interviewed by Jefferson Cowie and Bill Bamberger, October 19, 1994.

47. Ed Clayton, interviewed by Chris Stewart, June 21, 1994.

48. Jefferson Cowie, "The Buying and Closing of the White Furniture Company of Mebane: What Happened?" Paper produced for the Department of History, University of North Carolina at Chapel Hill, Southern Oral History Program, February 1995, p. 9. I am particularly indebted to Cowie's astute analysis of the Census of Manufactures for the furniture industry and for the White situation in particular.

49. Pete Engardio, "What's Rearranging America's Furniture Industry?" *Business Week,* September 29, 1986; quoted in Cowie, "The Buying and Closing of the White Furniture Company," p. 9.

50. Cowie, "The Buying and Closing of the White Furniture Company," p. 10.

51. Of course, these figures depend entirely on what is counted. Once purchased by Hickory-White Corporation, the earnings and debits for the Mebane plant would have been rolled into the larger corporate profile of Hickory-White.

52. Robert Marks, "Hickory White Closing One Plant," *HFD – The Weekly Home Furnishings Newspaper,* November 23, 1992, p. 16.

53. "Acton Announces Closing of Hickory White Company Plant," PR Newswire Association Release, November 11, 1992.

CHAPTER TWO

1. Quotations in this chapter are taken from an interview taped in the home of Margaret Holmes White and Stephen A. White V by Bill Bamberger on April 3, 1995, as well as from the author's informal conversations with Margaret and, on one occasion, Steve.

Historians hold widely divergent views on the use of taped interviews in oral history, with some

taking the purest view that only an exact transcript is permissible and others arguing that free adaptation is the only way to convey the "spirit" of actual conversation. My aim has been to make as readable a story as possible while conveying to the reader a clear sense of the White workers who shared their stories. Thus, when I have used quotations from the taped interviews conducted by the Southern Oral History Program, I have followed certain standard editing practices designed to make the quotations accessible. While striving to retain the character of an individual's speech patterns, style, and phrasing, I have corrected grammatical mistakes where they might lead to confusion and, on some occasions, I have reordered sentences for clarity. I have also omitted digressions that are normal occurrences in conversation but that would be irrelevant to this narrative, and I have done so without the use of distracting ellipses. Historians and linguists who wish an exact rendering of the interviews may refer to the tapes and transcripts housed in the Southern Historical Collection, Wilson Library, University of North Carolina at Chapel Hill. A full list of the interviews is provided after these endnotes.

2. See also, James C. Cobb, *The Selling of the South: The Southern Crusade for Industrial Development, 1936–1980* (Baton Rouge: Louisiana State University Press, 1982); John G. Selby, "Industrial Growth and Worker Protest in a New South City: High Point, North Carolina, 1859–1959," Ph.D. diss., Duke University, 1984; and Jacquelyn Dowd Hall et al., *Like a Family: The Making of a Southern Cotton Mill World* (Chapel Hill: The University of North Carolina Press, 1987).

CHAPTER THREE

1. Quotations in this chapter are taken from formal interviews with James Gilland taped by Patrick Huber on May 26, 1994, and by Patrick Huber and Kathy Nasstrom, taped on June 2, 1994, as well as from more informal conversations with the author.

CHAPTER FOUR

1. Quotations in this chapter are taken from a formal interview with Don McCall, taped by Bill Bamberger and Alice Boyle on January 24, 1995, in Brevard, North Carolina, as well as from the

author's informal conversations with Don by telephone and at Chianti's Restaurant in Brevard on June 22, 1995.

2. Closing a plant—disposing of waste, moving machinery and materials, organizing auctions and sales—is a complex and expensive business. As Jefferson Cowie notes, it cost nearly two million dollars to close the Mebane operation (an amount deducted against Hickory-White's corporate earnings for that quarter). See Cowie, "The Buying and Closing of the White Furniture Company," p. 12.

CHAPTER FIVE

1. Quotations in this chapter are taken from formal interviews with Annette Patterson, taped by Bill Bamberger at his studio on December 18, 1994, and June 18, 1995, as well as from the author's informal conversations with Annette Patterson.

2. The name of this company has been changed by the author.

CHAPTER SIX

1. Quotations in this chapter are taken from an interview with Robert Riley, taped by Chris Stewart on February 1, 1994; a taped interview with Riley, conducted by Bill Bamberger and Kathy Nasstrom at the photographic exhibit in Mebane on March 18, 1994; and an informal conversation with the author at Riley's home in June of 1996.

EPILOGUE

1. For a concise summary of these and other statistics, see John Cassidy, "Who Killed the Middle Class?" *New Yorker*, October 16, 1995, pp. 113–124.

2. Cassidy, "Who Killed the Middle Class?" p. 114; and, for a more detailed overview and analysis, Robert H. Frank and Philip J. Cook, *The Winner-Take-All Society: How More and More Americans Compete for Ever Fewer and Bigger Prizes, Encouraging Economic Waste, Income Inequality, and an Impoverished Cultural Life* (New York: Free Press, 1995).

3. Quoted in the *Chicago Tribune,* December 24–31, 1995.

4. Unprecedented in America, the top 5 percent of American households now earn 20 percent

of the nation's income (Cassidy, "Who Killed the Middle Class?" pp. 120, 124)

5. People who rush to blame taxation for the end of the middle class must be reminded that, as Cassidy notes, "the total share of the national income taken by federal, state, and local taxes was 31.1 per cent in 1973 and 30.9 per cent in 1993." What has changed demonstrably, however, are the ceilings on the amount that the very rich can be taxed and the "tax simplification" policies under the Reagan administration that resulted in virtually identical levels of taxation for middle-class citizens and the very rich. As a nation, we now pay fewer taxes than we did twenty years ago; however, a bigger proportion of the tax bill is paid by people of modest means. "If part of the motivation for taxation in the thirties was to redistribute income from the rich to the poor, it is a hallmark of the 1980s and 1990s that we have experienced the most radical redistribution of income to the wealthy in all of American history." See Donald L. Barlett and James B. Steele, "Shifting Taxes: From Them to You," in *America: What Went Wrong?* (Kansas City, Miss.: Andrews and McMeel, 1992), pp. 40–65; and Lawrence Mishel and David M. Frankel, *The State of Working America, 1990–1991* (Armong, N.Y.: M. E. Sharpe, 1991).

6. *New York Times,* July 6, 1996, p. 17.

7. In the past, it was typical for most lost jobs to come from the failure of small businesses. Many are alarmed that now it is the downsizing of the major corporation that has resulted in the greatest shrinkage of American jobs. See *The Downsizing of America, New York Times* Special Report (Random House: Times Books, 1996), p. 18.

8. For excellent discussions of how such downsizing especially affects middle managers and has caused a new level of economic insecurity among the middle class, see Barbara Ehrenreich's *Fear of Falling: The Inner Life of the Middle Class* (New York: HarperCollins, 1989); and Katherine S. Newman, *Falling from Grace: The Experience of Downward Mobility in the American Middle Class* (New York: Random House, 1988).

9. For case studies in how globalization has affected specific industries, see Helzi Noponen, Julie Graham, and Ann R. Markusen, eds., *Trading Industries, Trading Regions: International Trade, American Industry, and Regional Economic Development* (New York: Guilford Press, 1993).

10. "Explosion, Fire Destroy Methuen Textile Complex," *Boston Globe,* December 12, 1995, p. 1.

11. This comment was made by Ronald Alman, head of the textile workers union in New England, and quoted by Jon Auerbach and John Milne, "Methuen's Unstoppable Hero," *Boston Globe,* December 15, 1995, p. 30. My special thanks to Barbara and Richard Wissoker for collecting clippings about the fire from Boston-area newspapers.

12. See especially, Fred Block, *Postindustrial Possibilities: A Critique of Economic Discourse* (Berkeley: University of California Press, 1990); and Barry Bluestone and Bennett Harrison, *The Deindustrialization of America: Plant Closings, Community Abandonment, and the Dismantling of Basic Industry* (New York: Basic Books, 1982).

Interviews

The following interview tapes, conducted and transcribed by the Southern Oral History Program, are available for unrestricted use by scholars. They are housed at the Southern Historical Collection, Wilson Library, University of North Carolina at Chapel Hill.

Bradshaw, Wallace H. Interview by Valerie Pawlewicz, April 10, 1994.

Burnett, Tracy. Interview by Jefferson Cowie, November 15, 1994.

Capes, Kenneth D. Interview by Patrick Huber, November 28, 1994.

Clayton, Ed. Interview by Chris Stewart, June 21, 1994.

Cook, Cynthia S. Interview by Valerie Pawlewicz, February 19, 1994.

Eakes, Martin D. Interview by Jefferson Cowie and Bill Bamberger, October 19, 1994.

Faucette, Sam D. Interview by Jefferson Cowie, June 13, 1995.

Faulkner, Kay A. Interview by Patrick Huber, July 1, 1995.

Foley, Andy. Interview by Jefferson Cowie, May 18, 1994.

Gilland, James M. Interview by Patrick Huber, May 26, 1994; and by Patrick Huber and Kathy Nasstrom, June 2, 1994.

Gross, Jimmy Lee. Interview by Patrick Huber, November 22, 1994.

Hanks, Barbara. Interview by Patrick Huber, August 10, 1994.

Hunter, Paul. Interview by Patrick Huber, July 5, 1995.

Jacobs, Vickie. Interview by J. Blackwell-Johnson, December 11, 1993.

Jones, Ivey C. Interview by Jefferson Cowie, January 18, 1994.

McCall, Don. Interview by Bill Bamberger and Alice Boyle, January 23, 1995.

Newcomb, Jane. Interview by Valerie Pawlewicz, March 6, 1994.

Patterson, Annette. Interview by Bill Bamberger, December 18, 1994 and June 18, 1995.

Riley, Robert. Interview by Chris Stewart, February 1, 1994; and by Kathy Nasstrom and Bill Bamberger, May 18, 1994.

Smith, Robin L. Interview by Jefferson Cowie, July 18, 1994.

Sykes, Ronnie W. Interview by Patrick Huber, May 18, 1994.

Sykes, Zaner. Interview by Patrick Huber, August 2, 1994.

Thompson, Joseph R. Interview by Patrick Huber, July 18, 1994.

Tripp, Millie. Interview by Valerie Pawlewicz, August 12, 1994.

Vickers, Eston Kirk. Interview by Jefferson Cowie, November 7, 1994.

White, Margaret Holmes (with Stephen A. White V). Interview by Bill Bamberger, April 3, 1995.

Williams, Tommy Ray. Interview by Bill Bamberger, December 5, 1994.

Wood, Mike. Interview by Jefferson Cowie, November 10, 1994.

Wright, Ronnie J. Interview by Patrick Huber, July 26, 1994.

Acknowledgments

Fletcher Holmes first took me through the White Furniture factory in December 1992, three months prior to its official closing. I remember being awed by the sheer size of the plant, the seemingly endless sea of lights and sounds, and the colors of wood and metal. But it was the people we met and Fletcher's compassion for them that made the deepest impression. He introduced me to dozens of workers that day, describing them not so much by what they did or how their work was integral to production but rather by telling me about their families, how many children they supported, how long they had worked at the factory, and about their prospects for the future.

I am indebted to the many workers I came to know in the months that followed. They took me in and shared their lives at a most difficult time. This book—now nearly five years in the making—is for them. I would like to offer my special thanks to James Blalock, Cindy Cook, Fletcher Holmes, Vickie Jacobs, Harlton Lane, Don McCall, Annette Patterson, Robert Riley, Ronnie Sykes, Margaret White, and James Wynn for friendship and unwavering support along the way.

These photographs would not have been taken were it not for the support of Randy Austin, CEO of Hickory-White, and Robin Hart, president of the Mebane division. I am grateful to them for allowing me to photograph inside the factory.

A year after the closing, we premiered an exhibition of these photographs in downtown Mebane to honor the former workers and the company that was central to our community. I am grateful to the North Carolina Humanities Council for providing major funding. I also thank exhibition sponsors: the Mebane Arts Council, the Southern Oral History Program at the University of North Carolina at Chapel Hill, the Documentary Studies Working Group supported by the Institute for Research in Social Science at UNC-CH, and the Center

Little Man and Possum, a year after the closing

for Documentary Studies at Duke University.

Community and regional support for the exhibition was tremendous. For their generous contributions of funding and in-kind support, thanks to: Binswanger Glass Company, Byrd's Food Stores, Cathy's Flower Boutique, Central Carolina Bank, the City of Mebane, Dovetail Construction, Eurosport, Faust Decorative Arts, First South Bank, Freudenberg Spunweb Company, Henley Paper Company, King Electric Company, Martinho's Bakery & Deli, McDonald's, the Mebane Business Association, the *Mebane Enterprise,* Mebane Lumber and Hardware Company, the Mebane Fire Department, Mebane Packaging, Oblinger Construction, Robert and Meg Scott Phipps, Public Service Company of North Carolina, Ronnie Cook Electrical Service, Ruffin Woody & Associates, Warren's Drug Store, and Western Auto. Special thanks to Harperprints, which donated the printing of the exhibition poster, and to Elizabeth Ward and Jesma Reynolds for their design of both the poster and the invitation. Thanks also to Dan Ahern, Brad Attig, Steven Burke, Randy Campbell, Jeannie Gill, Melinda Hartje, Charles Honeycutt, Jimmy Isley, Tom Jones, Debra Kaufman, Buck Lankford, Ben Peacock, Glenn and Emily Peterson, Twyla Peterson, Elma Sabo, CiCi Stevens, Mary Ellen Taylor, John Vincent, Debbie Warren-Hicks, Clint Wilson, Paul Young, Byron Zook, and the many others who helped to install and staff the exhibition.

Thanks to photographers Rich Beckman, Jack Kotz, Elizabeth Matheson, and Brian Whittier for encouragement and advice, and to photographer Joni Lane for working with me on all aspects of the exhibition production from printing the black-and-white photographs to selecting and installing the work. Thanks to Peter Mauney for teaching me a new approach to black-and-white printing. Thanks to Pat Martin and Wendy McEahern at Visions Photo Lab and Steve Petteway at Chrome, Inc., for producing a remarkable set of original color prints.

221

I could not have had a greater ally from beginning to end than the Southern Oral History Program. Director Jacquelyn Hall offered her personal support as well as the full support of the program at a critical juncture. Acting director Kathy Nasstrom was integrally involved in the planning of the exhibition and subsequently initiated and co-directed the interview project. Projects director Alicia Rouverol also codirected the project and helped to broaden its scope as we worked with a team of interviewers over the course of several years. Special thanks to interviewers Pat Huber and Jeff Cowie who conducted the majority of the interviews, and to Jackie Gorman for the seemingly never-ending hours of transcribing. The interviews conducted by the Southern Oral History Program were supported by the North Carolina Humanities Council, the Davis Oral History Fund, the Conrad Southern Oral History Endowment Fund, the University Research Council at the University of North Carolina at Chapel Hill, and the Center for Documentary Studies at Duke University.

In the spring of 1993, just months after the factory had closed, Iris Tillman Hill and Alex Harris at the Center for Documentary Studies agreed to publish this book. Shortly thereafter, we began an in-depth search to find a writer who could place the story in a broad historic, economic, and social context while drawing on the life histories and insights of the former workers. I am grateful for Iris and Alex's early and enduring support and for their suggestion that we ask Cathy N. Davidson to write the text.

I am grateful to Cathy for writing a narrative that was all that we hoped for and more. Cathy brought passion, intelligence, and a deep commitment to this work. I trusted and relied on her visual sensibility. I appreciated the respect she showed for my work and the relationships I had established in this community. Her willingness to review hundreds of my contact sheets — an epic task — was indicative of her generosity and commitment to every aspect of this book. But most of all I am grateful to Cathy for her unfailing faith in what we were creating together.

Thanks to our editors, Jim Mairs at W. W. Norton and Alex Harris and Iris Tillman Hill at DoubleTake Books, who collectively and individually shared their vision for this book. Our designer, Molly Renda, also helped to shape the book and then crafted a design that beautifully balanced the narrative and photographs. Special thanks to Tabitha Griffin at Norton, and Cat Brutvan, Alexa Dilworth, Isabel Geffner, and Caroline Nasrallah at DoubleTake Books. I am grateful to the Lyndhurst Foundation for supporting my work and helping to make this publication possible.

I would like to thank John Coffey at the North Carolina Museum of Art and Harlan Gradin at the North Carolina Humanities Council for their generous support. Special thanks to Ken Wissoker for his advice and Bob Coles for his continuing support.

I am thankful to my family, particularly Frances Bamberger, my mother, and Jim Bamberger, my brother, who have supported my efforts for many years and who are always there when I need them most. For support and advice on this project and others before, I am grateful to dear friends: Robert Donnan, Lisa Hodermarsky and Sloan Wilson, Ann Joyner and Allan Parnell, Michael Lance, Rick Larson, Davien Littlefield, John and Dale Reed, Julie Thomasson, and Tim O. Walker.

Finally, Alice Boyle was an integral part of this project from the very beginning. From the early days of photographing the factory interior, through the weeks of endless hours renovating the Jones Department Store, to the sequencing and selection of the images, she was present as a trusted adviser and valued partner. All along she believed and shared in this work. For her loving support, I am deeply indebted.

Bill Bamberger
Mebane, North Carolina

I ris Tillman Hill, director of the Center for Documentary Studies at Duke University, called in February of 1994 to ask if I would be interested in writing the story of White Furniture Company. My narrative would be combined with Bill Bamberger's photographs into a book intended not for specialists in labor history, southern history, or economic relations but for anyone urgently interested in the human cost of postindustrialism. I started with two great gifts for a writer: freedom to craft the story as I wished and full use of the Southern Oral History Program's taped interviews with over thirty of the former White workers.

Each of the interviews is approximately two hours long and based on a standard set of questions prepared in advance. Bill Bamberger conducted some of the interviews; the rest were conducted by graduate students in the History Department at the University of North Carolina at Chapel Hill. Transcribed, the interviews are now archived at the Southern Oral History Collection at UNC-CH where they are an invaluable resource for future historians. I am deeply grateful to Jacquelyn Hall, director of the Southern Oral History Program, for her encouragement, advice, and support. I also thank the other members of the program, especially Jackie Gorman, Kathy Nasstrom and Alicia Rouverol (who, along with Bill, codirected the interview project), and Jefferson Cowie.

Because I knew that I would be able to rely on these tapes for direct quotations as well as basic data, I was free to pursue my research in a looser, ethnographic manner. For a year before I wrote a word of this book, I let serendipity be my guide, talking to various neighbors and friends whose relatives had worked for White Furniture Company. For a while, it seemed everyone I met had some connection to White's — the stepfather of one of my students was a retired minister from Mebane who had worked at White's

during the Depression; Smoky, at my local service station, had been laid off when the Hillsborough plant closed down; my friend Robbie had relatives at White's and so did Patsy, an administrative assistant at Duke. At an antique store, I ran into a woman who collected White furniture. She tried to convince me it was all made by hand. Before I did scholarly historical research on the furniture industry or on contemporary corporate practices, I collected these stories in order to piece together the larger story of the White Furniture Company. I am grateful to all who took the time to share their insights with me.

I also started "dropping in" on Mebane. At Warren's Drug Store, Martinho's Bakery & Deli, or the A & M Grill, I would ask strangers, "What's that big, abandoned building over there by the railroad crossing?" The animated answers I received to this simple question helped me understand how much had been lost when the Mebane plant shut down. I also began talking informally with White workers who had been interviewed by the Southern Oral History Program. I talked without benefit of tape recorder or pen and paper, although typically I would rush to the car after our chat and hurriedly scrawl down observations, poignant phrases, or facts to be checked out later. Our talk rambled along, the way southern conversations often do, with anecdotes, family stories, jokes. The many former White workers I met and talked to between February 1994 and June 1996 were unfailingly generous with their time, their stories, and their spirit. I came on to the project as an outsider to their world of work and to their community. I cannot thank them enough for inviting me in.

Material support for this project came when I needed it most. Generous fellowships from the National Humanities Center, the National Endowment for the Humanities, and the American Council of Learned Societies as well as a sabbatical from Duke University allowed me to take an entire year off from my academic duties in order to write this book. My

coeditor at *American Literature,* Michael Moon, took on the duties of the journal for a year in order that I might be free of editing. A year in residence at the National Humanities Center allowed me to take advantage of the incomparable library services of Allan Tuttle, Jean Houston, and Eliza Robertson. When I discovered, to my horror, that there was no full-scale, scholarly history of the American furniture industry, Jean and Eliza were at the ready, able to find me articles in the obscurest furniture trade magazines dating back to the first decade of the century.

At the National Humanities Center in the spring of 1996, I met almost weekly with labor historian Tom Dublin. We commented on draft chapters of each other's work and engaged in lively discussions of labor history and the merits and shortcomings of the various ways to make use of and to present oral history. Luise White and Rosalind Carmel Morris provided insights on "voice" from the different perspectives of history and anthropology. I also thank Fitzhugh Brundage, Mike Honey, Robert Korstad, Larry Grossberg, Kathryn Kish Sklar, and Arleen Tuchman for their insights and assistance, and Edwin Yoder for his recollections of growing up in Mebane. Ryan Schneider was, as usual, a superb research assistant.

Another colleague at the National Humanities Center, Bob Keohane, provided insights into contemporary economics and economic theory, and the impact of globalization, technology, and other forces in today's economy. My father, Paul Notari, taught me how to decipher a corporate balance sheet while my sister, Sharon Christian, astutely assessed the financial papers that White Furniture Company provided in advance of the buyout. From the point of view of a former Chief Financial Officer who had been on both the giving and receiving end of major corporate mergers, Sharon gave me a different perspective on what happened at White's than, as an outsider to the world of venture capital, I could have arrived at on my own.

Several people associated with the furniture industry provided invaluable assistance, including Bernard Bienenstock, publisher of *Furniture World;* Joanna Maitland of the American Furniture Manufacturer's Association; and the staffs of the impressive Bienenstock Furniture Library and the Furniture Discovery Center (both in High Point, North Carolina). I would also like to thank Kenny Garrett for taking Bill and me on a tour of Plant A of the Thomasville Furniture Industries in Thomasville, North Carolina, and Alan Myers, vice president of manufacturing for Councill Companies, for taking us on a tour of the facility in Denton, North Carolina.

Bill read several drafts of this manuscript with an eagle eye, as did Alice Boyle. So did my editors, Iris Hill and Alex Harris, of DoubleTake Books, and my editors at W. W. Norton, Jim Mairs and Tabitha Griffin. I thank them all for their perceptive feedback. Thanks, too, to Alexa Dilworth and Isabel Geffner; and to Molly Renda, who tranformed the manuscript into a book with rare sensitivity to both narrative and photographs. As usual, the members of my writing group—Betsy Cox, Alice Kaplan, Janice Radway, and Marianna Torgovnick—were there for me from beginning to end. Without them, this narrative would have been three times longer—and that much duller. Most of all, Ken Wissoker was an intellectual companion, a brilliant editor, and a loving partner as the months of this project grew into years.

Finally, Bill Bamberger was an inspiration as I wrote and a critical, supportive collaborator. This project began as the result of his passion, vision, and eloquent photographic eye. The main body of his work was over before I wrote a single word of the text. From the beginning, he assured me that he hoped I would come to feel that this project was as much mine as his. He did everything in his power to make this happen, and it did.

Cathy N. Davidson
Durham, North Carolina

The text of this book is composed in Janson.
Book design by Molly Renda
Composition by The Marathon Group, Inc.
Manufacturing by Tien Wah Press